A DIGITAL PHOTOGRAPHER'S GUIDE TO

Model Releases

MAKING THE BEST BUSINESS DECISIONS WITH YOUR PHOTOS OF PEOPLE, PLACES AND THINGS

Dan Heller

WILEY

Wiley Publishing, Inc.

A Digital Photographer's Guide to Model Releases

Published by
Wiley Publishing, Inc.
10475 Crosspoint Blvd.
Indianapolis, IN 46256
www.wiley.com

Copyright © 2008 by Wiley Publishing, Inc., Indianapolis, Indiana

All photographs © Dan Heller 2007

Published simultaneously in Canada

ISBN: 978-0-470-22856-2

Manufactured in the United States of America

10 9 8 7 6 5 4 3 2 1

For general information on our other products and services or to obtain technical support, please contact our Customer Care Department within the U.S. at (800) 762-2974, outside the U.S. at (317) 572-3993 or fax (317) 572-4002.

Wiley also publishes its books in a variety of electronic formats. Some content that appears in print may not be available in electronic books.

Library of Congress CIP Data: 2007941553

Credits

Acquisitions Editor
Ryan Spence

Editorial Manager
Robyn B. Siesky

**Vice President &
Executive Group Publisher**
Richard Swadley

Vice President and Publisher
Barry Pruett

Business Manager
Amy Knies

Marketing Manager
Sandy Smith

Book Designer
Dan Heller

Indexing
Johanna VanHoose

About the Author

Dan Heller is a freelance photographer based in Marin County, California. He is often on assignment, shooting images for adventure travel companies who use his work in their promotional materials. When he's not traipsing across continents, he taps this great body of work to create fine art prints, and to relicense photos for commercial and editorial uses, as part of his stock photography business.

Dan honed his photographic skills from years of taking pictures while on vacation. It was his decision to post those vacation photos on his Web site that sparked a growing business, generating sales and transforming his hobby into a career.

Dan has since become a photo industry analyst, who writes about trends and developments that shape the future of the business, both from an individual photographer's perspective and from the broader industry view. He is also a business consultant for companies entering or investing in the stock photography industry. You can read his blog on the subject at http://danheller.blogspot.com

Contents

CONTENTS

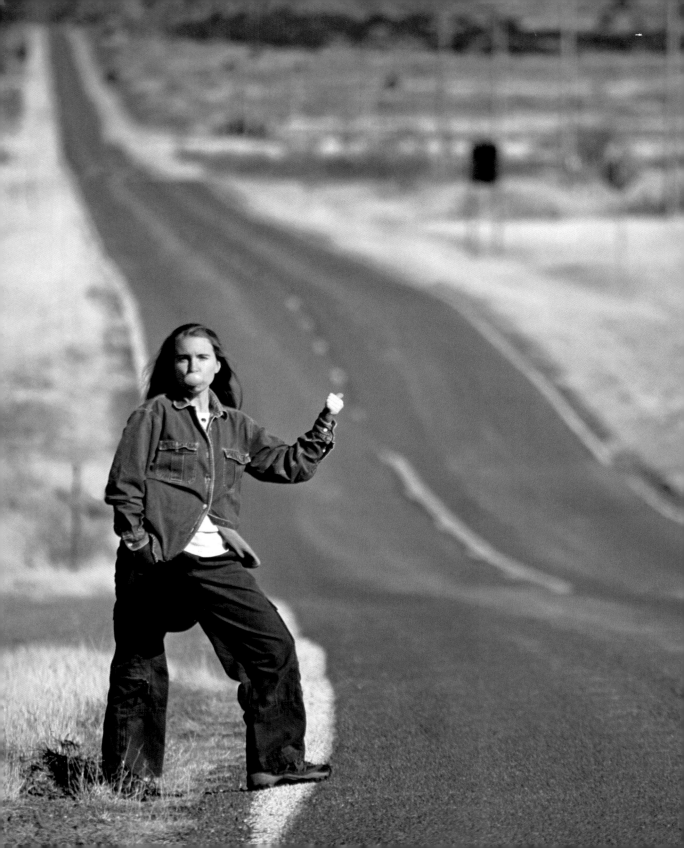

How We Got Here

L et's review what's happened so far. First the Earth cooled. Then photography was invented. Then the Internet came into our lives, and crawled its way into our collective cultures. Then came volumes of user-generated content, which has reshaped the way people interact with the world. Then came advances in digital photography that made it possible for everyday people to produce images that were once done only by professionals. And then finally, peanut butter meets chocolate: The Internet and photography joined to create not just a new wave of interest in the art, but the social networking aspects have also given rise to new business opportunities for nonprofessional photographers ("consumers").

Just about anyone with a camera and an Internet connection can and does engage in the business of photography and make money, and they're doing so in rising numbers. Some embark into the business only for the fun and excitement of making mad money, while others are looking to build a new career.

Of all the ways to make money in photography, the granddaddy of them all is stock photography: the licensing of photos to others who use them in publications, toy packaging, ads, posters, and so on. It's the fastest growing segment of the broader photo industry for several reasons: You can sell images you've already taken, you can do it in your spare time, sales grow and grow as you accumulate more inventory, you don't have to rely on specific clients (or even have to meet them), and you can do it in your underwear in your home. (Well, except for those times where

you have to leave the house to take pictures.) Stock photography is at a pivotal point today because more and more consumers are getting involved, largely for these very reasons. And it's not just on the sales side: They're also buying more photos, either for their own use or for their employers' — a job function that was once reserved for photo editors at large newspapers and magazines.

That raises an issue that can get eager consumers in trouble. It's the *use* of photography in publications, ads, movies, art exhibits, and infinite other uses that presents potential legal liabilities for both buyers and sellers. The best way to make money (or keep from losing money) when licensing or using photos is to understand the legal landscape involved.

First, what permits this industry to exist in the first place is the fact that photography is copyrighted material, which enjoys protections set by law. Those who want to use or publish photos legitimately must license them from the photographer who owns them (or through an agency that represents him) or face penalties that easily go into the tens of thousands of dollars. So most serious buyers have an incentive to be honest and pay for the photos they use.

Second, the Internet's use as a distribution channel means that people like you can participate in ways that were never before possible. (Before the Internet, you had to go through photo agencies, and getting accepted into one was difficult.) In fact, with the influx of images on the Internet from millions of people, it's no wonder that the biggest change in

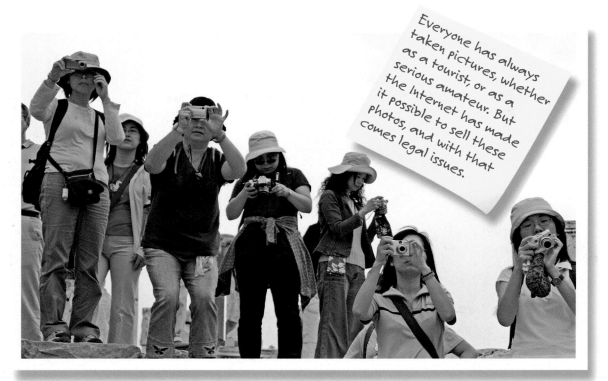

Everyone has always taken pictures, whether as a tourist, or as a serious amateur. But the Internet has made it possible to sell these photos, and with that comes legal issues.

the photo industry has been the increase in photo licensing, due entirely to the Internet itself. And it's not just new photographers selling to the same old buyers; people who never licensed photos before are using the Internet, whether it's a small church for a newsletter, a local dentist's office for its brochure, a young independent band for its self-produced music CD that it sells on MySpace, or a college professor who needs a photo of the mushrooms in your backyard for a research paper she's going to submit to a science journal. There is no end to the types of people who buy and sell images.

But the use of photos involves more than just getting a license to the image itself. Just as photos are legally protected in ways that require people to pay you to use them, so too may be the subjects of those photos be legally protected. Typically, photos are of people, places, or things, each of which may have protections due to privacy or commerce laws. Just as you can make money by letting someone else use a photo you took, someone else can make money because he — or in some cases his property — is in that very same photo. The permission to use his or his property's likeness is called a model release, and it's the least understood aspect of the photography industry (by buyers and sellers alike).

It doesn't matter what kind of pictures you take, everything has sales potential. Even really bad photos can (and do) sell. They key is making them "saleable," and one factor is having model releases.

Nature photography sells very well. But if you feel apprehensive about asking people to sign model releases, you shouldn't exclude people pictures that you sell. Not all uses need model releases.

At first, it all sounds pretty simple, doesn't it? First get a model release of your subject, then you're free to license the photo. Well, that's how it works in theory, anyway. There's a wrinkle: You don't always need a release. Sometimes you do, sometimes you don't, and it's not always straightforward which way to go. There's another wrinkle: It's not always easy to *get* a release. And there's a third wrinkle: People file lawsuits about these things anyway.

At the heart of all this is knowing whether permission is needed for any given use of a photo, which comes down to understanding a combination of legal interpretations and business principles. But who wants to learn all that? Is there a way to explain all this in ways that you can understand without using complicated lingo that makes your head spin? Well, that's my goal here: to help you piece together the gazillions of rules, exceptions, what-if's, and gotchas (see? no legal jargon here!) to make this whole mess work for you, not against you.

But there's one thing I'll need you to do first: adjust your way of looking at legal matters. They are not as a series of rules, but a series of concepts. Don't look for statements like, "You can't take pictures of kids at school without a model release," because laws don't work that way. Rather, you want to think more conceptually, as in, "People have certain rights to privacy, so the publication of photos can be perceived to violate those rights." There may be some uses for that photo that violate those rights, whereas there are others that don't.

In any event, the purpose of a model release is for the subject of a photo to give permission for its publication. That way, no one has to call any lawyers.

Well, that's how it works in theory, anyway.

The legal realm of when model releases are required is hazy at best, as the principles are based on the First Amendment of the US Constitution, which is the source of many disagreements.

PART 1

Everyone's Doing It. So What's Wrong?

Y ou're at your kid's soccer match at school, and you're taking pictures. Being the photo buff that you are, you get everything: kids scoring goals, parents screaming from the sidelines, the popcorn vendor, and fans in the stands. Later, you show the pictures to some of the people and find that some want to buy a print for themselves. This becomes a popular trend and, over time, your reputation grows. The local newspaper gets wind of your talent and wants to license a few photos so it can put some in the paper for an article on the school's sports curriculum. Perhaps the local gift shop wants to sell enlargements of the shot you took of the winning goal at the state championships.

All's going well — until someone tells you that you can't do any of these things unless the people in the photos sign a "release" allowing you to use pictures of them.

Are they right? After all, you're not the only person there with a camera. Everyone takes pictures. And, as evidenced from looking at just about any Web site on the Internet, photos are everywhere. Yet, whenever people take pictures in public (especially around schools and parks where children congregate), there's always someone in the crowd ready to voice objections, threats, or warnings. So, what's wrong with what you're doing? And if something is wrong, what can happen to you as a result?

In a world of heightened awareness and concern over privacy — partially exacerbated by the instantaneous, ubiquitous, and unpatrolled nature of the Internet — people have become more acutely aware of photography's role in society and commerce. Understandably, this has raised interest for people on both sides of the lens

THE ESSENTIALS

Many people think they understand the subject of model releases for photos better than they actually do, and when you combine that misinformation with fear or greed, people tend to swing to either overly conservative or overly liberal interpretations of legal matters. The best way to learn this material is to follow these basic guidelines:

☑ *The laws regarding model releases are not codified as they are with traffic laws.* There are no hard-and-fast rules you can apply mindlessly. The greatest mistake you can make is assuming that the law is written so clearly and unambiguously that you can just look up questions in a book and get answers.

☑ *Do not look for quick answers to specific scenarios you happen to be in.* I cannot possibly list all of the different types publications, art displays, or other ways that photos can be used that will even come close to satisfying specific questions. And even if I could, that would miss the point. You need to learn the underlying principles and extrapolate what you learn in other contexts and then apply them to your own situation.

☑ *Don't just know facts, understand them.* In business negotiations, it's less important to be right as it is to close the deal. Knowing facts about model releases is useless unless you can communicate effectively with other people. Whether you're dealing with an unruly subject who is upset that you took her picture, a mall security guard who confiscated your camera, or an overly protective client who insists on having a release for every single photo (even though he doesn't need them), it's how you communicate with people that determines the outcome, not whether you're technically right about the law. In business, you want a profitable outcome, not a legal victory.

☑ *Don't look for model-release templates.* (And if you do, don't use them unless you understand them.) I subscribe to the cliché "Give a man a fish and he eats for day; teach a man to fish and he feeds himself for a lifetime." Understanding what needs to be in a release is a benefit that will do more for you in the long run than by being spoon-fed releases that you don't understand. And, frankly, what are you going to do if that canned release is thrown back at you (or modified) by a client? If you don't understand the principles involved, how are you going to negotiate them?

due to the most primitive of human emotions: fear and greed.

On the fear side, people who take pictures for a living (or to earn extra income) are concerned their actions may get them into trouble, whether it's the simple taking of pictures or the publication of those photos, either on personal Web pages or in more traditional media. On the greed side, the financial opportunity to sell photos, either as prints or to other people who'll publish them, is a powerful motivator. There are even nonfinancial motivations, such as winning photo contests or getting praise in online photo forums. Yet, people pause and worry whether they "can" do these things with their photos of other people.

Similarly, those who are in pictures feel both greed and fear, too. On the fear side, people want to be sure their privacy is protected, especially if the publication of photos would bring them undue hardship or uninvited publicity. Accordingly, circumstances may cause people to react violently, through verbal abuse or worse, tossing about assertions that "you can't take photos here!" (Just ask any

photojournalist in a metro area who covers social matters what it's like to photograph the general public, whether it's people standing in welfare lines, going to the park or the beach, attending high-brow fund-raisers, or being in a compromising position with a politician.)

On the greed side, people want to exert a greater proportion of ownership of the photos they're in than they actually have: They usually believe they have ultimate control in how (or whether) a photo can ever be used. They also believe they should be paid gross sums of money to publish those pictures, whatever they may be. (Some even think they have rights of ownership to any photos they may be in. See Part 7 for more details on this.)

Almost everyone's assumptions about their rights far exceed what they actually have — and this is the case for those on both sides of the lens. These two extremes

No question about it: pictures sell. But there are also risks. Privacy and publicity concerns have put the brakes on many photos from being used for commercial purposes.

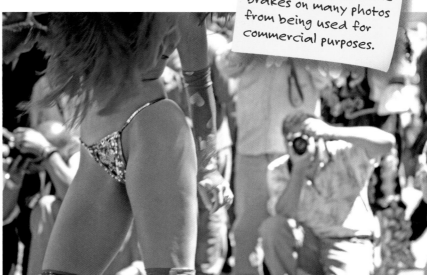

WHAT'S WRONG?

Photo subjects have fewer rights than they think for how pictures of them can be used. But photographers and publishers don't have carte blanche, either.

PREEMPTING MISINFORMATION

When I say that people's assumptions of rights (as well as fears of being sued) exceed reality, this is hardly an understatement. One of the ways I monitor this kind of information is by reading online discussion forums as well as my own e-mail inbox. Since I started writing about the subject years ago, I've been getting more varied and diverse questions from everyone — consumers, publishers, advertisers, models, even lawyers — all wondering about a tiny little nuance about their particular situation regarding the rights of people or things in photos. Looking at these questions as a whole, the one overriding commonality is a perception that the law is defined like a rule book, similar to traffic laws. If the sign says, "Speed Limit 30 mph," there are no exceptions — you go no faster.

But that's *not* how it works for the publication of photos, and that simplistic misunderstanding is the primary source of why people are so misinformed. It actually skews their interpretation of information when they see or hear about it. Just

of emotional responses have created more than just a passing interest in the subject; search trends show it as one of the fastest growing areas of public interest. This last point is no surprise — the sales of cameras and the growth of social-networking sites and photo-sharing sites are enjoying huge growth curves, so photo-related topics are capturing people's attention. And now that business interest is a major component, the subject is even more provocative.

> The laws on model releases are not like speed laws. You can't oversimplify what any one law says, because there are contradicting laws that point the other way, too.

because the law suggests that a release may be required to use a particular photo in a particular advertisement, it shouldn't be interpreted as a speed-limit sign with no exceptions. There could be extenuating circumstances that alter this requirement, and the list of such circumstances is potentially infinite, making the permutation of possible outcomes impossible to list as a set of rules. And even then, most cases still require the objective opinion of a judge before a firm answer can be established for that particular scenario. Ironically, the fact that interpretation is such a large factor in this has resulted in rampant misinfor-

mation from people who make their own interpretations from specific examples and then create their own "rules" that they generalize to a wide range of circumstances where they may or may not apply.

Just how uninformed are people on the subject? On my Web site, I have a very simple survey about how people use photography in their day-to-day lives. I get around 15,000 visitors a day and the portion of those who take this survey is enough to fall within the acceptable random sampling error of the general population. One of the nine questions in that survey is, "Do you know what a model

release is?" And although a consistent 80 percent of respondents say yes, my follow-up e-mails to some respondents show that not one person has been able to correctly answer four out of five very simple questions specific to the subject.

One person genuinely thought a model release was a device that helped you remove (that is, release) a toy (that is, a model) from its packaging. He actually said, "You know those awful hard plastic packaging they use these days? You can't get anything out of it. So, I thought it was something that made it easier." When I replied, "But what might that have to do with photography?" he said, "I dunno. I was just doing the survey." While this humorous anecdote may seem irrelevant, I was very surprised to learn that photographers who actually license photos for a living incorrectly answered four out of five questions on the subject (though not as humorously). So, when writing this

Misinformation about how model releases work and when they are required starts with the wrong frame of mind, and that comes from reading online discussion forums.

book, I found that just as much attention was needed to dispelling myths as it was to explaining how the world of photos and model releases actually works.

This all begs the more interesting question, though: How did people get so misinformed about this subject? And how can you avoid this same fate?

Earlier, I hinted that the core of people's initial misapprehension about model releases starts with the erroneous assumption that they are similar to succinctly defined traffic laws. So, when people then go online and do a search on the subject, looking for quick, immediate answers to specific questions about scenarios they're in, they start out with the wrong frame of mind for understanding what they're reading in those results. It's like trying to understand how the Earth's orbit around the Sun is responsible for seasons: If you still believe the Earth is flat, the explanation will never make sense. In both cases, a paradigm shift is required before you can truly digest the new information.

When doing an online search, there are two distinct kinds of information. The first consists of very, very short legal statutes on the law books (most being little more than a paragraph or two) that contain all the information you technically need to know,

WHAT'S WRONG?

You can <u>sell</u> photos of anything or anyone, regardless of whether or not you have model releases. Whether the licensee can <u>publish</u> them is a different question.

but they're too abstract for the average person, and they present insufficient or no analysis to help you understand how the circumstances piece into the puzzle. (These statute snippets assume that you're a lawyer and already know the context.) As a result, these sources don't answer people's specific questions, causing them to move to the second kind of source: online discussion forums.

The second kind of information found during such searches consists of people's opinions, presented in blogs, discussion groups, and other forums. Here, in the nonacademic playground of society, groups of largely uninformed people try to whittle a very complex subject down to simplistic rules, all using the wrong fundamental paradigm. In fact, one of the most common subjects discussed in these forums is whether parents are allowed to photograph their kids playing at a school soccer match.

In these forums, the most common question — and topic of misinformation — is this: Someone asks, "I took a picture of kids at my son's school playing soccer. Can I sell it to the local sporting goods store to put in an ad in the newspaper?" The "correct" response to this is, "You can't *publish* that photo in that manner without a release." However, the person making the statement may often say instead, "You can't *sell* that photo in that manner without a release," which is not the same thing. This subtle one-word difference changes the entire meaning and spirit of what the

law actually restricts or permits. That is, "selling" is not the same as "publishing."

The photographer can almost always sell the photo, regardless of the release, whereas the buyer may not necessarily be permitted to publish it.

This particular misstatement about selling versus publishing shifts people's impressions about culpability and legality away from the publisher and towards the photographer, which is exactly the opposite of how the law actually works. Once that sales paradigm is lost, it is never to be heard from again — at least in online discussion groups — and the domino effect of misinformation perpetuates long into the future, from one subject or scenario to the next. Most people won't catch these nuances.

Worse, people in discussion forums often take an example out of context and try to make sweeping conclusions from it. The typical example involves someone citing a case where a photographer was sued for taking a picture at a soccer game, but the discussion will not adequately examine any of the circumstances involved in the case. Forum members too quickly draw the mass conclusion that one cannot take pictures at soccer games, or any other kind of sporting event, or perhaps at school events. Yet, all the while, no one ever took a look at the specifics of the case that was cited. While a real court case may have happened, its details are largely misunderstood or taken out of context (because no one actually reads the court documents).

Often, cases having nothing to do with photography itself happen to involve a photograph as a circumstance, giving people the impression that photography is a core

Unless the judges make a ruling, don't assume that because a lawsuit takes place, someone did something "wrong." Baseless claims are made all the time.

> Beware of what people say in online forums. Many of the assertions are simply incorrect, based on partial or plain bad information or poor reasoning.

component of a judgment. For example, a case in New York involved a proposed law outlawing the use of tripods in subways, and several forums blew the discussion out of proportion, claiming that photography itself was about to be outlawed on public streets.

Even when people cite cases that are actually about photography and model releases, bad information often results, largely because many of these cases are either dismissed or settled before a precedent-setting judgment is made. The details on the case's claims and even proceedings get interpreted and reinterpreted in the forum, but no one in the group follows the result to set the record straight as to what was actually decided (and why). Another example is a case involving the use of a photo with no release on a book's cover, which caused many in a discussion group to conclude the use of photos on book covers is not allowed — even though the case hadn't been decided at the time. The prevailing sentiment of these forum participants was, "it doesn't matter how it turns out — you don't want to be sued." This is not rational business thinking. (The case ended up with the judge ruling that the photo's use on that book cover was in fact allowed.)

The most worrisome part about all this is that all these topics are reported on and discussed by professional photographers, big companies, and others who appear (and should be) authoritative on the subject. In one particular case, a pro photographer spoke about a personal experience where he needed a release for a particular photo, not because of a known law, but only because the company that licensed the photo demanded one. What wasn't said is that the company itself didn't *need* the release for legal reasons — it simply wanted one to reduce the risk of a frivolous lawsuit from the photo's subject. So most forum members came away with the wrong impression that a release is needed, period.

Another caution about naively believing anecdotal claims like these is that some people have an economic interest to deliberately deceive you. This deception is sometimes done by photographers and agencies trying to create fear that slows down new competition. More often, this misinformation is spread by those who don't want photos of their properties disseminated, or who want to collect license fees for uses that would otherwise not require them. (Copyright and trademark holders are notorious for claiming infringements for otherwise legitimate uses for this reason. This is covered in Part 7.)

WHAT'S WRONG?

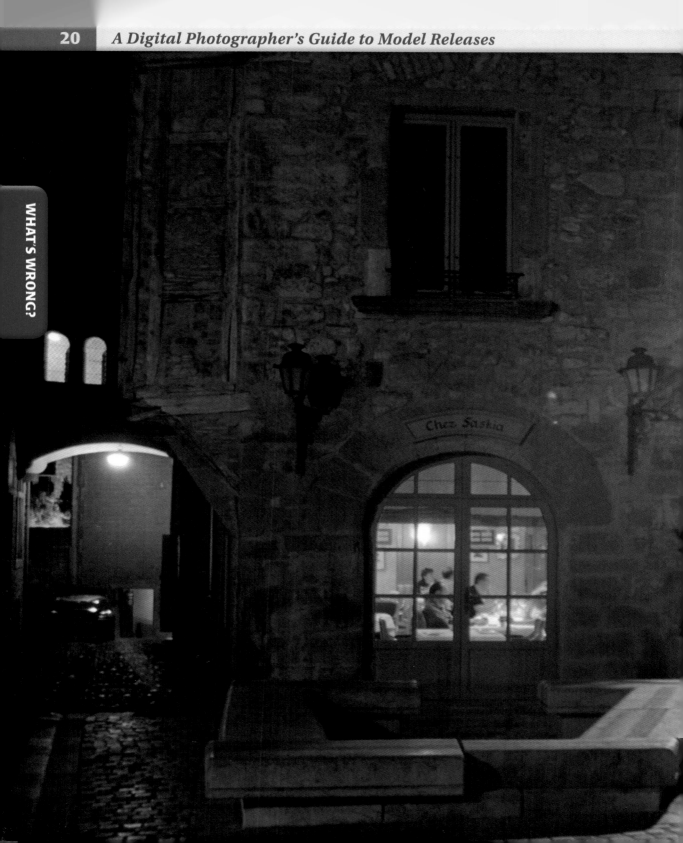

Ironically, there are very few actual lawsuits on model-release matters for two reasons: First, the bar to reach for an actual violation is high, and second, the penalties are so severe (compared to the ease of avoiding it in the first place) that publishers stay clear of the problem. If there were more actual cases to support the claims you see in online discussion forums, then perhaps more rumors would be justified. But this lack of cases is a double-edged sword.

The first edge is that, because there are few cases to point to, it's too hard to dispel rumors. The faulty rationale is, "If you can't prove me wrong, I must be right." The faulty business rationale is "better safe than sorry." (Hint: If you don't understand something, you don't know what "safe" is.)

The other edge of the sword is that this lack of cases means that it's hard to establish just what is right. Of the few cases that are decided by judges, most are decided on such specific circumstances that they cannot be used as a precedent for broader contexts. (Yet the discussion forums will attribute precedents anyhow, perpetuating the misinformation further.)

With all that as a backdrop, I want to preempt whatever preconceived notions you may have about model releases by asking you to wipe the slate clean on whatever you think you know.

While lawyers can't decide what risk is acceptable to you, always use one if you're ever involved in a legal dispute. Especially if you're instigating it.

WHAT'S WRONG?

WHAT'S WRONG?

Couples almost always sign model releases after they see great candids of themselves. If there's hesitation, be the advocate in favor of whichever of the two seems willing.

Couples are great for stock photography. Candid photos are best, so use a long lens, and lurk from a distance. If you get some good ones, approach them with a modest "Excuse me..."

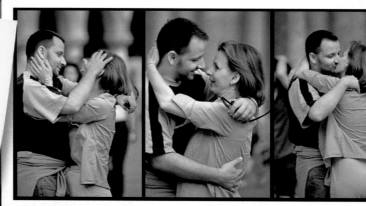

Large open squares or park areas are where most couples feel and act more relaxed. They also stick around for a while, giving you plenty of time to wait for the best pictures.

HOW TO THINK ABOUT MODEL RELEASES

As I mentioned, the first hurdle to clear in properly learning about this subject is to stop thinking about it as a collection of laws in a rule book. The second hurdle to clear is to avoid looking at specific situations as islands of facts — instead, look at them as the conceptual patterns they represent. When people ask me whether posting photos of their kid's soccer game on a personal Web site is legal, I say, "Yes, because personal Web sites are editorial," but they only look at the "yes" and fail to understand (let alone take interest in) the longer answer about personal Web sites. So, they naively ask the next question, "Okay, then what about the school play?" (I then remove this person's e-mail address from my address book.) The understanding should have been about Web sites, not about the school play.

While circumstances do play a major role in how such cases are determined, the high number of permutations makes it futile to anticipate and create rules for each possible circumstance. Besides, that's not the paradigm you want to adopt in learning this material. Instead, you have to understand the concepts — the intent of the law — and think in more abstract terms about what the law is trying to do.

Competing objectives: an individual's right to privacy and publicity, and that of the greater good provided by freedom of speech. Makes you think.

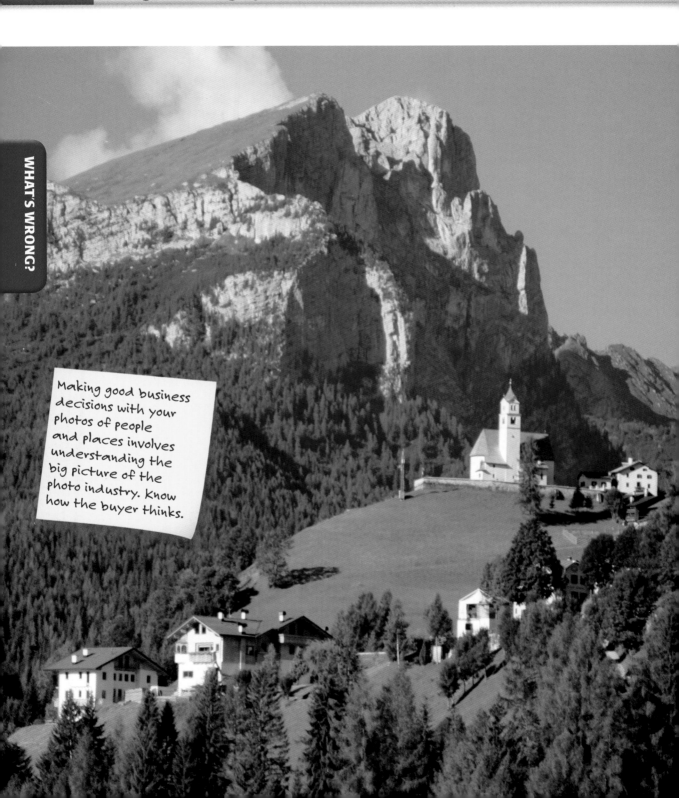

Making good business decisions with your photos of people and places involves understanding the big picture of the photo industry. Know how the buyer thinks.

Once you grasp that basic intent, examining specific scenarios becomes easier.

In the end, you're really looking to weigh the two competing objectives: the rights of the publisher and the rights of the individual. This invariably is going to involve drawing together circumstantial variables and coming up with a sort of weighting — a likelihood on whether a release might be necessary — and then evaluating the economic ramifications of your decision.

It's not that this stuff is hard to understand, it's just that approaching it is like solving a puzzle. It just takes getting used to looking at the big picture first, and then looking at the smaller pieces to see how they fit together.

That's why I am not going to spoon-feed you a dry, meaty chunk of legal jargon that explains everything you need to know about model releases that makes you doze off. Nor do I present reference material of sample release forms that you can tear out and use on an as-needed basis — that teaches nothing. If fact, there is only one sample model release in this book, and it's used to explain the intent, spirit, and practicality of real-world uses of releases.

My goal (as if the title of the book didn't give it away) is help you make better business decisions about photos you already have, or are about to take, that you will license to other people.

Although I certainly talk about law and may use big words now and then, I am keenly aware of how quickly one can drift into Neverneverland if there are too many instances of phrases like "gross negligence," "libel per se," and "joinder." We're not going to Neverneverland. Instead, we're going to the real world. And in that real world, your mindset should be focused on one thing: business. So that's what each part in this book comes down to: an analysis of the legal and economic conditions associated with the use of photos so you can make good business decisions.

You don't need a lawyer to get the basic ideas behind when and how model releases apply. Business decisions are based on weighing many factors, not just legal ones.

HEY, YOU'RE NOT A LAWYER

Some of you may be thinking, "Why look to a photographer for advice about this subject, when I should be asking a lawyer?" Glad you asked! There are many issues to consider here.

Yes, most people are fearful that they will get sued for what they do with their images. And yes, problems will arise if you do something that's illegal, like planting hidden cameras at work, committing fraud, or writing something malicious about someone that you post with their photo. But you don't need a lawyer to tell you not to do *those* sorts of things. (But you certainly will need a lawyer after you do them!) Lawyers are best at trying to make your case to a judge, or advising you on how to avoid getting there in the first place.

But you have such an infinitesimally small chance of ever getting sued for photography-related matters that the need for a lawyer to explain this material is, well, misdirected. The reason is that most photographers (especially stock photographers — those who sell photos to other people to publish) aren't liable for how a client uses a photo. What you need to know in the legal realm is not how to protect yourself but to better understand the business landscape of your clients. Well, that, plus being informed on managing business relationships that affect legal negotiations. So, as you read this book, you're going to be getting a very different kind of characterization of legal discourse that isn't

The global business landscape is wide open when you realize your legal liabilities are next to nil. You don't need legal advice about the use of model releases, you need business advice.

typically used by lawyers, mostly because they are trained to communicate to people who have different needs than you. Your clients need lawyers; you need business advice.

And this presents two more things of note:

First, licensees (the people you sell or license photos to) must have or should have their own legal counsel, and whatever discussion they have with their legal advisers is independent of your own decisions and your business relationship with them.

Second, I guarantee that all the lawyers who advise you or your clients are going to have different assessments for every single case. I have licensed one photo to different clients for the same use, each of whom had lawyers that rendered vastly different legal assessments on the need for releases, yet none of these affected my business relationship with them. Had I been too strongly influenced by the advice of a specific lawyer at an impressionable time in my

Licensees — those who actually use the photos — bear most of the legal risk around model releases.

career, I might not have licensed the image to any of those clients.

There's nothing unusual or surprising about this: Lawyers disagree with one another (often citing contradictory examples), just as judges disagree with one another on rulings within the same trial. It's often said that if you ask ten lawyers their opinion, you'll get twelve answers. If a lawyer were writing on this topic, you'd get a very persuasive argument on how she views or interprets the law on the matters I'll be raising. But her viewpoint is a singular one and may very well not square with the views of your clients' lawyers. Your business role is to be as agnostic as possible on legal interpretations, yet be aware of as many of them as you can. This helps keep you at arm's length from other people's lawyers.

Speaking of differences of legal opinion, many of the things in this book can (and will) easily be critiqued by lawyers using valid retorts. (Indeed, they do it to each other's books, too.) And that hones in on the point: I am not giving legal opinions or advice. I'm presenting business analysis tools, in which you are free to apply using the most conservative or liberal interpretations of the law as you (or your lawyers) desire.

> The technicalities of the law are not your main objectives. Instead, understand a breadth of interpretations that you can factor into your business decisions.

WHAT'S WRONG?

Lawyers often disagree over model-release requirements. That's just a fact of life, so temper their advice with your business's context.

Remember: It's Just Business

When business is the objective, legal opinions only get in the way if legality is not applicable to your end of the deal. For example, a lawyer may advise you that a particular image passes legal scrutiny for a given use, but his lack of experience in a given industry makes him oblivious to the risk associated with the litigious behaviors within that realm. You may not be happy about the outcome if your lawyer wasn't entirely on the ball.

Similarly, a lawyer may also advise you that a release would be required for a particular kind of use, but the business relationship between you and the client simply doesn't warrant that kind of expense, nor would a client perceive the risk to be high enough to bother.

It's sometimes better to not muddy the waters on a simple relationship involving a simple transaction just to make sure the "legal" aspects of a release are tidy.

All too many times have I seen photographers get so wrapped up in the legalities and details of such matters that they actually harm the relationship or the transaction itself. Or worse, they don't even sell photos of things that don't have releases. Lawyers know risk, but they often fail to put things into perspective on what makes a good business decision. "Risk" by itself doesn't mean anything — there's risk crossing the street, but it's a risk we assume by leaving the house.

In yet another example, you may have a client whose lawyer disagrees with you or your lawyer's read of a given situation, which begins the process of everyone emptying their wallets into the communal coffer to pay the lawyers to battle it out. Is such an expense worthwhile? If the photo is for a major ad agency for which you are paid hundreds of thousands of dollars, that effort may be a good investment (because the risk is usually proportional to the exposure the photo gains). But if it's for a local monthly newsletter, the cost just isn't worth it. When this situation finally

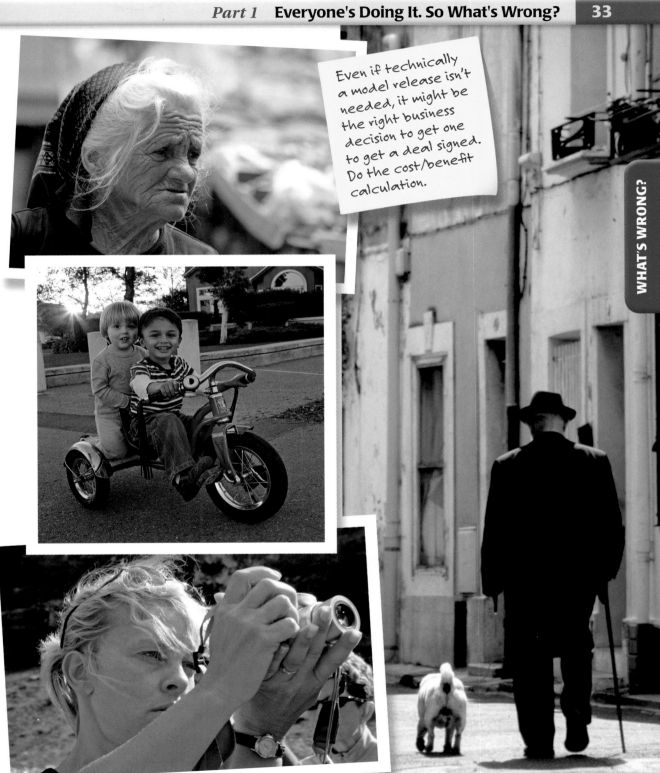

Even if technically a model release isn't needed, it might be the right business decision to get one to get a deal signed. Do the cost/benefit calculation.

WHAT'S WRONG?

WHAT'S WRONG?

Following the crowd can lead to nowhere. Look and listen to non-photography news sources for a much better analysis of legal and business trends.

happens to you (because it happens to everyone in the stock-photo industry at some point in time), your case will be somewhere in the middle.

Overly risky people rarely do well in business, whereas overly conservative people generally avoid too many opportunities and end up not making money. Your goal should be somewhere in the middle, which is the spirit of how I guide you through this book.

None of this is to suggest you shouldn't have a lawyer. And yes, if you ever get notices from a lawyer for some reason, you'd be best represented by a lawyer, not yourself. And finally, if you ever have to assert a legal position against someone for something, you should never try to do it yourself, as you will never be perceived as important, serious, or "credible" as you would

if the exact same message were to come from a lawyer. Even lawyers don't represent themselves in legal actions — they always get another lawyer to do it. As the saying goes, "A lawyer who represents himself has an idiot for a client."

But your lawyer should not drive your business decisions. Licensing involves a form of business analysis of the bigger picture that encompasses how the law and your business goals work hand in hand that most lawyers aren't really that well equipped to handle, because they don't have skills in both areas.

> While lawyers can't decide what risk is acceptable to you, always use one if you're ever involved in a legal dispute. Especially if you're instigating it.

General-practice lawyers and traditional corporate attorneys are not well-versed on the laws surrounding model releases. Choose your legal partners carefully.

WHAT'S WRONG?

Working with Your Clients' Lawyers

Whenever a photographer gets involved in licensing, he will invariably work with lawyers who often represent their clients (the licensees) in negotiations, especially if there are contractual points. In doing so, I've found that many lawyers who are experts at corporate or contract law are not as up to date on copyright or First Amendment law, which are necessary for anything related to model releases, whether for people or for copyrighted or trademarked items. As a result, you are often put against someone who is far more experienced at law than you, but probably less informed of the specifics of these aspects of law than they need to be. First Amendment lawyers often joke that 90 percent of their business comes from clients who got into trouble because they took the advice of general-practice lawyers. Your client is likely using such a lawyer, and you'll have to deal with him. This makes it hard to negotiate a contract because you're going to be up against someone who needs

to approve your deal, but may cause it to fall through because of a misinformed (or unnecessarily conservative) legal position. So, when working with them, you need to walk a delicate line.

The best thing to do is stick to the deal and not haggle about technicalities of whether a release is or isn't necessary, unless such a provision actually affects the deal itself. In this case, you may have no choice but to do whatever you can to save the deal. Usually, the case that comes up is that a client (by advice of his lawyer)

will want a model release for a particular subject, you don't have one, and you'll be locked in the discussion on whether one is actually necessary. Unless you are quickly persuasive, do not try to win this argument. You can try to save the deal by offering to sign an indemnity clause, as explained in Part 7, but barring that, the best thing to do is let it go. You will never win an argument with a lawyer if you aren't one yourself. (Of course, you could always send them a copy of this book!) ✄

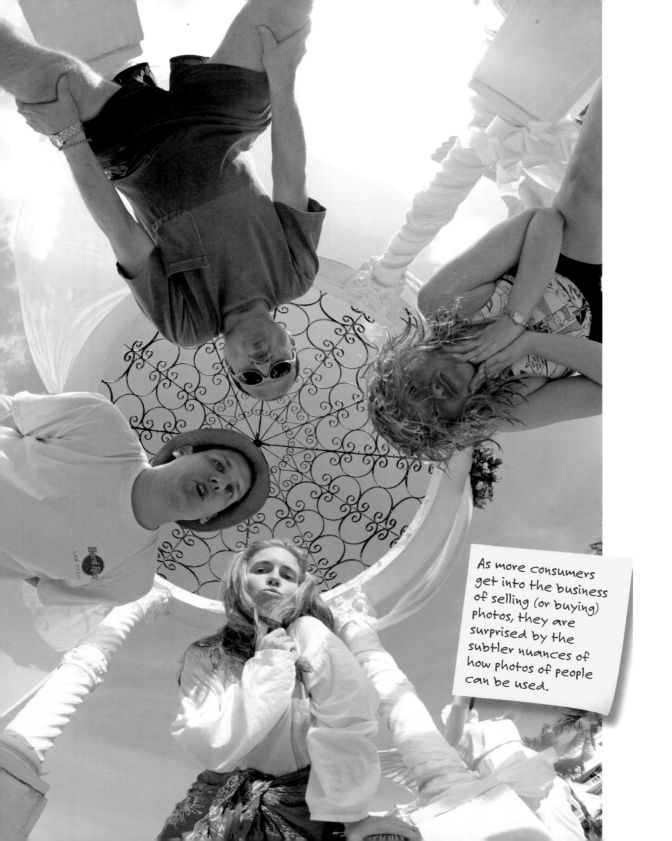

As more consumers get into the business of selling (or buying) photos, they are surprised by the subtler nuances of how photos of people can be used.

What's a Model Release?

S imply put, a model release is a legal contract that "releases" one party from liability for having (potentially) violated the other party's rights. It's almost always used in the context of a photograph. Despite the apparent association with models you see in magazines, the word "model" here is merely the subject of the photo. The Merriam-Webster dictionary's definition for a model is "a representation of something (usually on a smaller scale)." Thus, the subject of a photo is the model: a person, building, article of clothing, painting, and so on. It could be that a release may be necessary to waive whatever rights the model has if the photo is to be used in particular ways.

"What rights are there that can be violated?," you may ask. It turns out that both the subject of the photo and the photographer have rights. On one hand, people have rights concerning how their own likenesses or property are used, so they may choose to permit or deny the use in a photo that has them in it. The purpose of the model release is for the individual to waive the rights in return for compensation. On the other hand, the right of free speech and other uses permitted by the U.S. Constitution (and the laws in most countries that have a free press) override some of those individual rights, in which case, there are some ways that photos can be published without the need for a model release.

THE ESSENTIALS

It is the responsibility of the licensee to determine whether he needs or wants a release. (It's his prerogative to *want* a release, even though he may not technically need one.)

It is not your responsibility to know whether a release is necessary, nor should you render an opinion on whether you think one is necessary.

You should always disclose whether you have a release so the licensee is notified. Risk comes with the territory of photography, but the extent of your risk is largely limited to the inconvenience of being caught up in other people's disputes. Proper notification as to what model releases you possess mitigates most of those inconveniences.

If you are honest about whether an image has a model release and what the release document actually says — and if the client has been notified of this — you cannot be held responsible for anything they may do with that picture. The one exception is if the client tells you in advance of an egregious or illegal violation, in which case, you could be viewed as turning a blind eye to the matter and be held accountable. But you wouldn't do something like that, would you?

Also remember that publishers vary in their own assessment of what their release requirements are for any given use, so don't extrapolate what one client thinks as being legally necessary as "correct." Furthermore, do not assume that a client's actions represent a de facto standard throughout the industry. You may entirely disagree with a licensee on his interpretation of whether a release is required, but that's irrelevant to your business relationship: The client gets to make these decisions. If the licensee wants a release for a given image and use, it does not mean that a release is required; it's just that this particular client wants one.

The main objective of getting a release is not to protect yourself; it's to make the image more marketable to a broader range of clients. Although photos with releases have infinite licensing possibilities, don't underestimate the market for all your photos, regardless of whether they have releases. Editorial uses do not require releases, and the market for such photos is enormous.

Ethical considerations lie outside the scope of the law, such as whether you are comfortable licensing an image for a particular use. If the law permits an action, such as photographing people in a public setting without their knowledge and then licensing those photos to someone else, you should not consider it unethical. If you have an ethics issue here, this isn't the business for you.

Of living beings, only people have rights. Pets and other living things do not. Property, like buildings and structures, can have rights, but only through copyright and trademark registration, and even then, only under some limited conditions. Part 6 addresses these situations more fully.

Although the Constitution protects people's rights, and there are laws governing certain uses and conditions, the government doesn't mandate or oversee protection. Only the subject of a photo (or his assigns, heirs, or agents) can file a complaint against someone else for using a photo in a way that violates those rights. One cannot sue on behalf of someone else without the legal authority to represent that person. This is why a model release is usually signed by the subject himself, granting rights to use his image to whoever is on the other side of the contract. No one else is involved in this process. (Minors cannot sign legally-binding contracts, so model releases involving children must be signed by their parents, guardians, or agents; the release itself does not necessarily have to change because of this — just the number of names and signatures involved.)

The language of a model release can say whatever you want it to say, as long as both parties agree to it. It can also be retroactive. That is, you can shoot first and get the release later.

The wording of the release itself can be brief (one paragraph), or a lengthy contract full of stipulations on payment schedules, lists of permitted and nonpermitted uses, legal rights, remedies, and sometimes even limitations on the amount of money one party can sue the other party for in the event of a contract violation. (There's a saying in the fashion industry: "The longer the legs, the longer the contract.")

GETTING ON THE SAME PAGE

Because everyday people thrust themselves into the business of photography, the mixture of legal terminology and common vernacular can create great mis-

VENUES AND JURISDICTIONS

The laws that govern any given situation begin with where the infringement took place. And in today's world of global distribution of content, either in print form or over the Internet, that jurisdiction can include a very tricky series of triggers. It is the *publication* of the image that triggers the offense, not the act of taking the picture. But many factors can affect which court (and which set of laws) may apply: where the publication is distributed, where the publisher does business, or even where the target audience is. This usually yields many potential jurisdictions, and because each state has slightly different nuances in its laws, the state chosen is usually because its laws may favor the claimant under the specific circumstances.

In the United States, the laws apply to anyone, not just residents of a state or even only American citizens. That is, if the subject is a resident of California, he can file a claim in Louisiana, provided that circumstances permitted jurisdiction there. Similarly, if you take a picture of someone in another country, and license it (without a release) to a company that used it in an ad in a magazine published in the U.S., the subject could file a claim against that company in the U.S. This is regardless of whether the subject of the photo or the publication itself is American.

Conversely, if you took a photo of an American citizen and licensed it to a magazine in Cuba, where there are no such privacy or publicity laws, the infringement took place in a jurisdiction where no such protections are provided, and no claim can be made. The fact that the subject is American is irrelevant.

Still, clever lawyers often succeed in extending or moving the jurisdiction of the infringe-

understandings. This is especially problematic because the same words can mean something completely different when used between people of different backgrounds. It's as though there should be a translation dictionary to discern what people mean. So, I need to clarify certain uses of language here.

Strictly and legally speaking, a model release is used for any type of photo whose publication may require consent from a person. This is true for people as well as for property protected by copyright or trademark (the owners of the copyright or trademark are the ones who need to give permission). As such, the easiest phrase to use is "model release," which is a term used by stock photo agencies, modeling agencies,

ment to another state (or into the U.S.) simply because the violating company (or publication) can be shown to have ties (or "presence") there. As you can see, jurisdiction can be pretty fluid, and is a complexity beyond the scope of this book. Suffice it to say, however, that fancy legal maneuvering is unlikely unless there's a considerable amount of money at stake (in which case, you can rely on it happening). Even though most state laws are independently written, the relative ease in which venues can be moved to the state most advantageous to the prosecution make detailing the differences in those statutes largely academic.

Choosing the state in which to present a case is generally easy in the Internet era of mass publication, but disputes over photos published in smaller periodicals, such as local magazines and newsletters, are less likely to have such maneuvering – so the risk of litigation is lower. In such cases, you need to consult local state laws to know what rules can apply.

Readers who live in other countries should consult their corresponding legal codes, but be aware of the same propensity for misinformation as I mentioned in Part 1. In any event, U.S. laws still apply if you license images to clients that publish in, or distribute to, the U.S., which covers a lot of international media. So, regardless of where you live, if you license photos to publishers, those publishers may need to consider U.S. laws, which, in turn, can affect business decisions you make.

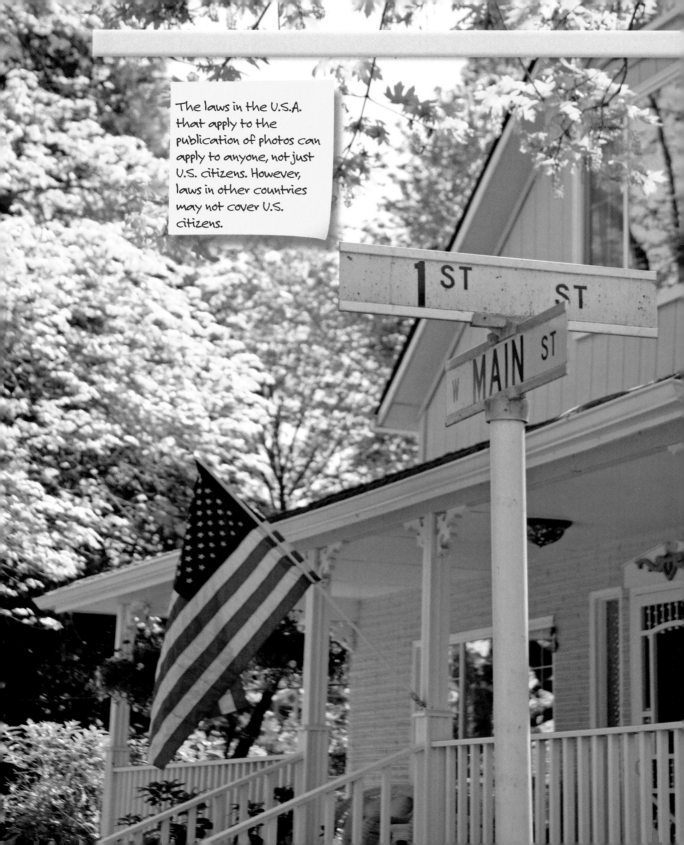

The laws in the U.S.A. that apply to the publication of photos can apply to anyone, not just U.S. citizens. However, laws in other countries may not cover U.S. citizens.

It's the publication of a photo that may trigger the need for a release, and the laws that apply are where the publication is sent and where the business has "presence" or agents.

publications, and so on. It's often cited as such in a license agreement or other kind of contract.

For example, a general stock photo license typically uses the phrase "all subjects, whether of persons or properties, will have proper model releases signed by authorizing parties that have been pre-approved by the licensee."

Other phrases may also be used (mentioned later), but they are all subject to the same definitions and so should not be construed as being somehow different in any way. For example, a property release is a model release where the subject happens to be a physical object, such as a device, a building, or real estate. (The term "real estate release" is also used in some businesses.)

The operative word in all these contexts is "release," because it has a very precise definition defined by Merriam-Webster: "verb(4): to give permission for publication …" Accordingly, the text of a model release also uses the word as a verb: "Subject releases photographer from liability." As such, it very common to use "release" as a verb, such as, "Has the photo been released?" But because a release contract is a physical thing, it's also just as common to see it used as a noun. "Does the photo have a release?" Which form you choose is more a matter of clarity in dialogue.

The word "consent" is important here, because it is also a legal term. Signing a model release agreement is called *granting consent*. This phrase is used in legal statutes that define the laws that govern all this.

Be careful using the expression "getting permission" to refer to a model release — it isn't necessarily the same thing. When you say, "I got permission to shoot," it almost always implies a verbal permission, such as asking people if you can photograph

This photo was taken in Chicago, but if it's used for an ad placed in a magazine published in Cuba, where there are no privacy laws, no claim can be made.

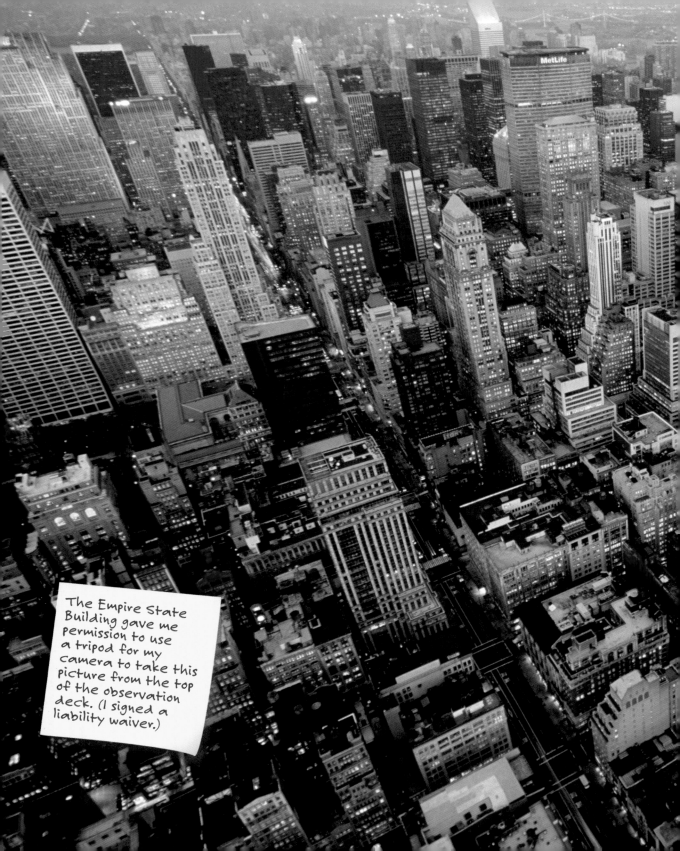

The Empire State Building gave me permission to use a tripod for my camera to take this picture from the top of the observation deck. (I signed a liability waiver.)

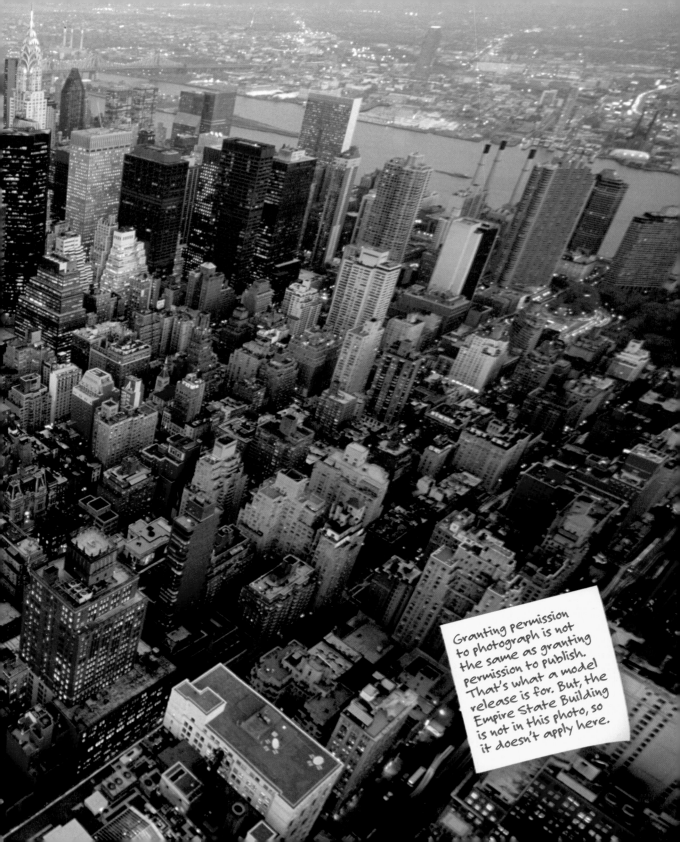

Granting permission to photograph is not the same as granting permission to publish. That's what a model release is for. But, the Empire State Building is not in this photo, so it doesn't apply here.

RELEASE BASICS

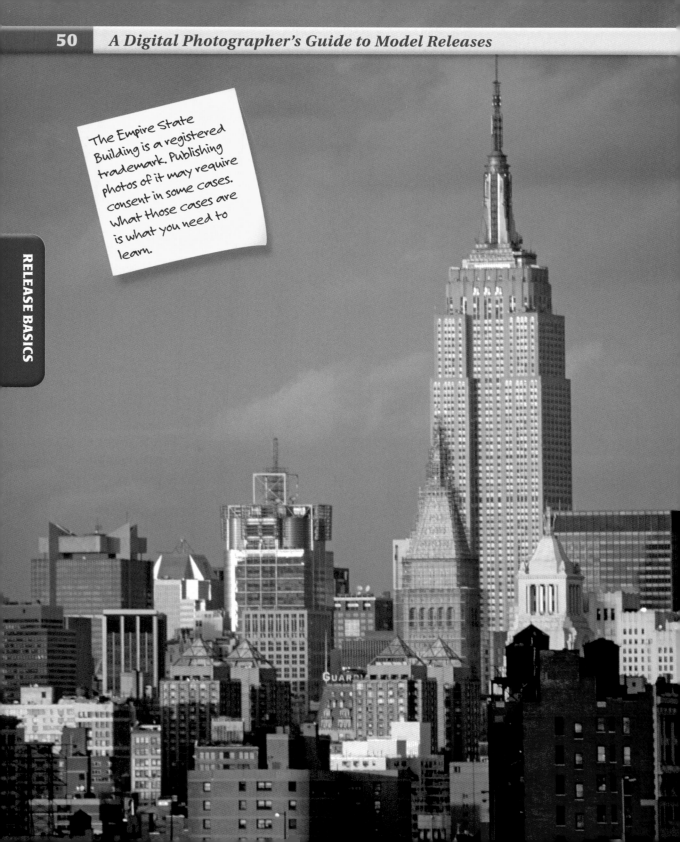

The Empire State Building is a registered trademark. Publishing photos of it may require consent in some cases. What those cases are is what you need to learn.

them or if you can enter a building to photograph the inside. For example, say you want to photograph the statue in the middle of a shopping mall. Your expensive camera and tripod gets the attention of an alert security guard who stops you (a very common occurrence). After explaining that you're not a terrorist, he allows you to continue. Many people would say that they "got permission," but this is very different than getting a legally signed release that grants consent for commercial use of the image.

The Empire State Building is another example: When you get your tickets to go to the top, if you have a tripod, you're directed to a clerk who hands you a liability waiver. The text of the permit itself indicates that you have "permission to photograph" and that you assume any liability resulting from the use of the tripod (such as if someone trips on it). This is a form of permission to photograph, but it has nothing to do with the consent necessary to publish photos of the building (for commercial use) — in other words, it isn't a model release for the Empire State Building, which happens to be a trademarked property.

WHO IS RESPONSIBLE?

For purposes of analysis, let's wave the magic wand and assume a photo requires a release in order to be published in a particular manner. This now raises the ultimate question: "Who is responsible for the release?" The most common answer is "the photographer." This, for very understandable reasons: It's true that the photographer can get someone to sign a release, and it's usually easier for him to do so (for the reason that the subject is right there in front of the camera). What's more, it's also conventional for the photographer to supply the release to the client that licenses the picture.

So, it may surprise you to learn that the photographer isn't ultimately culpable if images are published without a release. It's the publisher of an image that carries all the liability. Yes, whoever puts the image into use needs to have the photo release. Who puts the photo into use? The user of the photo — the publisher. The photographer is usually not that person. The fact that the photographer sells the photo (or licenses it) is not what triggers the need for a model release. It's how the

photo is ultimately put into use (or "publi-cation," in legal terms) that matters.

Let's put this into a realistic context: Say you were on a cruise to Alaska, and you photographed a man looking at a whale that was making a huge lunge out of the ocean. A nonprofit organization sees this great photo and wants to use it for a public service announcement for the "Save the Whales Foundation." Does the photo need to have a model release for this use? Think about it long and hard. Consider the various reasons why or why not a release may be necessary. Now that you have your answer, can you articulately explain your rationale? People weigh in differently on whether a release would be required for this kind of use. More importantly, lawyers and even judges themselves render differ-ent opinions on such things.

But, in this case and most others, it doesn't matter whether a release is required. The question is whether you as the photographer are responsible for know-ing this answer. Not just having the release,

but knowing whether one is needed. That's the pivotal question, and a very dif-ferent one than asking if you (not the pub-lisher) are required to have it. Turns out, you are neither responsible for knowing whether a release is required nor for hav-ing the release (if it were required).

If it were your responsibility, imagine how common it would be for photogra-phers to be constantly sued because of how other people used their photos. Companies, governments, and organizations large and small would be using all sorts of photos without a care in the world because they'd know the photographer would be respon-sible for the consequences. And this isn't happening. In fact, the only cases where individual photographers were sued for how publishers used their images involved celebrities, and the suits almost always involve violations of other rights, such as illegal entry and certain privacy laws.

If you're scratching your head still, the easiest way to understand this is to

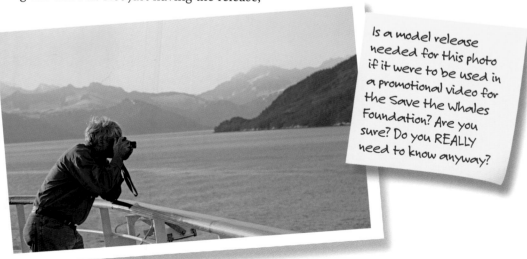

Is a model release needed for this photo if it were to be used in a promotional video for the Save the Whales Foundation? Are you sure? Do you REALLY need to know anyway?

Knowing whether a
photo needs a release
for a given use is not
your responsibility.
Leave that to you
client. Having a release
anyway just helps you
sell more pictures.

Selling photos is like selling guns: proper usage is the responsibility of the buyer, not the manufacturer. You can sell a photo without a release, but buyer beware.

think of how the law works with guns: If someone shoots his friend in the face with a gun, the law starts with the person who used the gun, not whoever made the gun. If the guy who got shot is going to sue someone, he doesn't start with the gun manufacturer; he sues his one-time friend. (We're assuming that, unless they are allies for a greater cause, the two are no longer friends.)

Now, the guy who shot the gun has to defend himself because it's his responsibility. Well, unless he can show otherwise. To that, he may say, "The safety catch was on, but the gun fired anyway." Here, he's trying to show that the gun manufacturer produced a defective product and can be held responsible. (And if it could be demonstrated to be true, he'd be absolved.) Alternatively, he may claim that an ad from the gun manufacturer said, "Go ahead, shoot your friend in the face! It won't hurt him!" Here, he is trying to suggest that the company misrepresented how the gun can be used. A noble, though perhaps naïve attempt to suggest that the gun manufacturer induced this idiot to shoot his friend in the face. Alas, people raise ridiculous claims all the time in the real world, but the few serious attempts to hold gun manufacturers liable for someone's own misuse of a gun have (currently) fallen quite short of success.

The exact same principle applies to photographers and photographs. The photographer is the manufacturer (and often the supplier) of the photo, but it's ultimately the party that puts the photo into

use that is responsible for using it properly. If there's a claim filed by the subject of the photo, unless the licensee can somehow shift responsibility back to the photographer, it's all on the shoulders of the licensee. There are ways to do that, in which case, you'll need to employ some protections, and I'll address these issues shortly.

One may wonder, though, if photographers are not really the ones responsible, why are they the ones that get the release from the subject, that hold the release, and do just about everything else having to do with the management of the release? Simple: They're the ones who want to sell the pictures, and the buyer is more likely to buy a image that has a release than one that doesn't. What's more, the photographer wants to license images a lot, so getting and holding releases translate to more sales opportunities. And, of course, there's the pragmatic reason: Photographers are the ones on the spot at the time the photo is taken — it's easier for them to get releases signed than it would be for the client. (Tracking down people later is difficult and time-consuming, and it's also more difficult to coax them into signing a release, since the spontaneity is lost.)

Now, just because photographers are not ultimately responsible is not to suggest that photographers don't have some liability — they do, limited though it may be. But this liability is easily managed.

> Those who try to get a model release for every person they ever photograph in a public setting aren't shooting nearly often or fast enough.

It should be part of your plan to shoot (and sell) as much as you can, because the more content you have, the more business opportunities you can yield.

What it boils down to is representation. Just as with gun manufacturers, photographers must be sure to properly represent their product (photos) to the buyer. If the licensee gets in trouble, the last thing you want them to do is find a way to blame you for their errors. Fortunately, this is very simple, and I walk though that process in the following section.

LITIGATION IN A NUTSHELL

Understanding the simplicity of how photographers protect themselves is best explained by understanding what's involved in a legal dispute of a contested photo, which is far from simple (but I'll try!). To do that, let's pick up on the earlier hypothetical example where you licensed your picture of a man watching a whale jump out of the water. But now I want to alter the situation a little and say that the licensee was a video production company that was on contract to make the video for the Save the Whales Foundation.

Assume the man in the photo files a claim that his likeness was used without his permission. The first point of contact for his lawyer is the foundation itself, because it put the photo into use. The guy filing the claim may not even know who took

his picture, which is often the case for candid shots. Nor might he be aware that the foundation itself didn't even produce the video. But even if he was aware of all this, the first contact is still the foundation, for the same reason as the gun example: The foundation put the photo into use, so it's responsible. How the foundation defends itself is next.

The first thing it's going to do is point the finger at the video company because it was the one that actually made the video (and which the foundation expected to do in the most legally responsible manner). Because it didn't secure a release, the foundation can rightly put the video production company on the hook.

Because the video production company got the photo from you, the finger now points in your direction — at least theoretically. (Even if the company got the photo from an intermediary such as a stock photo agency, the finger would eventually point to you as you were the source.) And if you had a contractor photographer working for you, you'd point to that person. The point is, everyone

points the finger at the next person in line until one of two things happens: Either there's no one left, or they get to someone not listed as a defendant in the claim.

This is a strategy that lawyers call the "empty chair" defense, and it's employed by lawyers to try to have their client's fines reduced or eliminated if it can be shown that someone else was at fault (reduced if it was another defendant's fault; eliminated if the culpable party isn't listed, since the prosecution can't add new defendants to a case once it's brought in to court).

Because the "empty chair" strategy is very well known in the legal community, anyone filing a claim will try to preempt this "not listed" defense and look for (and name) anyone that can possibly be associated with the project. Thus, you will be listed, along with the guy who parked your car and the waitress who served the coffee.

The actual legal strategy here is far more complicated than my simple summary, but it's enough to illustrate that the person to "blame" is where the buck stops; what happens next hinges upon whether the person actually did anything wrong.

For each rung on the ladder, the court will look at each of the various contracts and license agreements between each of the parties. That is, each contract usually defers responsibility to the next party down the ladder to assure that things in its control are taken care of. The foundation almost certainly required responsibility from the video production company, and so on down the line until someone messed up.

All of which leads to this: Remember when I asked if you could articulate your reasons why a release may or may not be necessary for this use? Here is where your opinion is going to come home to roost. If you told the video company (or the foundation) that you didn't think a release was necessary, the other defendants will point the finger back to you: "But, judge, the photographer said it was okay!"

Here, the judge will want to know whether you actually told the client it was okay, and if so, how you

expressed this. (Note: E-mail discussions can be submitted in court as evidence, and any discussions — especially if there are agreements made in them — are not just admissible but can be used to override previous agreements, even those in contracts.) So, it comes down to what you said.

For example, if you wrote, "Given that you're a nonprofit, it looks like an editorial use, so it's probably okay." With a sneer, the judge is going to wonder why a foundation of such a substantial size is placing its legal liabilities in the trust of a photographer who doesn't appear to be all that informed, not to mention a tad apprehensive by his wording. In other words, the judge is not likely to let the bigger fish pin it on the little one.

On the other hand, if you said, "Absolutely you can use it! And I am so confident in your safety that I will defend you if you get into trouble," the judge is likely to be more lenient on the foundation and start looking to you to explain yourself. If you're a seasoned pro who writes books on the subject, the judge may perceive your persuasiveness to be greater than that of a newbie photographer who got his opinion from some Internet discussion

Finding someone to blame when a claim is made for how a photo was used can be involved and arduous. But it usually ends up being the one who chose to publish it.

group. In such case, the foundation may get more leniency. But in reality, a high-profile photographer with that kind of stature wouldn't say such a thing; it would be paramount to the gun manufacturer saying, "Go ahead, shoot your friend in the face! It won't hurt him!" While this could yield considerable courtroom drama suitable for reality television, it's not a reality that will manifest itself in our universe.

Or is it? Although a photographer might not say such a silly thing, he might sign a contract that has that precise meaning in it. This would come in the form of an indemnity clause within a license agreement, and such a clause is common. Part 7 explains this key issue.

Short of your actually lying or committing another crime — such as fraudulently signing a fake model release to make it look like the subject signed it, or saying you had a release that you didn't really have — the publisher still owns the responsibility for how the image is used, and it would have to paint a pretty compelling case showing that you convinced it otherwise.

The video production company, however, has a larger role in the case. It actually produced the video, which means it had the actual administrative control and oversight over the project. Unless it can show that the foundation had more oversight, it'll be hard to convince a judge that the video production company wasn't the one that should have known better. Chances are also high that the foundation's contract with the video production company had an indemnity clause to protect it against scenarios just like this.

Also note this important fact: It still hasn't yet been established that the photo needed a release in the first place! Just because the person filed a suit doesn't mean he's right, or that he'll win. (Being right and winning are often

very different matters.) In fact, it could easily turn out that no release was needed, which would make the case moot (and a pricey diversion). But none of this is the point. The point is, well, two points:

☑ You are not responsible for how others use photos they license from you, unless you somehow assumed that responsibility by having an ill-advised license agreement for the photo, or taking on that responsibility through some statement you made.

☑ You don't want to be called into any of this in the first place.

Okay, but what about that point about the "empty chair" strategy? How can you avoid getting called into this if you're going to be named as a defendant anyway? It's unavoidable, right? To some degree, yes, but there are ways to minimize your responsibility and to keep your involvement as minimal as possible.

Cases that settle out of court do not set precedents for the future. If one side decides not to continue, it doesn't necessarily mean they had a losing case.

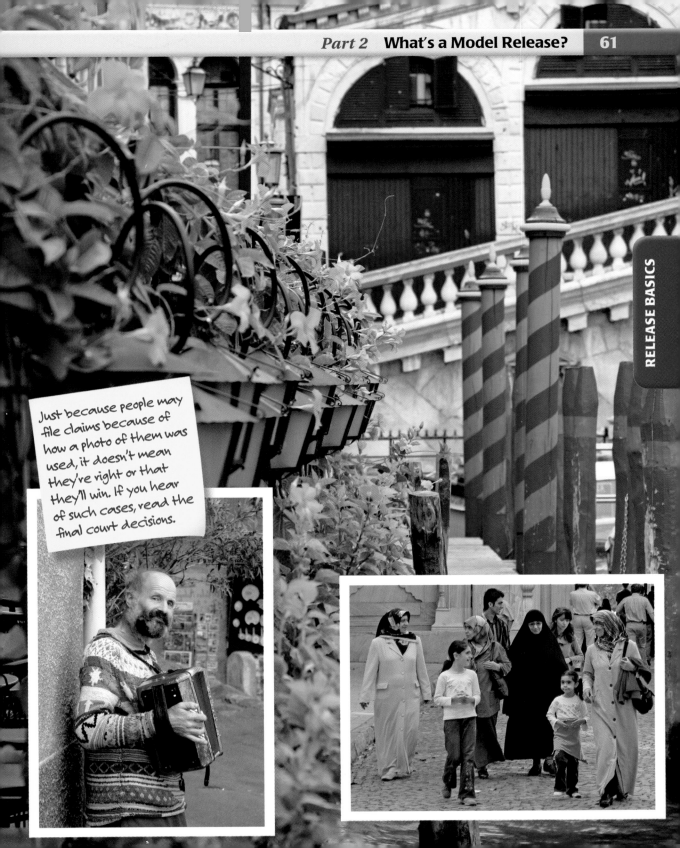

Just because people may file claims because of how a photo of them was used, it doesn't mean they're right or that they'll win. If you hear of such cases, read the final court decisions.

THREE WAYS TO LICENSE

There are three ways a publisher can acquire an image legally: by licensing it from a photographer or agency, by using "royalty-free" images, or by finding photos available in the "creative commons" domain. Though royalty-free and creative-commons images don't really have business objectives like traditional licensing does, they are very common on the Internet these days, so I'll review them for clarity and perspective.

First, creative-commons licenses are traditionally used by consumers to simply permit other people to use their images for free. Everyday people who just like showing their photos to the general public choose this option, largely because they don't understand it. You have to specifically designate photos to fall under the creative-commons, which is available on some photo-sharing sites, like www.flickr.com.

Still, even if you don't mind giving away the usage rights to your photos, it is still the responsibility of the user to assure that the person in the photo has signed a model release (if the intended use requires it). In fact, Virgin Mobile, the British cell phone company, did just that: It used a creative-commons photo from Flickr that was designated as free but forgot to check whether the person in the photo signed a release. Then Virgin Mobile got sued. (A link to the story can be found on my site at www.danheller.com/model-release-links.html.)

Royalty-free images are not "free" to license, but they are called this because the licensee makes a one-time payment for the image's use and doesn't have to pay ongoing royalties. Royalty-free images are usually distributed in bulk (or available from Web sites) at lower prices than traditional rights-managed images, though the distinction between these licenses is diminishing quickly. The point is that publishers often make the same mistake with royalty-free images as they do with creative-commons licenses: They forget to check the release status of the subjects in the photos. Like creative-commons licenses, most photographers who are serious about making money in photography aren't really interested in agreeing to royalty-free licenses.

If your objective is to have a business of licensing photos for money, you'll be engaged mostly in rights-managed licensing, where each use has an individual license agreement — often with some customized terms — especially over specific usage rights.

MINIMIZING YOUR INVOLVEMENT

In the case of any legal dispute involving a publisher and one of your photos, you begin — by default — absolved of all responsibility. That's right: Unless you actually do or say something that changes this default state, your responsibilities are limited. It's only when you open your mouth and say something, or if you sign something (like a contract), do you begin to slide downhill.

You could stay out of a lot of trouble just by saying nothing, but the problem with silence is that it leaves you open to a lot of questions. The best way to avoid scrutiny is to specifically say (at the time you license the photo in the beginning), "I make no representations as to whether any specific use of the image requires a release. The licensee assumes that responsibility." In fact, you may want to use this statement in all your license agreements, price quotes, and invoices for licensed photos. This gives the licensee fair notice, regardless of any other claims that may come up later.

With that base covered, the next concern is having someone claim that you said you had a release. If you say nothing, a judge might give credence to what appears to be a legitimate defense by the licensee: "Your Honor, of course we knew we needed a release, and the photographer said he had one." Just because you disclaimed responsibility for whether a release is necessary, the disclaimer says nothing about whether you actually had one. So the

RELEASE BASICS

Stay Free as a Bird:
Never tell a client
whether you think a given
use of a photo would
(or would not) require
a release. And, always
state whether you have
a release for a photo.

way to avoid this problem is to always state up front whether a release exists and, if so, what it says.

Now you have both bases covered. If you are called in for a deposition, your case is already there. People can ask you questions, but so long as you can say, "I told the licensee that I don't claim responsibility for this," there's not much else it can do (short of grasping for straws). And thus back up the ladder the blame game goes to the people who made the mistake in the first place.

One more thing that bolsters your case: Because legal liabilities often come down to *intent*, a judge is going to look at your *modus operandi* (normal business practices) and determine whether you're doing anything out of the ordinary. Engaging in legal speculation (or discussion with a client) on subjects that you are not necessarily well versed may be your undoing, even to the point of undermining written agreements. The judge could sympathize with the client that you were persuasive. (Thus, I never engage in these discussions with my clients, despite — or because of — the fact that I write a lot about it.)

The usability of any given photo is a legal question, and all licensees should have their own legal representatives for these decisions. If you begin to render an opinion on a situation, regardless of how clear-cut it may appear to you, you open yourself up to cross-examination later, and your words may come back to haunt you.

An exception would be that if the intended use of the photo would so obviously need a release, and the kind of use in question could cause significant harm, that the judge might consider your actions as having turned a blind eye to the violation. Such a case is going on right now between the estate of the late singer James Brown versus Corbis, the large stock photo agency. The estate claims that Corbis has turned a blind eye towards licensing images of the singer without model releases to publishers that used the images in ways that so clearly and obviously required a release and that Corbis knew what was going on, but took no steps to prevent it. Odd though it may sound, Corbis has won the case

already (and this is the only case on record where a licensor was accused of such a thing), but the estate has appealed the ruling. You can read the original court's opinion from a link at my Web site: www.danheller.com/model-release-links.html.

The point is, while circumstances are important, judges look at *intent* by

all parties when making rulings. If the photographer or the publisher was acting maliciously, it trumps most other factors. However, this and other acts of fraud are obviously exceptions to typical (ethical) behavior.

As evidenced by the above examples, there are many possibilities that could shift

the ultimate liability from one party to the other. In a lawsuit, the judge's job is to unravel it all. But by default, the party that puts the image into publication carries the liability, so it's that publisher's responsibility to know (and to enforce, if necessary) whether the image has a proper release for that usage. The only time the photographer could be held responsible is if it can be shown that he willfully misled the publisher and thus caused the publisher to do the wrong thing. Because the photographer's liability is so limited, and because his responsibility is so narrow, the best thing for photographers to do is to simply disclose whether he has a model release and what its terms are.

THE LICENSEE'S RESPONSIBILITY

If the client wants to use an image in a way that would require a release, it is his responsibility to demonstrate two things:

1 that he acquired the image properly (presumably from you or an agency that has your photos)

2 that his use of the image was in compliance with the terms of the release (and that a release exists)

Regardless of the licensing approach you use, the model-release issues remain the same, and you should know how to answer the following two key questions in case the licensee tries to pin the blame on you. These are all questions the licensees should know the answers to, but you may need to know them as well to ensure you can't be blamed.

☑ How was the image acquired?

☑ Was the release status understood?

Those who publish photos must demonstrate that they acquired images properly and that their uses are compliant with the terms of the model release (assuming one is necessary).

How was the Image Acquired?

If a person files a claim against a publisher for using an image in a way that should have required a release, the photographer's involvement varies depending on how and whether any of the following scenarios apply:

☑ If the publisher stole the photo (for example, got it from a Web site without proper permission, or acquired it from someone else without the photographer's permission), then the photographer can't possibly have any liability. Full stop.

☑ If the image was acquired with the photographer's verbal permission, but there's no written legal agreement and no receipt of sale, the photographer has no liability, but a judge is going to want to know what the discussions were like to ascertain the degree to which the publisher can be held responsible. In the most minor case, the publisher might be fined for an infringement (such as copyright — it depends on what the subject of the photo is and how it was used), or it can be deemed a willful violation, where the fines are highest.

☑ If there is any disclosure at all from the photographer that stipulates whether a model release is available and, if so, what it says, then the publisher's liability is highest (probably willful intent) because it was given

notice by the photographer about the release, yet the publisher chose to ignore it.

☑ If there is a license agreement, but no statements about the model release, then the licensee is still responsible, but it may be able to reduce its liability if there is a weakness in how the license agreement was worded or if there are other areas of ambiguity.

☑ If the licensee got the image from a stock agency or other third party, then the same issues apply, but the chairs are filled by different parties. If that third party is a stock agency, they simply make the same disclosures you did when you gave it the image in the first place. Their liability is safest of all because they are merely a "conduit of information" (as ruled by the judge in the Corbis vs. Brown case).

For any of the above events, the photographer's liability is limited, provided the case is rather straightforward — that is, there is no foul play. If the photographer misrepresented the image's usability by telling an eager client (or stock agency) that the subject signed a release, even though he didn't, the photographer's going to be in hot water, no one else. This sort of thing happens more than people realize, especially when photographers are unaware of the extent of their liabilities, are too liberal in their interpretations of the law, or desperately need the business.

Stock agencies are merely conduits of information, passing along property from one party (the photographer) to another (the licensee). They bear no responsibility for photos being released; it's still the licensee's.

RELEASE BASICS

Was the Release Status Understood?

Now, let's consider the question, "Did the licensee understand the release status of the image?" This seems rather obvious, but as you'll see, there are various scenarios that may arise. So, let's consider them:

✅ The photographer disclosed to the user that the image didn't have a release. Assuming the photographer said he had no release, the licensee is always responsible.

✅ The photographer had a release, but the terms of that release aren't precise enough, or he did not disclose the release itself. Here, the licensee is probably responsible, though it's possible the photographer could share in some of it.

✅ If the photographer said the release existed, but he didn't actually have one, this is fraud, in which case, the photographer owns all responsibility.

As an example for the second scenario, say the release was limited to a geographic region, but the licensee used it worldwide. Now it becomes a question of whether the licensee actually saw (or was notified about) these limitations in the model release. The judge is looking to see who dropped the ball in the communication process and then weigh culpability accordingly. While it is still the publisher's responsibility to have had all its ducks in order, the real world of such paper trails of disclosures (and of who said what to whom and when) is harder to piece together than it may appear.

Ultimately, it's the responsibility of the licensee to demonstrate that the photographer was negligent. Here, the licensee would have to convince the judge that it made (what the judge agrees to be) sufficient attempts at getting a copy of the release, but the photographer rebuffed it. For example, the licensee could claim the photographer said, "Yes, I have a release, and I'll send you a copy of it," but failed to do so. The judge could reply, "Then

you shouldn't have taken the risk; that's your fault." To which the licensee may reply, "True, but it was one of hundreds of photos obtained by the photographer, and the releases were provided for all the other photos. We made a reasonable assumption that the photographer was telling the truth about this one." At this point, the photographer may reply, "I had it, but now it's lost." In which case, it's his word against the licensee filing the claim: Was a release signed? Or did the photographer lie?

A far-fetched scenario? Not likely — these kinds of statements are common, regardless of what "actually happened." Remember, there's money at stake here, so there's lots of incentive to say whatever you (think) you can to either get that money or not have to pay it. Anyone could be lying: The photo's subject might have seen dollar signs and have filed a claim knowing there was ambiguity, or the photographer himself is the one who's lying because the entire license agreement was too lucrative to pass up just because of one image for which there wasn't a release.

The judge has to get to the bottom of it. Assuming the claim isn't frivolous, the question is what's the weighting of responsibility. This is where the judge has to decide whether to use reasonable efforts or best efforts to measure the licensee's role.

A "reasonable efforts" ruling would be made if the judge decided that the licensee made "reasonable assumptions" due to the fact that the photographer did in fact provide nine out of ten releases; that shifts the blame to the photographer. A "best efforts" ruling would be where the judge determines that the licensee should have made sure every single picture had a release. Which standard the judge chooses would be based on the severity of the violation, which is measured most commonly by the monetary or personal harm that the publication of the photo caused. (Sometimes, contracts stipulate which of these two standards the parties would like the judge to use.)

In the case of the third scenario — the photographer lied — the photographer is liable, since he committed fraud. With the advent of many micro stock-photo sites and other agencies accepting millions of images from millions of people, the lure of easy money can lead many people to submitting images with claims that they have model releases when, in fact, they don't. Because of the rarity in which real lawsuits happen due to photos without releases, it's not a stretch to envision some people forging what appear to be legitimate releases

Having a bird's eye view of the licensing landscape helps you pick out good opportunities while staying clear of danger. It's not that you will get sued, but unscrupulous licensees can get you wrapped up.

There are billions of great photos on the internet, but those that can be used are actually rarer than one thinks. It can be especially problematic if people forge fake releases to sell pictures.

Though publishers tend to be the big, tough dogs, they have to be very careful when licensing photos from unknown sources. They are on the hook if something goes wrong.

WORKING WITH STOCK PHOTO AGENCIES

Some stock photographers don't license images on their own and instead submit them to stock photo agencies that take care of licensing on their behalf. (The photographer gets a royalty check for a percentage of the license fees collected.)

Some agencies, particularly micro stock-photo agencies, will accept only photo submissions that have releases (for recognizable people, and sometimes for buildings as well). There are two motivations for this. One is that the agencies don't want to be on the hook if the licensee gets sued for using an image with no release. Even though such lawsuits have yet to happen (with the exception of the possible unresolved case concerning Corbis, mentioned earlier), the concern is there nonetheless.

The other motivation is to "lock in" photographers to using only their agency by accepting only photos that use the *agency's* model releases. In this approach, because a photographer is unlikely to ask a photo subject to sign more than one release (one for each agency), the likelihood that the same photo ends up at multiple agencies is therefore low. Your business decision is whether it makes sense to jump through the agency's hoops for the potential sales you'll get in return. An agency had better perform well for you to place all your eggs in that particular basket.

Many photographers (and some stock photo agencies) assume they should license no image for which they do not have a release. That's a mistake.

knowing that there's little risk of getting caught. But again, the responsibility of the licensee is to assure the existence of releases if the use is particularly risky, in which case, the second example applies.

After having read and understood all that, let me give you some perspective. The vast majority of published images do not have releases — and nothing happens. In fact, most disputes never go to court. It's extremely costly to litigate, so you don't get that process started unless there's a really high chance that a lot of money is going to be made. Of course, this is not a green light to license nude photos of your ex-girlfriend to certain magazines with forged model releases all because she kicked you out of the apartment, leaving you homeless and living under a bridge.

There's no protection against uninformed people and their ideas about when and how you can take pictures. Don't try to win arguments with angry people, just try to get along.

THE PRACTICAL APPROACH

Still, there are also the practical matters of getting releases: people being upset with you. The hassle factor of being constantly badgered by phone calls and letters from angry people who may threaten suits, even though they may never follow through with them, is a price unto itself. Even if an irrational person gets the legal process started, his lawyer is going to think rationally and talk him out of it, but it's still a pain (and potentially costly) to deal with.

The emotional reason for why people sue — because they're upset about how they are represented — more often than not finds its roots in something other than money. People's usual goal is to stop the image from being used, so the first thing they're going to do is talk to you, perhaps by yelling and screaming or by sending e-mail replete with capital letters. If they're upset, they're not going to silently avoid you and go directly to a lawyer and prepare a lawsuit against you.

Furthermore, such people will invariably make (misinformed) statements about how you are "not allowed" to take pictures, or how they never signed a release, and so on. If (okay, *when*) you face this situation for the first time, the most intuitive thing to do is try to explain to them what the law says or why you have a right to do whatever it is you're doing. This is by far the worst thing you can do. (Believe me. I've tried.)

The best way to handle any situation is to talk to the complaining parties at their level. First, apologize profusely. If you really want the photo, try to explain why there is nothing to worry about (don't talk about the law), and spice it up with ways it can be to their advantage. Allaying people's fears about how their images may be used typically eliminates 90 percent of the problem. But don't hold your breath — most who complain are not open to new ideas. If you are the rare one who succeeds, you get a merit badge.

The most difficult people to deal with are those who just don't care *and* are misinformed, such as security guards. They are known for frivolously stopping people from pictures, even though they are wrong in their understanding. They may have been instructed to do so by

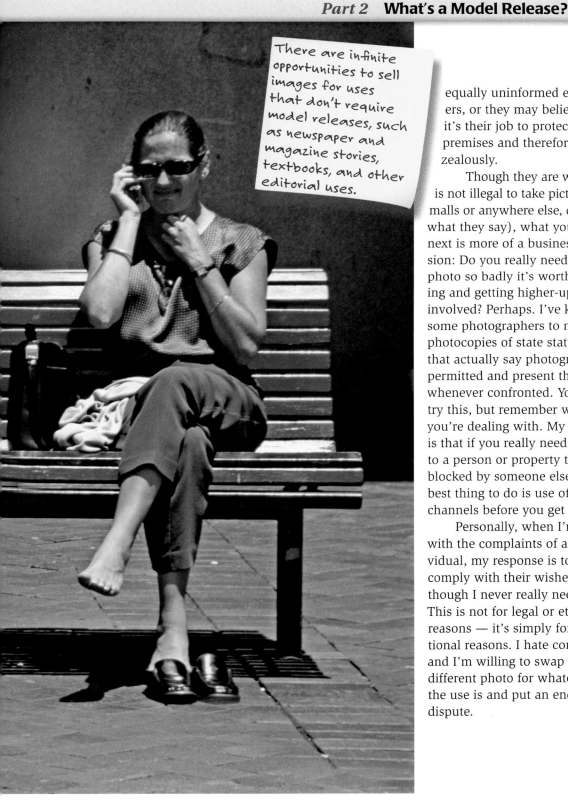

There are infinite opportunities to sell images for uses that don't require model releases, such as newspaper and magazine stories, textbooks, and other editorial uses.

equally uninformed employers, or they may believe it's their job to protect the premises and therefore do so zealously.

Though they are wrong (it is not illegal to take pictures in malls or anywhere else, despite what they say), what you do next is more of a business decision: Do you really need the photo so badly it's worth resisting and getting higher-ups involved? Perhaps. I've known some photographers to make photocopies of state statutes that actually say photography is permitted and present them whenever confronted. You could try this, but remember whom you're dealing with. My advice is that if you really need access to a person or property that's blocked by someone else, the best thing to do is use official channels before you get there.

Personally, when I'm faced with the complaints of any individual, my response is to always comply with their wishes, even though I never really need to. This is not for legal or ethical reasons — it's simply for emotional reasons. I hate conflict, and I'm willing to swap in a different photo for whatever the use is and put an end to the dispute.

There's a social side to talking to people about model releases that many people enjoy. But that kind of time can add up if you shoot a lot. Most releases aren't _that_ valuable, so be judicious in the cost of time vs. more photos.

I rarely hide my act of taking pictures, so people usually notice. Sometimes, I'll show them what I shot in my preview screen, which is a good time to ask them to sign a release.

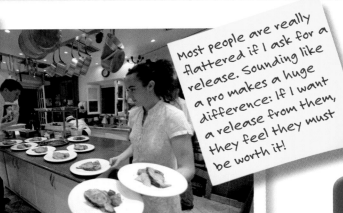

Most people are really flattered if I ask for a release. Sounding like a pro makes a huge difference: If I want a release from them, they feel they must be worth it!

I never really know whether a photo may have commercial value when shooting. I just shoot what I see and ask for a release if it won't take much time and there's opportunity.

THE ROLE OF ETHICS

It's natural and human to inject ethics into the decision of whether a model release should be obtained for some photos. Many people believe it is wrong to photograph people without asking permission first (regardless of the question of releases). Then there are others who believe that selling photos of people who didn't sign releases is a form of exploitation. And, there are those who believe that one should never pay for photographing people in poor countries, because it ruins work ethic and encourages begging.

Though such perspectives are understandable, they are personal choices, not economic decisions. To be in the business of stock photography, you must consider and come to terms with all these ethical parameters, because they will probably have more impact on your ability to succeed in stock photography than any other single decision.

In my opinion, there's no conflict between ethical and business decisions as far as the law is concerned. The law is there to give weighting to each side, taking into account the balance between the rights of individuals and that of the greater public interest. As such, I consider that working within the spirit of the law is akin to working ethically.

Ethical questions: Is it OK to photograph the poor or homeless? What if someone doesn't know you're shooting? Or, maybe they're everyday people, but they don't know you may be selling their picture. What to do...

For those ambiguities, which are numerous in this business, I personally side on the spirit of what is the "greater good."

What you choose to do is up to you; if you have a problem with the balance of the law, and thereby make different choices than what the law may dictate, then you will either end up doing poorly in business (because you're too forgiving to the photo subject) or you will be in a lot of trouble (because you're not forgiving enough to him). Either way, no one should engage in a business where success requires behaviors that go against one's personal ethics.

So, as you consider which direction your ethical compass points, consider this: Ethical behaviors govern a lot more about decisions you'll make well beyond the question of using photos without model releases. For those who are overly aggressive in business and skew their interpretations of the law too liberally in their own favor, such patterns have a tendency to leak into other business decisions, especially when economic incentives grow. Flying close to the mountains may be profitable, but given enough time, you will hit them.

On the other end of the spectrum are those who are overly ethical or overly cautious about legal and financial risks. The mistake here is that you don't mitigate risk by always doing the "right" thing. It's not always the safest way, especially in the forest of ambiguity. Many issues do not have a correct answer, either ethically or financially, and your senses of right and wrong from a business perspective will not develop until you've been at this quite a long time.

WAR STORIES FROM THE MUDDY MIDDLE

Strictly speaking, you know that the person assuming all the legal liability is the publisher of the image, not the photographer. Yet, the photographer is often caught in the middle, simply because he was there to take the picture in the first place. But people don't always take well to being asked to sign a release (timing is important!), so you can actually cause yourself more headache by trying to get a release than if you just took the picture and dealt with it later (or not at all). By having a better understanding of certain realities, you can find the best balance between the upsides and downsides of doing business.

When the Best Intentions Go Awry

I was on a photography assignment for a fledgling cycling company based in Colorado when I learned that none of the clients on the trip had signed releases or photo waivers as part of their general paperwork. (Such releases are customary for travel outfitters, so it surprised me that this hadn't been done ahead of time.) Of course, the company never had a problem before, nor had it even ever heard of model releases. The staff members were all close friends with the clients, and everyone was happy to help each other out with photos, so what's the bother?

Well, the problem is, the company was growing, adding new trips to new countries, hiring more staff, and consequently expanding its marketing to a broader audience. Because I was used to shooting for larger, more well-established companies, I figured the risk of not having releases as part of the company's normal liability waivers would be something it would soon realize.

For example, imagine a guest who was there with a mistress and what might happen if a photo of the two of them was used in the next year's catalog. If the exposed husband sued the travel company because he didn't give consent for using his image, the company would be liable.

So, with my best intentions, I figured

Photo assignment gone awry: clients for a cycling trip in Italy had not signed a model release, and a domino effect of miscommunications cascaded, resulting in a set of pictures bikes, but no people.

I'd preempt any problems and inform the clients on the trip about the situation, then get them to sign releases right away. I presented my standard model release to each one and said that if anyone had questions or concerns, I'd be happy to discuss them. I've done this before without so much of a hint of discomfort, and it didn't seem as this occasion would be any different.

Things started to go awry because one guest happened to be a litigating attorney, although in a completely different field. Being a lawyer, of course, he read the sweeping rights granted by the language of the release and got very upset without realizing the broader scope of the industry and the intent of the photos. Making things worse, he didn't bring it up to me;

instead, he spread fear among the other guests, telling them that if they signed the release, their photos would be used in ads for "hemorrhoid creams."

Because I was unaware of all this background discussion, I couldn't set the record straight. I didn't even find out until the president of the company showed up at the end of the trip to have a talk with me about it. Once it was all figured out, the people signed the release, but not before my reputation with the company was ruined. (People don't like unhappy clients, and it doesn't matter how the unhappiness came about. The reality is that if something bad happens, people get rid of the source that caused it, even if it wasn't his fault.)

Bad timing and poor planning were responsible for this fiasco, and both the company and I were responsible for mishandling this situation. It would have been much better if I'd never brought it up to the clients at all, and instead mentioned it only to the president after the trip so he could deal with it on a case-by-case basis with the clients.

Though the trip didn't turn out well, I discovered that photos of bikes do! So, whenever I see bikes sitting around, I take pictures of them. You may discover similar passions for particular articles.

RELEASE BASICS

Pay the Quarter to Avoid the Parking Ticket

The famous American playwright, Clare Boothe Luce, once said: "No good deed goes unpunished." This truism often applies to attempts at getting a model release.

In the Murphy's Law category, consider what my friend Bob experienced as he was shooting in Jamaica for a tourism magazine, whose use is editorial in nature and thus doesn't require having model releases. (Bob shoots only editorial footage, so he's never gotten releases from anyone he photographs.) On one occasion, he took a picture of a family lounging on hammocks on the beach at a resort. By coincidence, the family happened to see the magazine months later, with a photo of them in it. They contacted their lawyer, who immediately started writing threatening letters to the magazine and to Bob.

The parties were informed that the image did not have a model release, and that "remedies would be sought." Bob made two mistakes at this point. First, he didn't ask the magazine whether it was contacted as well. And second, he failed to redirect the lawyer to the magazine. (Neither Bob nor the magazine was aware that the other party also got the letter.) So, Bob, thinking he just wanted to get rid of the problem, responded with an offer: 50 percent of what the magazine paid him for the image. A month or so passed before he heard from them again, at which point, the family accepted his offer. Bob sent them a check for $150 and never heard from them again.

It wasn't hard to piece together what happened behind the scenes. The magazine had, in fact, been contacted by the lawyer and replied that the use didn't require a release (because it was editorial in nature). Because the editors were unaware that Bob was contacted as well, they didn't inform him of it. Had they done so, he wouldn't have. So, his rationale was that $150 is cheaper than paying a lawyer $250 an hour to deal with it. Speaking of lawyer fees, either the family itself or their lawyer spent more time and money than what they got back because their lawyer made the same erroneous assumption as many people do: that a release was necessary.

> Don't be penny-wise and pound-foolish. Just because someone's upset about a photo you took, do some homework and cover all your bases before starting to pay lawyers or settlements.

You could say that Bob could have avoided the problem in the first place by having gotten a release. But the editorial nature of his usage didn't need one, and the time and effort necessary to do so would be prohibitive — especially since he does this full-time and has to get a lot of shots in limited periods of time. Sure, the effort for one family might not be much, but it adds up quickly for a photographer who shoots this much. This photo was one of thousands, and it's not feasible to get a release from everyone you shoot, especially just to be "safe" is an industry where you never need releases anyway. This is the reality of a travel photographer.

THE BOTTOM LINE IN BUSINESS

The business of licensing images involves getting as much content as possible to sell to clients, whether they are magazines, newspapers, ad agencies, the corner dentist's office, a small church in Topeka, Kansas, or a toy company that wants to use a photo of a funny dog on a coffee mug. Many of the uses of photos for each of these clients require a release, whereas many do not. Because it's not always easy to know which is which, you need to conduct a risk/reward analysis that involves pairing up the right clients with the right photos: Solicit images without releases to those that might not need them, and vice versa.

Although it isn't your responsibility to know if a release is necessary in each case (and you won't get in trouble if you're wrong), the better you know the conditions that may trigger the need for a release, the better you become at finding the right clients for all the photos you have. (You also get better at negotiating business terms and contracts.)

Here's another bit of business calculus: Photos with releases are easier to sell. After all, the client is the one taking the risk, so it's more likely to choose photos with releases than those without, even if their use wouldn't need one. So, it's good to get releases when you can, so long as it's a good use of your time at the moment. Indeed, the process of getting a release is often more involved than one thinks,

and the time it takes is time you're not spending shooting other things that may generate income. You might also scare away a subject by raising the issue of a legal contract. And if you ask before you shoot, you're likely going to lose the spontaneity of the moment. Photos with releases may be easier to sell, but they may not necessarily sell for more money, or in high enough volume to offset the effort in getting them. There's also all those other photos you're not getting because you're bogged down in talking someone into signing a model release.

Think about that balance in each case you come across. Not everyone will come to the same conclusions on what the right calculus is for making the "Do I ask for a release?" decision, but those who are most successful in the photo business are those who consistently choose smartly, not necessarily conservatively.

RELEASE BASICS

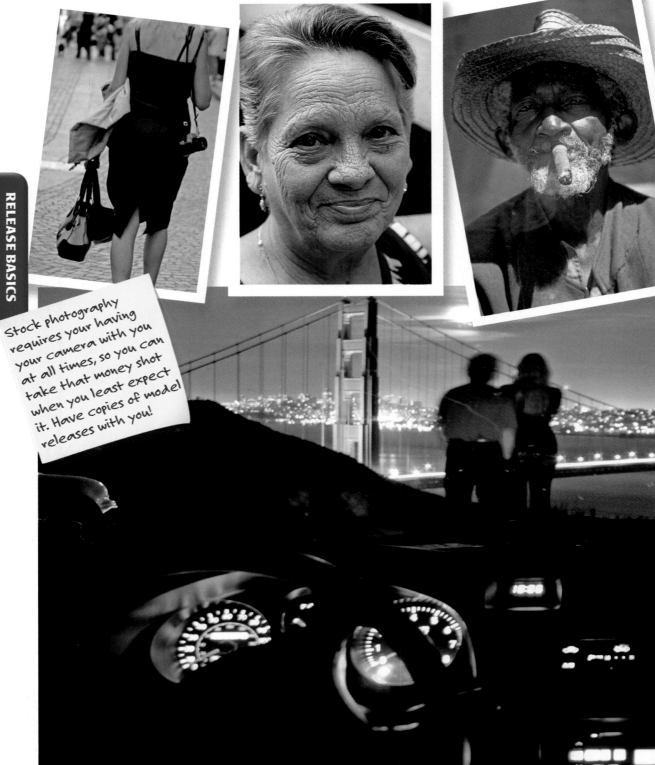

Stock photography requires your having your camera with you at all times, so you can take that money shot when you least expect it. Have copies of model releases with you!

Photographer Ahead
no obligation

Developing a good eye for photography is one thing. Seeing what kind of photos sell is another. Know the industry that buys the kind of photos you shoot.

Shooting from or through the car window yields surprisingly good results. But you have to be quick! And needless to say, you let someone ELSE do the driving while you shoot. :-)

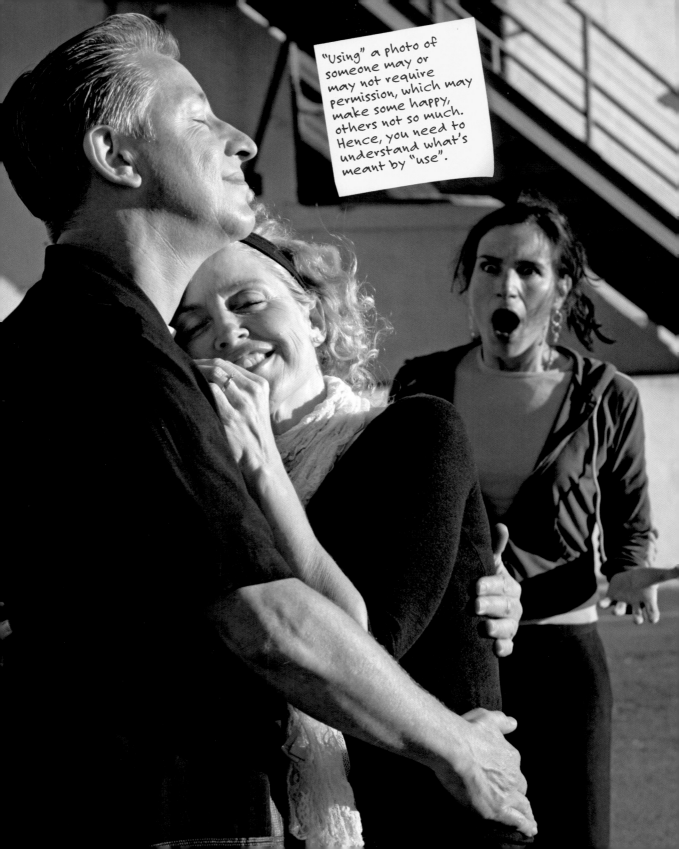

Understanding "Use"

At the heart of the issues of when a model release is needed is something called *use*. Before moving forward, let's test your current understanding of the subject using the most commonly asked questions about model releases.

- ☑ Do I need a release for a photo I took of someone in a public place?
- ☑ Should I get a release even if the person in the photo is unrecognizable?
- ☑ Does profiting from the sale of a picture trigger the need for a release?
- ☑ I'm going to put the picture on public display. Is a release required?
- ☑ What if the person is dead?
- ☑ Do I need a release if the subject is naked?
- ☑ I have tons of pictures of my ex-girlfriend. Can she sue me if I sell them?
- ☑ I own a portrait studio. Do I need clients to sign releases?
- ☑ I took a lot of pictures as a hobby, and now I want to sell them. Do I need releases for all my pictures of people?

To score your knowledge, give yourself one point for each item you answered yes and two points for each item you answered no. In fact, make it three points. Now, total up all your points. If your score is above zero, you have a lot to learn about model releases and the underlying issues of use.

No, these were not trick questions. The reality is that they have no clear-cut answers. The reason is because none of these questions indicated a *use* for the images. Unless and until there is a specific use for a photo, there can be no answer on whether a release is required. Regardless of whether you have already taken pictures, or you are about to shoot new ones, if you're wondering whether you need a release for them, the answer starts out as no. It's only if you plan on using the photos yourself (self-publishing) or licensing them to someone else for publication (stock photography) can you ask the question of whether a release may be necessary.

Is the image to be used in an advertisement? A release may be necessary. Is the image to be used as part of a story in a newspaper? A release may not be necessary.

THE ESSENTIALS

Determining whether a model release is required for any given photo is based on a number of intertwining factors. To understand them, you must first dispense with the most widely misunderstood assumptions on the subject. Here are some basic truisms to set your foundation:

- ☑ You don't need a release just because you took a picture.
- ☑ You don't need a release to sell a picture, even if the subject refused to sign one (exceptions to be discussed).
- ☑ Until a use of a photo is determined, the question of a release doesn't apply.
- ☑ Rarely does a release trigger by itself (such as whether someone is recognizable) trigger the need for a release. <u>Many</u> factors are involved.
- ☑ Personal uses of photos never require releases or permissions, including making prints, sharing with friends and family, and placing photos on your personal Web site.
- ☑ If an intended use of a photo would suggest the need for a release, other factors come into play that may reverse or compound that need. This is addressed in the next chapter.

So, unless you are in the business of selling (licensing) pictures, or are in a business (or political or religious activity) where you use pictures for publication (yours or anyone else's), you never need to think about this stuff. No, artists do not need releases, unless they license their work to people or the businesses just described.

Once you've established that a client has a specific use for a photo, determining whether a release is necessary begins with an analysis of whether the use is commercial or editorial, which is a controversial subject by design. The framers of the U.S. Constitution intended to protect both the freedom of expression and the interests of people's privacy and rights of publicity.

Photography as an art form has almost always been universally protected by the courts. For example, photojournalists have nothing to worry about because of their trade's clearly editorial nature, which the First Amendment protects. On the other hand, photos used in commercial contexts require consent from people depicted in them, but only under certain circumstances, the conditions of which are not always entirely clear-cut.

"USE"

"USE"

Regardless of quality, price, content, or readership, Publishing takes many forms, some of which require releases, others not. Newspaper stories do not. The ads placed with them do.

DEFINING "PUBLISHING"

In the context of this book, the "uses" that I refer to fall under the broader umbrella of publishing. And for this subject, the kinds of publishing that matter are those that involve a certain degree of distribution. This differs from "personal use," which is a form that never requires a model release.

For example, say you went on vacation to San Francisco and took photos of everything from the Golden Gate Bridge to tourists having fun at Pier 39. When you get back, you want to share your pictures with your friends and family by making a book of those pictures, complete with a hard-cover binding and high-end glossy paper, much like you'd see in a retail book store. This personal use is not a form of publishing that requires a release because the scope of people you are sending the book to is limited. You could even make all sorts of slanderous statements about the people you took pictures of, or reference products and properties, all without risk of liability, simply because it is considered "personal use."

You could even make the book available in a "print-on-demand" form, by any number of online printing companies, where your friends and family could order their own copies (rather than you spending the money to send it to them), and the book would still not be considered a form of publishing that requires the photos to have releases.

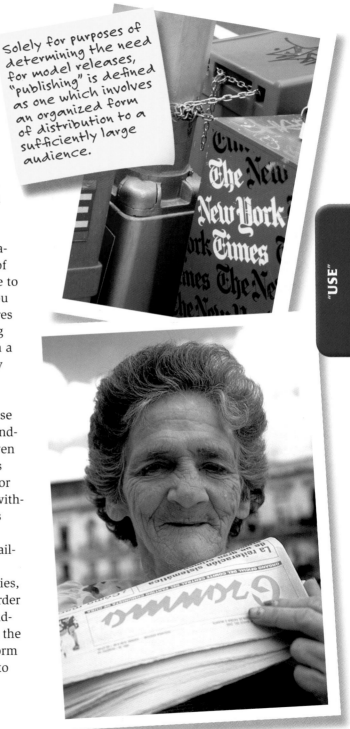

Solely for purposes of determining the need for model releases, "publishing" is defined as one which involves an organized form of distribution to a sufficiently large audience.

"USE"

But what happens when your friends tell their friends, and the word gets around that this is a great photo book of San Francisco? If the popularity of the book grows, at some point the wider distribution of the book crosses the very wide gray line into the realm of public distribution. The difference between these two areas of use can be rather vague nowadays, because tools (such as print-on-demand and online ordering) were never available in the past. It used to be that simply being a book implied a form of publishing because you didn't do it unless it was for public distribution. Yet the law is written in such a way that what worked before continues to work now, though it may take a discerning eye of a judge to wrestle with those more ambiguous cases.

The most recently famous example of this was the Napster case — the Internet music-sharing site that allowed people to share music files with one another. Because copyright law permits sharing of music with others for personal use, the vastness of the Internet allowed this to get somewhat out of hand. The music companies filed suit and eventually the courts found the site to be in violation of music copyrights because it was deemed to be a "distributor" of music to the general public. This interpretation has also found its way into the publishing world.

Yet, there is still no way to describe what is, in fact, "distribution." Even the fact that hundreds of millions of people were sharing music using Napster didn't make it easy for the courts to instantly jump to the conclusion that it was a form

Shedding light on the subject of editorial versus commercial uses is not so easy because there will always be complicating factors that obscure what may seem obvious.

"USE"

of distribution that violated copyright protections. (Model releases typically deal with privacy and other rights, not so much with copyright, but the connection to publishing is that new technologies and media make it hard to distinguish publishing from personal use, which can affect all of these rights, even if in different ways.)

Anyway, the take-home message is that when I use the term "publishing" in this book, I'm talking about the kind where there is broad enough public distribution of material that it would no longer be considered private use.

When your photography is used in a publishing context, there are two usage categories to understand in terms of implications for model releases: commercial and editorial. Editorial uses do not require a release; commercial uses often do. Understanding the difference is not an easy task, and it is the basis for almost all legal claims in this area of photography. Because lines often blur between them, the subject becomes even more difficult to address. In fact, delineating the points along the continuum of commercial and editorial expressions of speech is a complicated and focused subject that is an entire division of law studies. So, what I will try to convey in this chapter is an overview sufficient for use as a context for other aspects of determining whether the need for a release is necessary.

"USE"

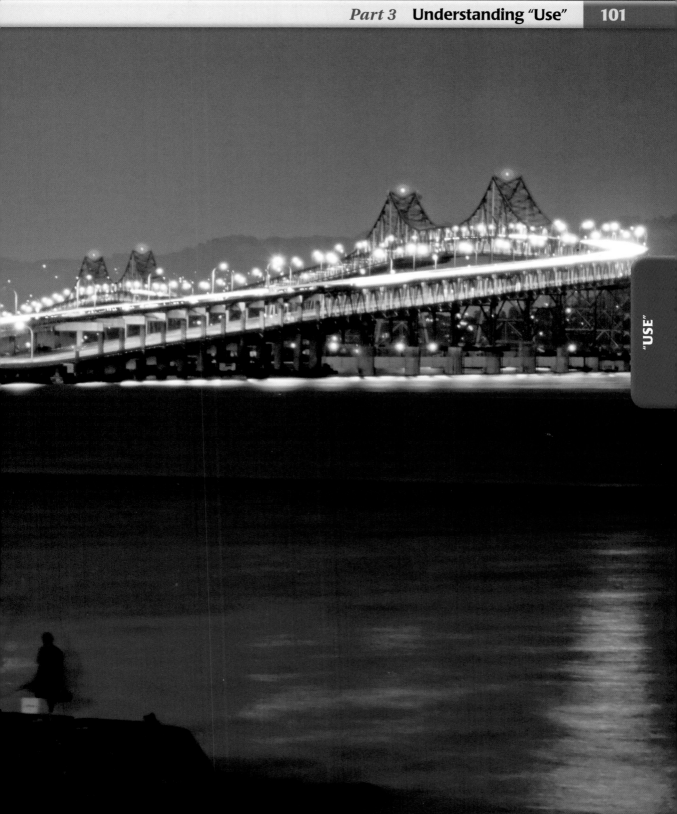

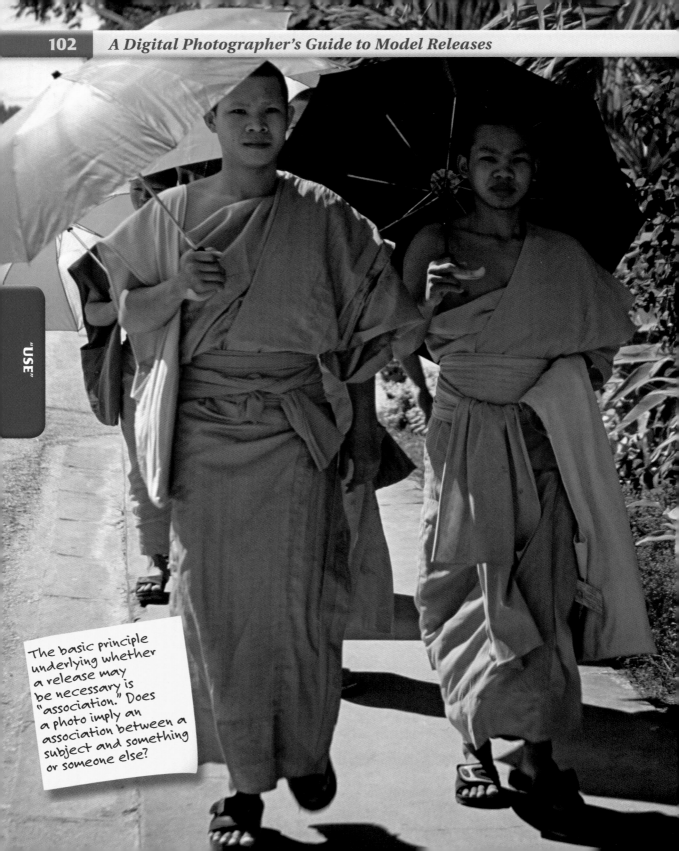

"USE"

The basic principle underlying whether a release may be necessary is "association." Does a photo imply an association between a subject and something or someone else?

> **California Code Section 3344(a):**
> *Any person who knowingly uses another's name, voice, signature, photograph, or likeness, in any manner, on or in products, merchandise, or goods, or for purposes of advertising or selling, or soliciting purchases of, products, merchandise, goods or services, without such person's prior consent, or, in the case of a minor, the prior consent of his parent or legal guardian, shall be liable for any damages sustained by the person or persons injured as a result thereof.*

UNDERSTANDING COMMERCIAL USE

In the U.S., people are entitled to approve the use of their likeness for promoting a product or idea (including political and religious views). So, in determining whether a release may be needed for a given photo is to assess whether the use of the photo implies an *association* between people or things for which they may disapprove, or in which they have a right to be compensated. This is the recurring theme you'll need to keep in mind as you read through most of this book. And, as simple as it sounds, there are many ways to interpret individual cases, so I'll walk through them iteratively to set a pattern of analysis.

The most common form of association is advertising. Let's say you wanted to license a photo of a child scoring the winning goal at your kid's soccer game to a soccer ball company for use in a magazine advertisement. The association between the kid and the soccer ball company is implied, so a release would be necessary. Without one, the kid's family could sue the company that used your photo.

Advertisements are the easy cases. The problem is, many situations are not so clear-cut. For example, consider the above excerpt from the California civil code section 3344(a). A link to the full text can be found at my Web site, www.danheller.com/model-release-links.html. Note that I'm using California code merely as examples, not as the legal standard you should follow; the law's specifics will differ from state to state, though the underlying principles are often — but not always — the same. The entire content of the code is longer than what is shown above, but the rest of it is mostly comprised of marginally related material, such as "groups of people" and "employees" and whatnot.

The important section quoted above is rather short, which means that it's open to a great deal of interpretation. For example, it doesn't define what an advertisement is. As such, it's very easy and common for people to assume that a photo used for a purpose that doesn't appear to advertise a product therefore doesn't need releases from the people in it. A classic example of this are the "advertorials" that you see on television and in magazines, which are advertisements designed to look like news broadcasts or stories. Some are laughably obvious, but others fool us because there may not actually be a product being sold. As a student of the subject, you're looking for "association."

"USE"

For example, the *New York Times* reported in March 2005 that various so-called news reports shown on local television stations across the country were actually video press releases created by the government to promote (and advocate) positions that the administration wanted people to support. A link to the article can be found at www.danheller.com/model-release-links.html. One such report (of many listed in the article) included a jubilant Iraqi-American who told a camera crew during the fall of Baghdad, "Thank you, Mr. Bush," which was perceived to be his emotionally positive reaction to the American presence in Iraq. Turns out, this man was an actor, and the "reporter" was a press relations agent for the Bush administration, and it was filmed in Kansas City. The piece was folded into existing, legitimate news reports, giving the public the impression that this was a similarly bona fide news item.

The courts have already long established that such works are not editorial in nature, because they advocate a specific agenda. Although no laws were broken (yet, serious controversy was raised on ethical grounds at the time), the people in the videos would be subject to California civil code 3344(a) if the "news" was broadcast in that state. That means that model releases would be required from anyone who could be perceived to be an advocate for the underlying message. Namely, the Iraqi-American and the news reporter.

Many companies, religious groups, and, yes, even well-intentioned nonprofit interest groups that advocate socially beneficial endeavors often fall into this trap: thinking that a message that doesn't "sell a product" is not an advertisement. Unlike the government's videos, which involved professional actors, other organizations that may be unaware that their "media presentations" may, in fact,

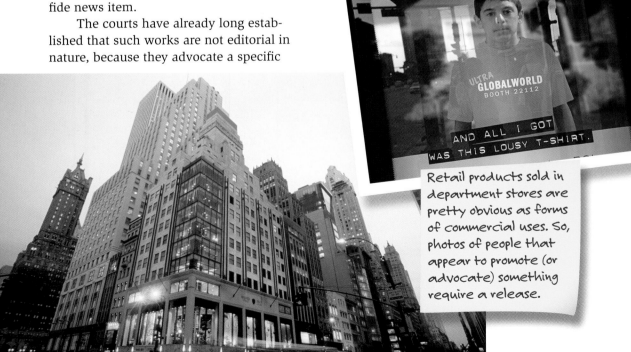

Retail products sold in department stores are pretty obvious as forms of commercial uses. So, photos of people that appear to promote (or advocate) something require a release.

need model releases from the people shown. Again, the key-word is "association."

Sometimes, it's not imme-diately clear that there is any promotional component that crosses the line into commer-cial use. Consider the common practice of charities producing "news items" that show heart-wrenching visuals as though they were being reported by mainstream news organizations (for the ultimate, even though not explicitly stated, purpose of raising money). These photos would require releases from the subjects because of that objective of raising money — a commercial use — so the depiction of the children would be considered exploitation of their image for financial gain. The chari-ty's nonprofit status has no bearing on this.

One thing about these "media presen-tations" and the need for releases is the scope of how many people are covered. There could be other people visible in the video or photos, but unless they could be perceived as actual advocates, releases are not necessary for them. After all, the image

> Many organizations try to hide their true "commercial intent" by projecting an appearance of editorial commentary. However, courts have a keen eye for this.

may have been shot in public and the bystanders were unaware of the photography, making them less likely to be considered "directly connected." And this specific phrasing ("directly connected") will be the basis for much of how you think about whether releases are required throughout many exam-ples presented in this book.

In general, the more visible (or "apparent") any one face gets in the piece, the easier it is for viewers to believe that person is specifically promoting the idea or product; it's not just a random face in the crowd. In the event of a disputed claim, a judge would be the ultimate arbiter.

"USE"

> California Code Section 3344(d):
> *For purposes of this section, a use of a name, voice, signature, photograph, or likeness in connection with any news, public affairs, or sports broadcast or account, or any political campaign, shall not constitute a use for which consent is required under subdivision (a).*

UNDERSTANDING EDITORIAL USE

To explain editorial use, I'll begin with another section of the California civil code, 3344(d), shown in the excerpt above.

All this falls under the fundamental premise of the U.S. Constitution's First Amendment and, in other parts of the world, the laws or constitution that protect free speech. An aggravating factor here is that what constitutes "editorial" changes over time as culture and community standards change.

The most common examples of editorial content are news, commentary, art, parody, satire, and opinion. (Oh, and the mudslinging political campaign ads you see on TV.) That means newspapers, magazines, books, and other sources of editorial content can use images of people without a model release.

But, as I highlighted in the previous section, there's a fine line between expressing an opinion and directly associating someone else with your opinion in a way that would suggest they support or sponsor it. In fact, the law uses the words "in connection with" to draw this very distinction. It means that you can express opinions about people and things, but you cannot make attributions to them in such a way that the objective viewer might think you're speaking on their behalf or that you are quoting them. Without a release, that is — or unless their statements are already part of public record and thus clearly reflecting their opinions. This "in connection with" is often the part that people miss or misunderstand.

For example, it was thought at one time that you needed a model release for a person in a photo if it were to be used on a book's cover because the cover was deemed to be a form of "promotion" (even though the content itself may be considered editorial), because it was assumed that the people (or properties) on the cover were somehow "connected" in a way that would demand a release. But this has been shown to be a false assumption many times.

The most recent precedent was one that also happened to include online uses of book covers: Amazon.com includes images of all the books it sells at its Web site — essentially, an online catalog — including cover images of books sold by third parties for which Amazon.com had no

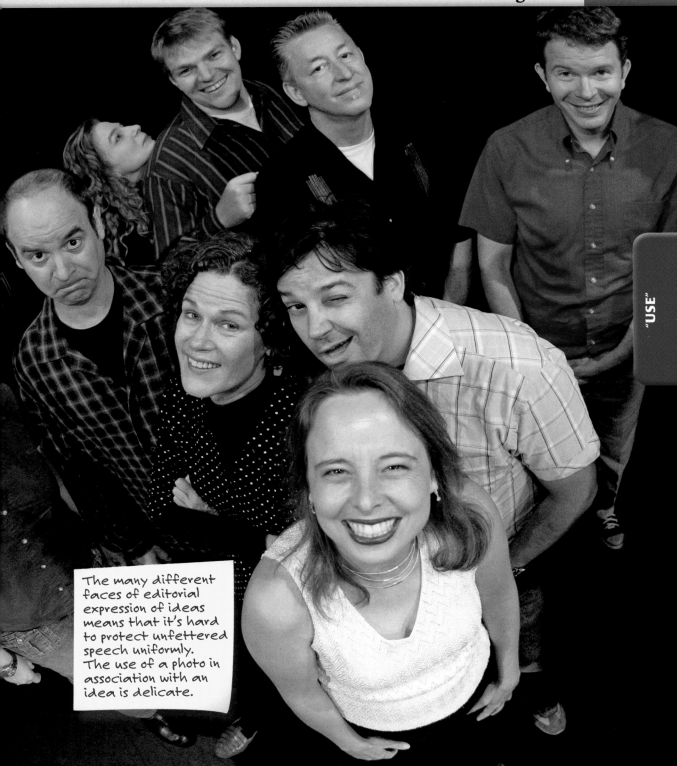

The many different faces of editorial expression of ideas means that it's hard to protect unfettered speech uniformly. The use of a photo in association with an idea is delicate.

"USE"

direct agreement with the publisher. In July 2006, the 11th federal circuit court ruled that it was okay for Amazon.com to use those images without permission. I've posted a link to the ruling at my Web site, at www.danheller.com/model-release-links.html.

The implication of this particular ruling is far-reaching, even beyond the "book cover" requirement for a release for anyone's promotion of the book. Having a person's face on the cover of a book does not necessarily imply that they are "connected." Other factors must be used to show that connection.

For example, a book titled *The Unofficial Biography of Robin Williams* can use a portrait photo of the actor on the cover without Williams having signed a model release, regardless of who wrote the book or whether Williams consented to its being written. In fact, even if he vehemently objected to the book, it's fair to write about him and to use a photo of him on the cover whether he likes it or not.

But the same photo could not be used without a release if the title were *Robin Williams' Favorite Jokes*. Such a title would either assume that he wrote the book or that he has endorsed and approved it. Hence, the "connection" trigger.

Satire and Humor

It's probably easiest to recognize satire and humor as editorial in nature, even if you don't find a joke funny. (Like most lawyer jokes.) Just about anyone and anything is free from the requirement of a release for humor or satire — after all, it's a form of opinion, which is definitely protected by the First Amendment. You see this all the time on television and in printed form. *Saturday Night Live* has made such forms of satire a household name in contemporary culture. Therefore, satirical expressions that involve photos of people do not need releases as a general rule. Even pretending to quote someone directly as a caption to a photo of them can be permitted if it would be generally accepted as a joke. Granted, this is a very gray area, and many people can simply not be funny, despite their best attempts. But

"It is the ability to take a joke, not make one, that proves you have a sense of humor."

--Max Forrester Eastman

"There are people who can talk sensibly about a controversial issue; they're called humorists."
—Cullen Hightower

"Beware of those who laugh at nothing or everything."
—Arnold H. Glasgow

"It takes a big man to cry, but it takes a bigger man to laugh at that man."
—Jack Handy

A person without a sense of humor is like a wagon without springs. It's jolted by every pebble on the road.
—Henry Ward Beecher

what a judge would be looking for is more of the *intent* of the photo and the caption, irrespective of whether the audience's funny bone was tickled.

Also, you can run into trouble if you try to use the "satire" excuse to justify an otherwise nonsatirical commercial agenda. For example, a company that makes bobbing-head dolls made one of Arnold Schwarzenegger after he became governor of California. The governor sued under the premise that he's a movie star and can protect his image from unauthorized commercial uses, but the defense claimed that as governor he had become a public figure and that the doll was satirical of his persona. The company lost the case after a long court deliberation, because the court ultimately decided that the doll was taking advantage of Arnold's movie star status, not his role as governor. That it was a close call is a reminder that these things are never cut-and-dried.

"USE"

"USE"

Artwork

Art exhibits — and indeed, the sales of photos as artwork — are exempt from requiring a release from subjects portrayed. This includes photo contests, exhibitions, and photography books (in fact, most books of all kinds, except those sold with products, such as instruction manuals for cameras). Art is probably the most protected form of expression, but it is also one of those uses that most concern, everyday people. It also triggers the most vociferous responses, often from people who claim their likenesses were used without a release. Therefore, people wonder whether they can be held liable if the subject doesn't like their work, especially if it depicts them in an unfavorable light.

For a work to be so offensive that you'd get in trouble (for not having a release for the image in question), it would have to exceed the kind of gratuitous uses of violence, sex, or other visuals we see everyday in mainstream media. As with the other laws, the one pertaining to this kind of expression was written so that cases would be interpreted on a case-by-case basis to provide sufficient room for people to express themselves freely without undue suppression by the government (or other people), while also protecting societal standards for any given era. On the other hand, where artists (or commentators) can get into trouble by adopting an overly liberal interpretation of this freedom is when they cross the line into libel, or trying to advocate an agenda. I'll explain this later in the "Publicizing" section.

Although art generally doesn't require releases, an exception may apply if a work were displayed in, or underwritten by, an organization in a way that would make the exhibit appear to be more of an advertisement, or in which the people portrayed in the photos appeared to endorse the underwriter. For example, American Express, the credit card company, once sponsored an exhibit of photographs from Annie Leibovitz, featuring her portraits of famous people. So far, there's nothing about this particular exhibit that would trigger the need for a release from any of these celebrities, because the photo themselves were merely portraits. However, the one trigger that changed the status was that under each large portrait was a copy of an expired American Express card that was once held by that particular celebrity. That endorsement is what triggered the need for model releases from each of the celebrities (for which they were probably paid handsomely by American Express), converting the use from editorial to commercial.

Let's be clear, though: Just because artwork is sold for money — even large amounts of it — that fact doesn't trip the "commercial use" trigger. That question was put to rest by a judge in Manhattan who ruled on a case involving a dispute between a photographer and the Orthodox Jew whose picture he surreptitiously took at Times Square. He sold 10 prints at $20,000 to $30,000 each, but the state's supreme court ruled that the amount of money realized from a sale does not affect

"USE"

whether the work itself is considered art. I've posted a link to the case, Nussenzweig v. diCorcia, on my Web site, at www.danheller.com/model-release-links.html.

Sales of postcards, posters, calendars, and other similar products of your own work is also protected by the right to make money from your artwork as if they were original prints. These are not "commercial uses" that require a release, unless any of the other triggers described here apply. The same goes for items that may contain trademarked or copyrighted items, such as buildings and the like. (See the case involving Gentile v. Rock and Roll Hall of Fame in Part 7 for further information on trademark issues.)

These conditions make it impossible to make a hard-and-fast rule such as "photos used on postcards never require a release." There must be an "association" implied by the photo or its use. And because you can't get a "pre-ruling" from a judge on such things (rulings only occur when both sides present themselves in court), you roll the dice and see whether you win or lose. Still, assessing the conditions outlined in this book can give you a hint as to what may cause any given use to make you lean one way or another into the editorial or commercial side.

Blurred Lines

But what if an organization that promotes a particular point of view and agenda produces a genuine "news item" that doesn't actually depict any advocating point of view at all? Would releases be required of the people depicted? Remember, it's not just the piece being news-like, but the risk of implied *association* with the entity that produced it. The further that organization is from being generally regarded as an independent news organization, the higher the need for a release for any of the people depicted, simply because of the risk of implied association. This isn't always easy to discern — in the 21st century, many of the media have been shifting away from an objective editorial approach and towards one that favors a particular position. In fact, it's ever harder to discern between news and entertainment, or between fair and balanced. For any given case, rulings would be decided on the specifics by a judge, who would likely take intent into account.

Still, when it comes to art that isn't trying to breach the border with commercialism, courts almost always rule in favor of requiring no

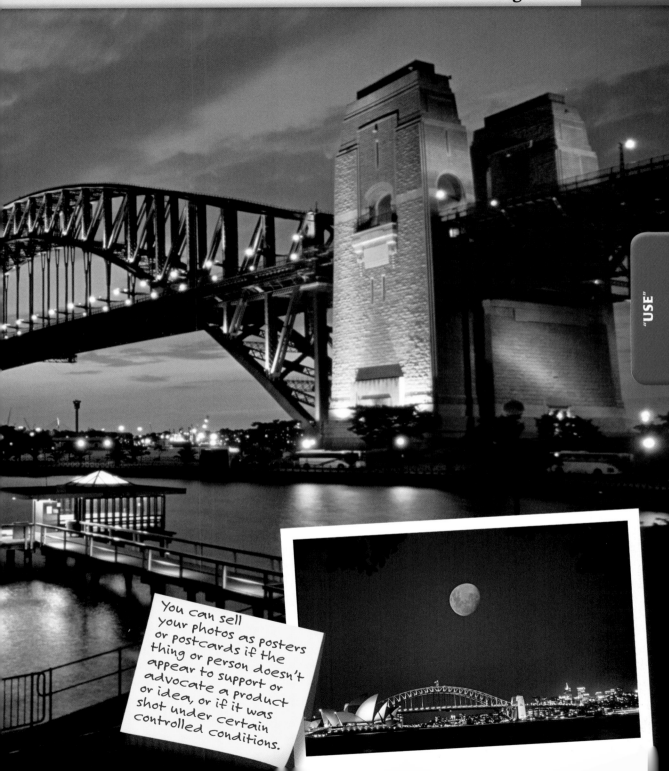

"USE"

You can sell your photos as posters or postcards if the thing or person doesn't appear to support or advocate a product or idea, or if it was shot under certain controlled conditions.

> Federal law of torts, section 652D:
> *One who gives publicity to a matter concerning the private life of another is subject to liability to the other for invasion of his privacy, if the matter publicized is of a kind that (a) would be highly offensive to a reasonable person, and (b) is not of legitimate concern to the public.*

THE PERILS OF PUBLICIZING

One of the more important risks associated with deciding when to get model releases is the matter of *publicizing*. The federal law of torts, section 652D, is shown above. As you might imagine, both (a) and (b) are highly subjective. That said, one way that courts generally view these sorts of things is by determining whether the photo (for our interests here) suggests something that isn't true about the subject, that caused harm to his personal life or career, and that is not in the public's interest to know. Note that publicizing itself is not illegal. It is only a problem if it causes harm *and* is not protected by other editorial uses. We see this all the time in political contexts, where one candidate smears his opponent, even with what may appear to be outright lies, but such mudslinging is permitted because the public interest is quite high. (Sad though it may be.)

Also note that publishing and publicizing *aren't* the same thing. If you make a bunch of flyers that contain a picture of your ex-boyfriend and post them on trees around town, saying, "This man is a dirty, rotten drunk," you're not publishing (not for the definitions we're using), but you *are* publicizing. Presuming the statement isn't true, and presuming he doesn't already publicize this fact about himself, you can be liable for slander, libel, and/or defamation of character — provided he can be shown to have been harmed by this. (For example, if he gets fired from his job.)

If he gives you a model release that allows such information to be known, you're of course protected — not that he would sign such a release, unless he were drunk at the time. But then you get into a

The door is wide open on whether someone can (mis)construe a photo as a form of undue (or unfair) publicity. But if the photo was shot in a public setting, it'd be a hard case to make.

There is no defined blood alcohol level that delineates whether a signature on a model release may or may not be valid.

sticky situation as to whether a judge would consider a signed release valid if the person were not of sound mind at the time of signing. In fact, this comes up a lot when getting releases from people who genuinely are drunk. One popular case was a scene involving two drunk men in the movie *Borat*; they sued the film studio over how they were depicted, arguing that the director got them drunk first, and only *then* did he ask them to sign model releases. The judges ruled against the men in this particular case, but courts haven't made such rulings consistently. Unlike traffic laws where statutes define a specific blood-alcohol level as being "intoxicated," there is no such standard for how much a subject might be under the influence before his signed model release may become unenforceable. So, judges evaluate cases individually.

"USE"

Expression of opinion is rather delicate because of the risk of libel and slander, which is often independent of the photo itself. For example, a photo of fundamentalist preacher Jerry Falwell can have the text, "Jerry is against gay marriage" and no release would be required, not because he is a public figure but because he is already generally known to have taken that position on public record. Once it's out there, you're allowed to bring more attention to it, even if such attention harms his reputation. In fact, we see this all the time in politics: Ancient quotes, video clips, photos, or other recordings are brought back to light after having been buried for years.

However, a photo of your neighbor with an alarming quote from him would require a release unless he has also made the statement publicly, such as in a town hall meeting or newspaper interview. If his statement was not public, and your

Expressing your opinion is your right. Attributing statements to other people (with or without photos) can be trickier, especially if it's not "news."

publicizing it causes him personal or professional harm, he can sue you. Your only out would be if it were in the public's interest to know. This can be the case whether there's a photo or not, but if there is a photo, and if he filed a claim, then the photo will probably be tied up into it.

In general, it's rarely the photo that causes the problem, but what's stated along with it (or the implication or association that can be made). The mere fact that some opinions are controversial is what starts the trouble. For example, a religious magazine using a recognizable photo of a kid scoring a soccer goal with the caption "Scoring another goal for God" could very likely get the parents of that kid upset if they don't approve of that message, even if they are "believers." The implied association between God and the kid in the photo can be objectionable to some.

The potential controversy doesn't have to be so obvious. For example, one

man brought forth a case that a photo of him water-skiing used on a postcard damaged his work and personal life because he is known to be a member of a strict religious sect that does not condone "having fun."

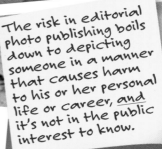

The risk in editorial photo publishing boils down to depicting someone in a manner that causes harm to his or her personal life or career, <u>and</u> it's not in the public interest to know.

"USE"

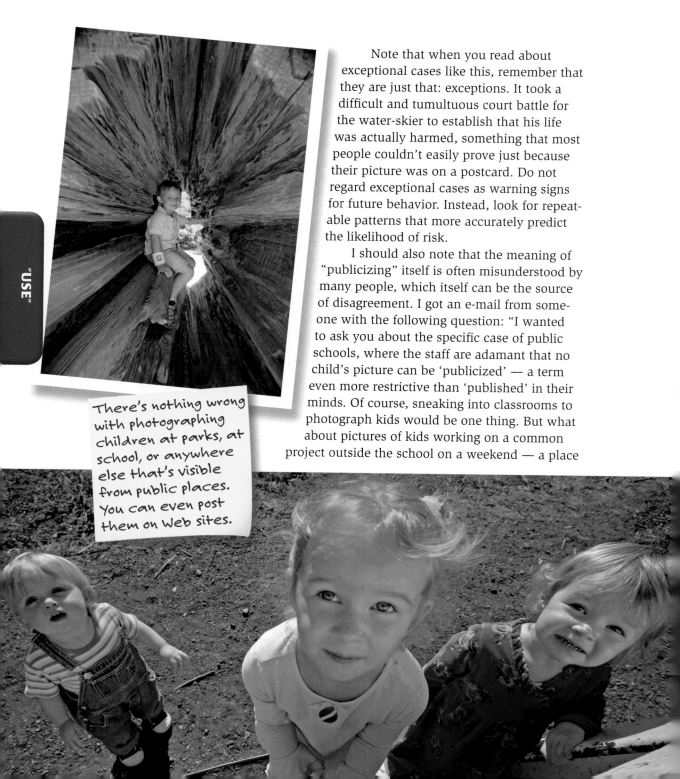

"USE"

There's nothing wrong with photographing children at parks, at school, or anywhere else that's visible from public places. You can even post them on Web sites.

Note that when you read about exceptional cases like this, remember that they are just that: exceptions. It took a difficult and tumultuous court battle for the water-skier to establish that his life was actually harmed, something that most people couldn't easily prove just because their picture was on a postcard. Do not regard exceptional cases as warning signs for future behavior. Instead, look for repeatable patterns that more accurately predict the likelihood of risk.

I should also note that the meaning of "publicizing" itself is often misunderstood by many people, which itself can be the source of disagreement. I got an e-mail from someone with the following question: "I wanted to ask you about the specific case of public schools, where the staff are adamant that no child's picture can be 'publicized' — a term even more restrictive than 'published' in their minds. Of course, sneaking into classrooms to photograph kids would be one thing. But what about pictures of kids working on a common project outside the school on a weekend — a place

fully public and accessible? Are pictures showing recognizable kids in that situation a problem to publicize?"

First, the photo as described is not publicizing — something has to be said or implied about them, either in text or by the photo itself for it to be so. However, it does provide the basis for additional consideration, especially when children are the subjects.

Consider the case of Jack McClellan, a self-described pedophile, who has had Web sites detailing how and where he likes to troll for children. As reported by the *New York Times*, "he had been posting nonsexual pictures of children on Web sites intended to promote the acceptance of pedophiles, and to direct other pedophiles

to events and places where children tended to gather." Parents were understandably upset and wanted McClellan locked up.

But he had not done anything wrong by posting the pictures and his descriptions of what he advocates. According to the *Times* article, "while posting pictures of children in sexual situations is a felony, posting them fully clothed in everyday situations is not, even in the context of sexualizing them by proxy, so to speak, First Amendment scholars said." Eugene Volokh, a law professor and First Amendment expert at UCLA explains: "The general rule is pictures of people in public are free for people to publish. Now if it is without permission and the person is a child and he suggests the children are sexual targets, you can imagine a court saying this

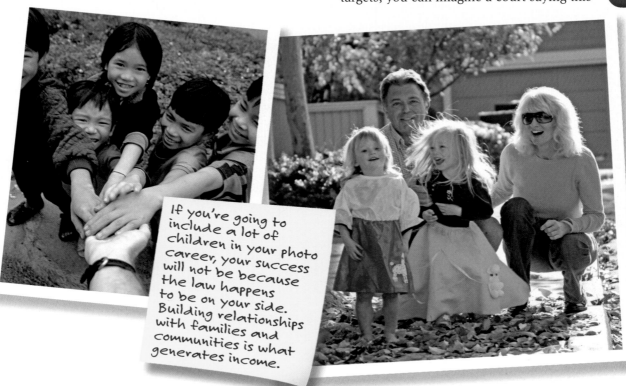

If you're going to include a lot of children in your photo career, your success will not be because the law happens to be on your side. Building relationships with families and communities is what generates income.

is a new First Amendment exception. But it would be an uphill battle." You can find a link to this article at www.danheller.com/model-release-links.html.

Instead, let's say your pictures of the kids in the playground at school were hypothetically part of a news story about interracial children playing happily together. That would be fine, since an observer can clearly see who's who. However, if the story were about gay children happily associating with heterosexual children, it would imply that at least one of the children in the photo is gay, which then raises a concern about publicizing. Although this distinction may appear obvious to you today, consider the example of the interracial children had it been published 50-plus years ago. Back then, it was a stigma in some communities for such a thing to be publicized, and doing so might have invited legal action on the part of one or more of the parents. Community standards change, and you need to

be cognizant of whether any given depiction is not just acceptable to you but in the broader scope of where the photo may appear.

Despite the fact that such an article is clearly an editorial use, it would be really smart to know for sure whether the kids in the photo are gay and if it is something that may cause alarm in your community. Assuming it would be, and if the claim were true, then it might be something that the child (and his parents) might not want to be made public. If it's not true, then there could be a case of libel. If the story inadvertently informed the parents of a true fact they previously didn't know, then all bets are off as to what the legal consequences would be.

Despite all of this, the question of who is liable (for the libel) doesn't change — the newspaper is. If the editors choose to use the photo in association with the story, they're the ones who have to clear it with the parties involved, or to make the editorial decision to run with the story anyway.

One thing to be aware of through these examples is that sensitive matters can be considered so delicate that they could potentially supersede a model release. That is, even if you had a broadly worded model release signed by the children's parents, if they didn't know the photo was to be used for the story in question, the existence (and language) of a model release is largely irrelevant. That is, a broadly worded agreement wouldn't be as solid as a very specifically worded one, making it clear that personal information was going to be revealed.

Indeed, matters of this nature are why companies that make ads for sexual dysfunction drugs never license images from an agency or photographer without specifically seeing the actual written release

"USE"

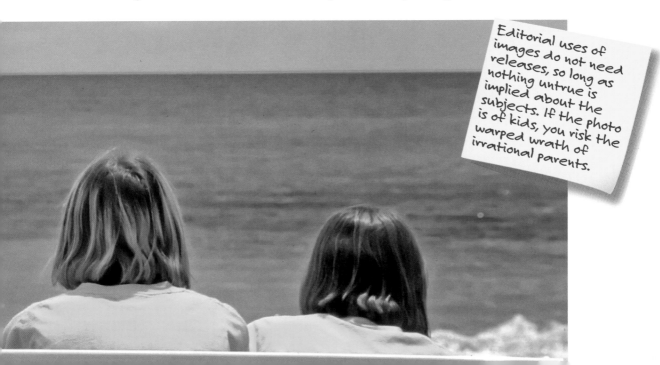

Editorial uses of images do not need releases, so long as nothing untrue is implied about the subjects. If the photo is of kids, you risk the warped wrath of irrational parents.

"USE"

that the model signed. No matter how broad a release may be, it's not a far stretch to see a silly claim made by a model whose fiancée decided to leave him because she was tired of being laughed at by her friends and coworkers because photos of her spouse-to-be were plastered all over national magazines with a quote that reads, "I've fallen and I can't get up!"

When releases are written specifically to be associated with particular uses that are known in advance to be sensitive, the precise use is spelled out so everyone knows exactly what is going on.

Returning to the photo of the children playing at school, if it showed them injecting themselves with syringes, and the caption said, "These kids are on drugs at school," a claim of libel or publicizing may be harder to press, since it would be a statement of fact that is of general public interest. One could even use sensationalized headlines like, "Are Your Kids Safe in America's Playgrounds?!" (Of course, if one of the children is a diabetic, and he's merely taking his insulin, then the publisher may find himself in hot water again.)

Coming full circle: The objections the school raised about the man taking pictures there reflect the reality of the 21st century. Anyone with kids can certainly understand how a school may feel uncomfortable about a man taking photos of the kids and posting them on a Web site. It can be especially frustrating for them if they know there's nothing they can do about it. The least informed person will assuredly be the one to scream the loudest, "You can't take those pictures!" But that doesn't really mean anything. The fact that you're doing nothing wrong should play second fiddle to the more important matter: having a good relationship with people and the school.

Photographing children in other countries is entirely different than in the U.S.A. Parents often highly encourage, if not demand, that you take pictures of their kids.

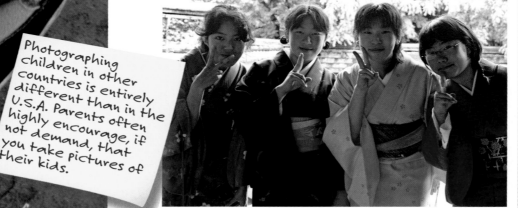

"USE"

"USE"

Self-publishing puts you in the same hot seat as the publishers who license your photos. So, now <u>YOU</u> have to consider the colorful spectrum of scenarios in which you place your subjects.

SELF-PUBLISHING AND SELF-PROMOTION

Although photographers don't assume risk by licensing photos for such uses to others who want to publish them, the act of self-publishing causes photographers to assume the same liability as any other publisher that uses a photo. This is particularly important to address because many people who take pictures and publish them on the Web and are not in the photo business do so with the intent of expressing opinions or advocating particular positions. The general public is almost completely oblivious to the use and need for model releases (especially in this context). As the cost of publishing approaches zero, the growth of this kind of self-expression raises the likelihood that people will inappropriately attribute their ideas to other people or misquote them.

While it's perfectly legal to express your own opinions, it's the implied association you may make with or

of other people that can get you into trouble. Hiding behind the veil of appearing independent and "news-like" is often a mistake that lulls opinion-makers into complacency that they don't need releases from the subjects of their photos.

The problem with personal Web pages isn't the placement of photos, it's the tendency people have for attributing their ideas to other people, or implying untruths about them.

There is one form of self-publishing that isn't subject to this consideration: self-promotion. When you put your images on the Web, in a portfolio or in a catalog to promote yourself, or make the photos available for sale or licensing, this self-publishing is not considered a form of commercial use that requires a release from the subjects of your photos. The general principle that permits self-promotion has its roots in many and varied arguments, but the easiest one to reference is the same civil code cited earlier regarding association. Photos used for self-promotion don't require a release as long as the people in them are not perceived to be

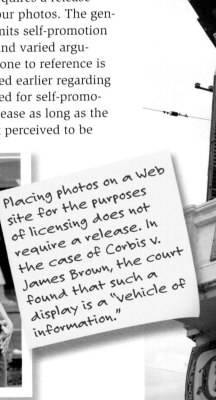

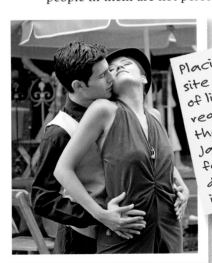

Placing photos on a Web site for the purposes of licensing does not require a release. In the case of Corbis v. James Brown, the court found that such a display is a "vehicle of display information."

"USE"

advocates or sponsors of your business. (If so, you'd have to have a release.)

Now, if it happens that you only sell photos that have model releases, this isn't an issue. But most stock photographers' Web sites show many photos of people who haven't signed releases, and that's okay too — provided that it's clear that the photos being shown are simply examples of your work, part of a portfolio, or designated as items for sale. Such conditions would make it difficult to make the case that any given person in those photos could be singled out as "sponsoring" the site or the photographer. In fact, it's almost always going to be an uphill battle for any photo to be assumed as such, unless there was specific text saying otherwise.

What is also important is *how* a photo was shot — that is, what were the conditions at the time? Were you in a public setting? Was it a private photo shoot? Was it for money? These and many other conditions can trigger the need (or lack thereof) of a model release, sometimes overriding other conditions listed here. The specifics of these are spelled out in Part 4, but I foreshadow those points here because they pertain to self-representation.

For example, professional (and aspiring) models are often photographed under controlled conditions, such as a studio with special photographic lighting equipment, so the use of these photos are exceptions to the more conventional photo taken in less controlled environments, like the public. Professional models often restrict photos from being used on Web sites or in portfolios unless they're compensated because, as you can imagine, it's in their business interests to have ultimate control over if and how they are ever portrayed.

Self-promotion may also include self-sales — that is, you're allowed to sell your artwork.

Whether a release is necessary for sales is stricter than whether you can use those images in self-promotion, only because the scope of the kinds of uses is broader. Generally speaking, however, because you can always sell a photo for an editorial use — one that does not require a release — it implies that any photo can be sold and thus placed on a Web site for sale (with the restrictions of association mentioned earlier).

Also, a reminder of those hot-button issues, such as religion, politics, or any kind of advocacy message: The hotter the button, the higher the risk that a photo of someone can be associated as an advocate or sponsor. For example, if you run a site that sells pictures targeted towards evangelical religious groups, and the site was designed in a way as to suggest that it is an advocate for such views, one of the people in these photos could raise an objection (if there was no release, of course).

As usual, though, you have to take into account the specifics of the case: the photo, the "message," and how the person might be represented or affiliated with it (and the chance he would have an objection). ✦

Analyzing the Need for a Model Release

Part 3 presented the basic fundamentals about model releases, such as commercial and editorial uses, and whether photos of people can be "associated" with an idea or agenda. Using these foundations, the actual analysis of whether a release is required must be done on a case-by-case basis. But, once you gain experience with this, patterns emerge that make it easier to assess scenarios more quickly.

To get started, you have to begin by adjusting your impression — and by consequence, your expectations — on the evaluation process. As a photographer whose business objective is to sell the most pictures to the widest possible client base, a large part of this analysis depends on the type of business you have — or rather, the type of business the people who license your images have. Remember, the release is not there to protect you — it's for those who license images from you — so you need to put yourself in their shoes.

RISK ANALYSIS: THE THREE KEY QUESTIONS

To assess whether a release is needed, ask three key questions about the photo, the intended use, and the circumstances around how it was taken:

- How is the photo to be used?
- Is the subject clearly recognizable?
- How did you take the picture?

THE ESSENTIALS

Although there are no black-and-white rules as to when you or your licensee may require a model release, the three key questions listed in this part act as the basis for analysis:

- ☑ How is the photo to be used?
- ☑ Is the subject clearly recognizable?
- ☑ How did you take the picture?

Note that context can matter, and even change the decision you make. For example, photography done in private settings more often requires a model release, while a photo of the same subject in a public setting would not. As another example, while commercial use typically requires a model release, that's not the case if the subject is not identifiable. Doing this analysis may seem challenging at first, but over time, patterns evolve, and you begin to recognize those trigger points — both for and against releases.

If you or your client determine that a model release is necessary, be sure to compensate the subject; otherwise, the model release contract is not enforceable. Compensation need not be money, but it has to be something both parties consider valuable.

How is the Photo to be Used?

This is always the first and most important question to ask. As shown in Part 3, it doesn't make sense to ask whether a photo needs a model release until you have a specific use for it. Editorial uses usually don't require a release, and commercial uses usually do, but these are only factors that affect likelihood — they are not, by themselves, determinants. Getting used to this fact is tough for many who look for (and, to their peril, depend on) defined rules for when releases are required.

The best way to think about this is the ambiguities of a batter's swing in baseball: Some may think it's a strike, others may think it's not, but it's nothing until the umpire calls it. For any given use of an image, no matter what it appears to you or anyone else, ambiguous cases remain that way until judges rule on them. And even then, they may still not be settled until the appellate court rules, too. If a case is that ambiguous, it's up to the licensee to determine what risk he wants to take (if the photo doesn't have a release).

Deciding whether a photo needs a release starts with how the photo is to be used. But even then, one can walk into a different set of conditions.

ANALYZING NEED

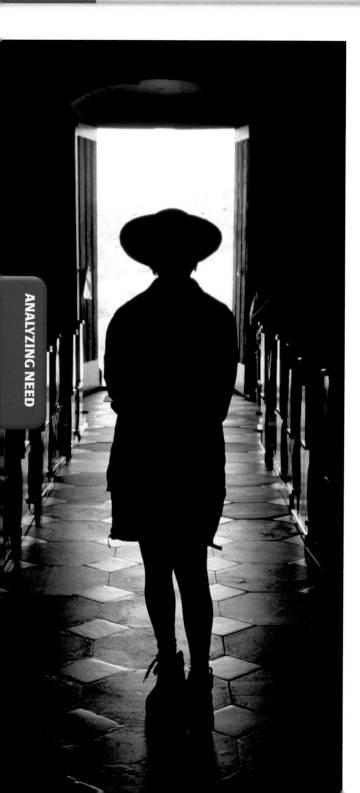

<div style="vertical">ANALYZING NEED</div>

> **California Code Section 3344(a)(1):**
> *A person shall be deemed to be readily identifiable from a photograph when one who views the photograph with the naked eye can reasonably determine that the person depicted in the photograph is the same person who is complaining of its unauthorized use.*

Is the Subject Clearly Recognizable?

To determine whether someone is recognizable, many states follow the principle embodied in California civil code section 3344(a)(1), as shown above. If the subject is not recognizable, a release isn't required. If he is, then you consider the other questions.

If the identifiability is ambiguous, it's still useful to examine the other questions to help gauge the risk, but if those analyses don't yield anything decisive and you're back at this question, the ultimate decision could be made in court by a judge or jury looking at both the photograph and the person in the courtroom. They are the deciders, and no one else. Most people who have an ambiguously identifiable photo usually rationalize in their own favor and never really think about the objective observer's perception. (This identifiability issue applies not just to people but also to protected property as well, as Part 6 explains.)

When you don't have a model release for a photo of a recognizable person (or protected property), one workaround is to digitally alter the image to make the person unrecognizable. "Rubbing out" an otherwise identifiable face is perfectly legal. If you alter the image sufficiently so no one could

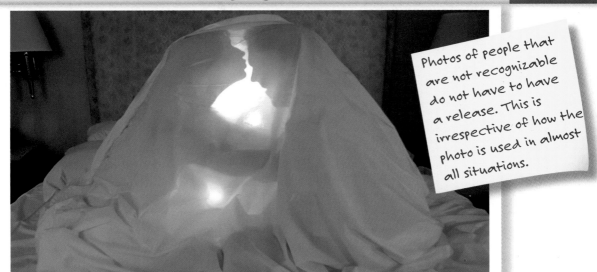

Photos of people that are not recognizable do not have to have a release. This is irrespective of how the photo is used in almost all situations.

ANALYZING NEED

possibly identify the person conclusively in court, a release is not necessary. This happens all the time — far more than most people are aware of. Even (or especially) the subjects themselves.

But this isn't something you should do — leave it up to your licensee. As explained in Part 1, since you are not responsible for how other people use the images they license, you can license an unreleased photo of an identifiable person for a commercial use because you can assume they understand their liabilities. Whether or not they choose to "rub out" a face is not your concern.

Yet, even if the subject is recognizable, there's that old provision addressed in Part 3: *association*. Section 3344(e) of California civil code, shown on the right, illustrates that the nuances are critical, and they affect a great deal more photos

than what most people think. It's not just that the person is recognizable, it's how he is portrayed that matters. This can either be because of how the photo was shot, how the subject looks, or how any text around the photo is used. Whatever the case, if it appears as though the person is directly connected with the message, or could be considered an advocate or sponsor of it, then this argument for needing a release is pretty strong. (Part 3 explains the issues of association in detail.)

California Code Section 3344(e):

The use of a name, voice, signature, photograph, or likeness in a commercial medium shall not constitute a use for which consent is required under subdivision (a) solely because the material containing such use is commercially sponsored or contains paid advertising. Rather it shall be a question of fact whether or not the use of the person's name, voice, signature, photograph, or likeness was so directly connected with the commercial sponsorship or with the paid advertising as to constitute a use for which consent is required under subdivision (a).

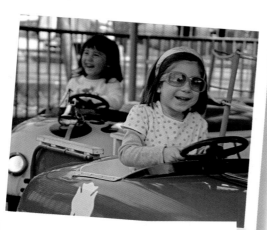

How Did You Take the Picture?

Or rather, how, where, and under what conditions was the photo taken? All of these come into play. Was it a public setting, such as on a street? Was it in a studio? A private home? Did you hire the person to sit (such as a model for an assignment, or for artistic photo shoots)? Does the subject know ahead of time how the photo will be used (if that use was even known then)? Did you provide direction? How much?

The location and context matter because they introduce limitations as to whether a release would be necessary if the photo were to be licensed (again, depending on the use).

Photos taken in public places give the most latitude in their usage because the law states that people give up their right of privacy in these conditions, insofar as photos are concerned. This includes parks, government properties, national forests, streets, and most other outdoor settings. Certain nonpublic places may also apply as well, such as amusement parks, concerts, night-clubs, and other venues where people can be photographed candidly. (There are other issues with photography in these places, covered later.) The point is, in an open environment, anyone can expect to have his photo taken at any time. (Note: Some countries don't necessarily have this freedom, and some municipalities in Canada and some parts of Europe are trying to impose limits. When working outside the U.S., it's important to understand local laws.)

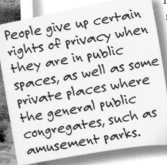

People give up certain rights of privacy when they are in public spaces, as well as some private places where the general public congregates, such as amusement parks.

Editorial uses of photos of people photographed in the public can be published without model releases, even if they are recognizable, provided there are no other restrictions covered in Part 3 or in this part.

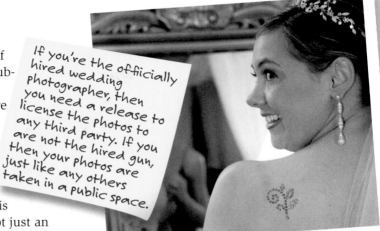

If you're the officially hired wedding photographer, then you need a release to license the photos to any third party. If you are not the hired gun, then your photos are just like any others taken in a public space.

A photo taken in a private setting — such as a studio or someone's home — is another matter entirely. It's not just an indicator that the photo was not arbitrarily taken in public, but that time and resources were expended to bring the subject in and cooperate with the photographer, regardless of at whose expense. It's this setting that gives the person a right to know why his photo is being taken and how it might be used; he has a right to privacy and compensation for the use of the photo, either of which the subject can waive (via the model release).

The two most common examples of people being photographed in a private setting are when:

1 a model is paid to be photographed
2 someone pays the photographer to take his picture

Portrait studios in shopping malls are controlled settings, and people who pay to have their photos taken have a right to privacy that their photos won't be used by anyone else. No uses of any kind by any third party — including the photographer — are permitted without a release from the subject. Even if you ask a neighbor to come over to your studio so you can practice your photography skills, this is a private setting.

ANALYZING NEED

Professional models who have their photos taken often have their own model releases that they have the photographer (or the hiring agent) sign as part of their normal business. However, the lack of a release does not revert rights of usage of the likeness to the photographer or anyone else. As Part 7 explains in detail, the photographer owns the copyright to the photo and the model owns the right to decide when her likeness may be used.

The two ownerships are entirely independent of one another legally, yet entirely *inter*dependent on each other in any practical terms, because there's only one physical photograph (or set thereof, each of which is subject to the same limitations). It's like having Siamese twins: Either they both agree about where they are going, or no one's going anywhere.

The "private setting" conditions affect anything and everything you photograph, even pets, property, and anything else that finds its way into the picture. Despite the fact that animals don't have the same privacy and economic protections that people have, the private setting overrides this unprotected status.

Now, even though the photographer and subject are legally "handcuffed" to one another, unlocking the bond is easily done. For example, say you own a private photo studio in a shopping mall. When customers come in and sign an agreement that allows you to perform photographic services, you can have a clause that has a model release in it. In fact, many studios request at least the right to use the photos they shoot to promote their own business in the store. Some studios request editorial uses of images as well, since the private setting itself normally

If people hire you to photograph them, you own the physical photos, but they can prevent you from licensing them. You're each handcuffed to one another (outside of personal uses) without mutual consent.

overrides even that use of an image without a release. To optimize your business opportunities, you could use a very broadly worded photo release, similar to the one shown in Part 5.

Most people don't take objection to this, because they don't really care how their photos are used, perhaps due to ignorance of the topic. Other times, it's because they may be totally unaware of the release clause in the first place. Most portrait, wedding, and studio photographers aren't in the business of licensing images to third parties, so such release clauses are rare. Subjects who do care, such as actual professional models, may very likely raise objections, at which point, start negotiating.

Do note that "private setting" is not limited to indoor spaces. Even outdoor locations can be considered private if the photos are shot under the same kind of pre-arranged and controlled conditions, which includes weddings and movie shoots. Note: Only the wedding photographer is subject to this limitation. If it's in a public space and visible by the public, anyone else can photograph the people in it and not be subject to the same use limitations as the photographer who was actually hired to shoot. In other words, the photographer

on contract is limited to whatever's in the agreement. Anyone else taking pictures is not. If you are a wedding photographer and want those rights, add them to your agreement.

In less structured photo shoots — such as when you spontaneously ask someone who happens to be standing nearby to pose for a picture because you think it might have licensing potential — you're in gray area. It's not something that can be easily and unambiguously described, but the usual metric is whether the subject was asked by the photographer (or vice versa) to participate in a specific photo shoot for a specific purpose. The less formal the arrangement appears, the less the "private setting" limitations apply in terms of getting a model release.

Where you can drift further into the "public" area, but still remain in private settings, are places like zoos, bars, restaurants, and theme parks. Those places are privately owned but open to the public, and few, if any, restrict photography directly. In most cases, you can consider such photography no different than any other open space. However, the risk goes up if there are identifiable elements that may be copyrighted or trademarked, like

ANALYZING NEED

such as logos and such. Part 6 addresses these issues, but the key concerns boil down to whether the use of the photo implies an association with the holder of the trademark or whether the use of the trademark is being unfairly exploited by financial gain by the publisher (your licensee).

Also bear in mind that you may be subject to an implied contractual agreement as part of your entry fee to these private "public" spaces. Many private properties with public access are trying to protect their commercial interests by prohibiting photos "taken for commercial purposes," an "agreement" they print onto the back of your ticket and that you "agree to" by entering the premises. That agreement may make the whole private/public model-release issue moot by prohibiting any sale of photos, no matter what the use or circumstances.

To put you at ease about this, most such properties are really only trying to keep you from interfering with their commercial activities, such as licensing their own photos of their properties and making posters and postcards for their own gift shops. So, if you happen to have a great photo of an elephant taken at a theme park that can be licensed to a nature magazine, you should certainly feel comfortable licensing it, as long as there are no identifying elements that show a trademark. Without such elements, the recognizability test would fail, and the need for the release is nil.

A side note: Another benefit of restricting commercial photography by theme parks and zoos is to alleviate any liabilities in case a photographer hurts himself, such as in a stupid attempt to get a really great shot of the inside of a polar bear's mouth by holding the camera inside it. Commercial photographers tend to go to much greater — and sometimes ill-advised — lengths than the average tourist to get a great "money shot." Dissuading these people from inadvertently taking themselves out of the gene pool also helps

ANALYZING NEED

Each of these women was paid for the use of these photos if the pictures were taken in a pre-arranged controlled setting, despite the fact that no face is visible, and the poster is a public service message.

Give your breasts the support they really need Do a self-exam.

This year, over a million women worldwide will be diagnosed disease can be successfully treated. So do a monthly self-

MODEL RELEASES AND COMPENSATION

In the U.S., contractual agreements are not enforceable unless there is some form of compensation. That is, one party gets something in exchange for something else. Every contract has some form of compensation, although it doesn't have to be money. It can be services, access to something, or a product you bought. Simply put, it's an exchange.

Model releases are incomplete, and thus unenforceable, if they don't include compensation. What's more, compensation without a release does not imply consent. That is, you can't pay someone and by consequence force them into the contract under the premise that they were compensated — they actually have to sign the agreement.

The contractual requirement of compensation is done to protect people from performing services for free. For example, you cannot sign a contract that says you will wash someone's dishes and clothes and receive no money or other value. If you did sign such a document, but failed to perform the duties, the other person couldn't sue you for failing to live up to your contract — that'd be tantamount to slavery. He's not paying you, so he can't force you to do anything, because the contract is unenforceable. But if the contract said that you would be paid $10 per hour for your work, the employer would legally be able to stop paying you if you stopped working.

Although the law requires that some form of compensation be given, it does not state how much or what form it takes. Compensation doesn't have to be money, which is why many

> You need to give some sort of compensation for any contractual agreement to be valid. There is no law about how much, or what form it takes. Even the benefit of participating in a photo shoot has been ruled as "fair."

ANALYZING NEED

model releases say "for valuable consideration." Because this criterion is vague, most courts interpret it as being whether parties were done in full awareness of what they were getting into. In other words, those who sign the agreement are left to decide whether the value exists. So, if you write into the model release that you will give the subject a fake Rolex watch and the person agrees, a judge would say that's okay.

Of course, it's not always that black and white. If the contract says you'll give the subject a verbal compliment, a judge might have a problem with that. And the item of value must be legal — recreational drugs are not going to look good in a judge's opinion, regardless of how much value they may have. On the other hand, someone who accepted the drugs as compensation is unlikely to file a lawsuit about the matter, unless they're on drugs.

Some people use a physical print of the photograph as compensation for signing a release. This is especially common for shooting emerging models who want to build their portfolio with the fine photography you're no doubt capable of producing. While that's acceptable, and certainly manageable, beware of the time, cost, and effort to do this on a frequent basis — especially

if you're doing grab shots in the streets. For the masses, it just might be easier (and quicker) to just pay them money. A dollar is typical. And while a dollar doesn't seem like a lot of money, this has to be factored in when you start doing a lot of "grab" shooting. Those who dutifully ask people for model releases on an ongoing basis are probably doing it all for naught if they aren't compensating each and every person. Factor this into your risk/reward analysis when you think about how often you really feel the need to ask a subject to sign a release.

Another aspect of compensation is when the release already exists as part of a broader agreement between the subject and another party. A typical example is where one goes on tour with an adventure travel company. Here, the liability release waiver, which usually states that you won't sue the company if you slip and hurt yourself, usually has additional language that allows the company to use pictures of you in its catalogs. In fact, this is part of my business. I shoot photographs for travel outfitters that sell trips to clients who pay to go hiking, biking, or take cultural tours around the world. The advantage here is that the release has been obtained ahead of time, thereby relieving me and everyone else from the hassle of asking them to sign releases during or after the trip.

Last, the money you earn from licensing photos has no bearing on what the compensation is. You could sell an image for thousands of dollars or give it away for free. What does matter is that the subject was compensated. ▓

Dissecting a Model Release

A model release is technically a contract, no different than many that you see and agree to on a regular basis. A rental agreement, the warranty card that comes with your camera, the license agreement that you never read when you install software, even the credit card receipt you sign when you pay for a meal at a restaurant — they're all contracts of one form or another. You're even agreeing to contracts when you're not aware of it, such as posting a comment to a blog or discussion group, uploading a photo to a photo-sharing site, putting something up for sale on eBay, or posting information about yourself on a dating service. Each of these sites has a contract that you explicitly or implicitly agree to the moment you engage in its services. You are almost always offered the option to review the agreement, but few people ever do. In fact, people seem to be increasingly more oblivious to their very existence even when the fine print is not hidden from them.

So, you agree to them, but do you understand them? Are you aware of the caveats of these agreements in the fine print? Perhaps not, but your risk is somewhat lower, because these are mostly benign uses. However, as a photographer, some of your income may depend on your knowing what kind of model release you should have your photo subjects sign, lest you find out later you gave away your house. So, how do you evaluate contracts

THE ESSENTIALS

For photographers engaged in the business of general stock photography, where they license their photos across many industries to many buyers for many uses, the best model releases are those that are as broad in scope as possible, are concise, and are the least intimidating. The sample model release presented in this part not only satisfies these requirements but also provides the most flexibility in case it needs to be altered to fit a new constraint or address concerns or objections by apprehensive photo subjects.

However, this sample model release may not be accepted by those who work in niche industries or by professional models, where there are conventions and standards adhered to by most who do business in that context. For photographers who specialize in these areas, it's imperative to understand all aspects of business conventions, including (but not limited to) the types of contracts employed. Under these conditions, it may be best to adopt boilerplate agreements used by such niche industries.

No matter where your model-release contract comes from, I strongly advise that you try to understand everything you can about any contract you use, because your business depends on your clients being safe.

that use words like "herewith" and "indemnifies" and "irrevocable," which themselves are surrounded by copious comma-separated lists of things? Even if you may understand the words, it's the implications and the meanings that matter more, and if you don't know how it all fits together, those who license your photos may also end up losing their houses, too! (That certainly won't bode well for your budding career.)

Fortunately, there's a brighter side to this: Because the risk of using any given photo is on the licensee, not you, your clients are going to be more likely to use their own model releases when the risk is high.

Although it may not seem so, this is actually a good thing. A very good thing. In fact, the greater the risk, the more likely those at risk are going to handle this responsibility on their own, leaving you with little to do. By consequence, the lower the risk, the more willing licensees will be to use your model releases, which (because of the lower risk) will be simpler and easier

to understand and use. And the best part is — because the vast majority of license agreements will be for these much smaller, less risky publishing uses — what you need to actually do and understand does not require going to law school or dating a lawyer.

That said, you do need to learn something — albeit just the basics — of how model releases are constructed. To help you understand what you need to know for your own business uses, I'm going to cover the various cases where you will be more or less involved in the model-release process, so you can get a big picture of the kinds of uses that you won't be responsible for. That will make it easier to deconstruct the actual generic release that you can understand in the context in which it will be applicable. (Plus, you can walk away with something tangible.)

> Emerging photographers usually only need basic, broadly worded model releases. Specialized shooters (especially those who focus on specific industries) may require more explicit (and narrower) terms for their businesses.

DISSECTING

CONTRACT AUTHORSHIP AND THE SPECTRUM OF RISK

Let's begin with a scenario where you have a photo of a construction worker swinging a hammer and two different kinds of clients that are interested in licensing it. One is a small, local hardware store; the other is the internationally known clothier Calvin Klein. If your photo was used by either of these companies, and the construction worker chooses to file a suit involving the use of the image, the two cases will result in different outcomes. From understanding these outcomes, you can better assess the kind of release that should be used.

For the local hardware store, its use of the image is limited to a small, local community newspaper's advertising insert, making the prospect of monetary damages too limited to bother bringing a suit, regardless of whether there was a model release. Still, the man in the photo could take the case to small-claims court and collect up to $5,000 (in California). That's nothing to sneeze at, of course,

so a release should be considered, but it doesn't have to be bullet-proof — there aren't going to be attorneys using words like "herewith" with that (relatively) little money at stake. It'll be the construction worker versus the hardware store, and maybe versus you.

On the other hand, Calvin Klein could be on the hook for gazillions of dollars if the language in the release was poorly written, or if there wasn't even a release in the first place. Such an error could allow the construction worker's lawyer to lunge from one end of the courtroom to the other in a single leap and eat the other lawyer alive, suit and all, possibly causing several jurors to cry.

For these reasons, the lawyers for Calvin Klein wouldn't license a photo that didn't have a rock-solid model release. In fact, when the potential liabilities are this high, they probably wouldn't even use a photo where the subject didn't sign their release. They will do their best to

The spectrum of risk for how a photo is used is inversely related to the likelihood that your release will be acceptable by a client. And the more money that's at stake, the higher the risk.

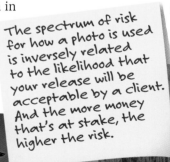

assure that the contract is very precise about the specific terms of who gets what for how much, what's permitted, and what's excluded.

Essentially, there is a spectrum of risk, where the greater the potential monetary damage (from the licensee's point of view) or reward (from the subject's point of view), the higher the risk and thus the more importance of the model release's terms and conditions.

This spectrum of risk can be broken down into four sections, each of which will require different levels of your involvement for the acquisition and execution of a model release.

1 If this is a work-for-hire assignment, where the client owns all rights to the photos you shoot, you are nothing more than a technician on the job, so there is no reason for you to act as a legal representative for the client by assuming control of the model-release process. Have the client provide the release. (The client may even opt not to use a release at all for this shoot — whether you think that's wise; that decision is up to the client.) And if/when a release is produced,

do not assume this is a good release, a solid release, or a representative release used throughout the industry. It is not your place to comment on it. Over time, you will invariably find great differences in the releases that pass by your eyes, each of which may have merits and risks that pertain to your given client. See Part 7 for more on the ramifications of work-for-hire agreements.

2 If this is not a work-for-hire assignment (so you get to keep the copyright of the photos you shoot), you can have the release assigned either to you (see the sample release later in this part) or to the client. If the release is extremely specific about the client and the use of the image, it's of no use to you whatsoever: Have the assignee be the client. If you can provide the release, or if it's open-ended enough that you can use the images in the future, see items 3 and 4 below.

3 If you are a freelance photographer and not on assignment for a specific client but instead shooting photos for anticipated use as part of your ongoing stock-photo inventory, you will want

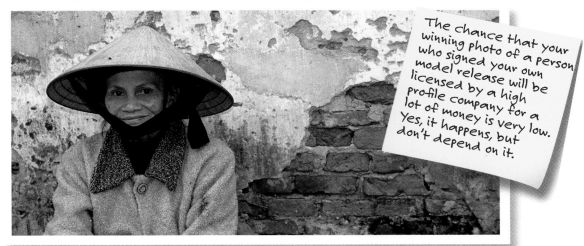

The chance that your winning photo of a person who signed your own model release will be licensed by a high profile company for a lot of money is very low. Yes, it happens, but don't depend on it.

DISSECTING

DISSECTING

the model release to be assigned to you so that you can license the photos in the future as opportunities to do so arise. The question now is: What kind of release? To answer this, there are two considerations: First, if the subject of your stock photography business focuses on a particular industry, know and understand the standards and conventions used by that industry, including the language and style of their contracts (such as model releases). Future licensees of your photos will be happy that their own lawyers can sign off on them, which makes sales better for you. Second, some industries, such as fashion, glamour, and especially (ahem) pornography each have (or require) very specific language that adheres to the industry's business practices and legal contexts. For such industries, use templates that are known to be standard. Other industries, such as film, media, and sports, have unions that permit only specific contracts to be used for specific circumstances, in which case, your job is easy — they define the releases you can use.

4 If you are a freelance photographer with no specific use or focus in mind for the photos you are about to shoot (for example, you're on vacation), you are on your own. But the good news is, this is the easiest type of release to find or even write yourself. And best of all, these are also the easiest to get other people to sign (well, other than professional models) and to present to prospective clients that license your images.

It should be noted that for the first case, stay as clear from the model-release process as possible. Otherwise, you'll become involved in a legal arrangement that can only add risk to your business.

That said, the real world is full of clients that heavily rely upon photographers to take care of such things, although the companies who do so underestimate their legal liabilities. Therefore, it is not uncommon for photographers to involve themselves in getting releases on behalf of their clients for assignments; my recommendation against it is more idealized advice than it is a reflection of the real world.

Most photographers (from pros to consumers and everyone in between) will fall into cases 3 or 4 (or both). Even wedding and portrait photographers, pet photographers, photojournalists, and art photographers all have opportunities — whether they know it or not — to take and license photos outside of their usual lines of business, which puts them in case 4, at least for those uses. For case 3, your clientele and projected use scenarios will tend to steer you to specific model releases that already exist. For case 4 — where most beginners and "sideline" photographers fit — the only kind of release needed on a practical level is the most basic, rudimentary kind.

DISSECTING

YOUR OWN MODEL RELEASE

You are now in the market to find or craft a model release that you can use for your own licensing business. Where do you start? Like most emerging photographers, you usually start when your first licensing opportunity comes up. So, let's say you have a client that wants to license a photo of a woman washing a car in the next edition of a magazine insert for a local newspaper. It would seem straightforward to have the release state: "I, Jane Doe, permit the attached photo to be used in this Wednesday's edition of *Auto Shopper* newspaper insert."

While that would certainly work, the most important thing for you to think about when crafting releases is your future business opportunities: A stock photographer's goal is to license pictures in perpetuity to many clients, so you want to have a release that's open-ended enough that it can be used over and over in different ways.

For these reasons, it's not necessarily a good idea to state precisely how the photo is going to be used for any given client or use, even if you could state so at the time of signing. Of course, professional models who make money on their pictures do want releases to be very specific about the use, because they don't want to lose future modeling opportunities when you have new clients (even if it's the same

Stating the specific use for how a photo may be used within the text of a model release may make the photo's subject happy, as well as your client, but you'll limit your own longer-term sales opportunities for the image.

DISSECTING

Boilerplates Gone Bad

photo to be used for another client). If you're working with pros, or are at least restricted in the kind of breadth you can have, you're going to have to work it out separately. But that's a different world than what most photographers live and work in.

What most photographers (and models) do is to look for boilerplate agreements. They search books and back-alley photo discussion forums, and usually end up with some full-page (or longer) draft agreement from who knows where. Most forum members don't understand these templates (although they speak as if they do), yet they make assertions that such templates are "de facto standards" and that "everyone uses them." Such claims are

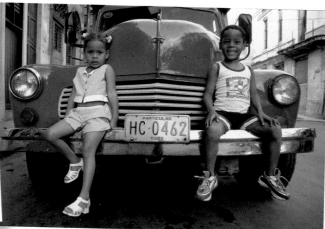

usually false, with the possible exception of the industry-specific forms noted earlier (though I would still advise caution in accepting such statements, unless you are intimately familiar with that industry and can know for sure).

It's not that there's anything wrong with boilerplate releases from a legal perspective — they're usually okay. But because all that's really needed is a very basic contract — even one that you may need to modify for specific considerations — almost all such templates are going to be overkill, and that in itself presents problems. It's sort of like using an elephant gun to shoot a mouse: You will hit your target, but cause a whole lot of other damage in the process. And the extent of the damage from using a template you don't understand can affect you in ways you likely can't anticipate.

These risks have to do with business realities, not with legal matters. For example, the likelihood that potential subjects won't sign the typical boilerplate model releases is higher because they are intimidating, they are hard to explain to people (including licensees), they are impractical for most "grab" shooters in spontaneous environments, and they often contain language that really belongs in the license agreement for using the image, which should always remain completely separate from the model-release agreement. Entangling different licensing contexts into one agreement is a sure-fire way to create havoc later.

In short, template releases are like placebos: The only protection they provide is relief from the self-induced psychological fear of being sued. And because that likelihood is next to zero anyway (because it's the licensee that's on the hook), photographers who use them mistakenly ascribe the fact that nothing bad happens to them as proof of their effectiveness, perpetuating their use (and the misinformation about them).

Boilerplate model releases "can" be OK, but you don't want to rely on a contract that commits you to terms you don't expect. It's best to start with a clean, empty slate, and fill it with terms you know and understand.

A SAMPLE MODEL RELEASE

For valuable consideration received, I hereby grant to _____ ("photographer"), and his or her legal representatives and assigns, the irrevocable and unrestricted right to use and publish photographs of me, or in which I may be included, for editorial trade, advertising, and any other purpose and in any manner and medium; and to alter the same without restriction. I hereby release photographer and his or her legal representatives and assigns from all claims and liability relating to said photographs.

Name: _____

Address: _____

City: _____ State: __ ZIP: _____

Phone: (_____) _____ - _____

E-mail: _____

Signature: _____

Date: _____

This model release has survived scrutiny by the courts! See case: Bonner v. Fuji Photo Film. The article and text of the ruling can be found on my site's "links" page for this book.

A Simple Sample Model Release

Believe it or not, writing your own model release is not only easier than you think, but doing it yourself gives you so much more flexibility because you arm yourself with knowledge that allows you to alter the release if necessary. More important, you are in a better position to negotiate the terms more intelligently. And negotiations will happen.

In crafting any legal agreement, there's one rule that almost always applies: Don't make things more complex than they need to be. In that spirit, I use and recommend the model release shown above, which will do the job you need for those occasions where you don't need to use someone's specific agency or industry model-release contract. But before you open your word processor to draft your first model release, let's review the objectives of this simple one:

☑ To cover all possible uses for a photo, to allow use by future licensees.

☑ To be as easy as possible for anyone who reads English to understand.

☑ To be as brief as possible, so as to avoid legal confusion.

☑ To appear as unintimidating as feasible.

These are the most important factors in having a useful, enforceable release, and one that has the highest likelihood of being signed (or can be easily modified to be). With that, you can now craft real language. The sample model release has the following key text segments:

1 "For valuable consideration": Contracts are invalid unless the person signing them gets something in return. (For details on this, see Part 4.) If you already know what the payment is, write it in. If it involves an agreed-upon royalty rate, or any other customized provision, state it in this section. The brevity of the language used here is due to the fact that the

compensation isn't yet established; you can determine the details later and separately, such as via an addendum or even stated, "as per agreed upon in e-mail." In fact, a receipt is good enough. Formality is less important than mutual agreement. Clarity is important. Personally, I just use the above release as is, unless the subject wants it stated otherwise. No sense in doing more than necessary, and this works.

2 "I grant to [your name here] and his legal representatives and assigns": This is the part that allows you to license the photo to other people (your clients that license your photos). They become the "assigns" in this release. If you're on a work-for-hire agreement, use the name of the employer here.

3 "the irrevocable and unrestricted right to use and publish photographs of me": The "irrevocable" part means they can't change their minds later, and the "unrestricted right to use" part means that they are placing no restrictions on *your* rights, not the

Copying and modifying an existing model release may result in something that appears the same, but it's what you don't see inside that makes all the difference.

usage rights. This section is to get around subtler statutes within some state laws that supersede more permissive (to the photographer) federal laws. If the subject is under 18 years of age, then change "me" to be descriptive: "my son, Jason, who is 12 years old." In that case, the signatory is the parent, not the kid. If the subject is not a person but an item protected by copyright or trademark (see Part 6), then describe the item here (or attach a photo).

4 "for editorial trade, advertising, and any other purpose and in any manner and medium": This means you can literally do anything with it (and so can your assigns). Mentally bookmark this point; it may need revision on a case-by-case basis.

5 "and to alter the same without restriction.": In other words, you can Photoshop the subject's head on the body of an elephant, and the subject can't sue you or your assigns.

6 "I hereby release photographer and his legal representatives and assigns from all claims and liability": Bingo! That's the secret sauce. Without this, the rest of it is moot. This language should never change.

If you had such a release signed by a subject, anyone interested in licensing the image could use it for anything, making your sales opportunities infinite. Clearly, this is the best of all worlds — you optimize the number of people interested in licensing your photos because your release gives them the most protection.

Another advantage of a simple, easily understood contract is that a judge factors into his ruling whether the parties involved knew what they were signing. And that is an important, but separate, consideration: If the subject can't read — or at least, not the language the contract is

The freedom you have with a photo that has a broadly worded model release is virtually limitless, so long as you don't try to harm someone. No release can protect malice.

written in — this will have a great effect on its enforceability (usually in the subject's favor). For subjects who aren't native English-speakers, having accurate translations of the agreement would be wise. No matter a person's language skills, it helps that short, simple, plain-language contracts are easier to understand. There's less room for legitimate confusion or dubious claims of not understanding what they signed.

Last, one of the best aspects of this sample release is that it's short enough to print and place in a wallet or pocket, like a stack of business cards. It's common for photographers to carry around many photocopies of this general release and hand them out as needed.

REVISING A RELEASE

What's the downside of this simple model-release agreement? Oddly enough, it's the very thing that makes it so good: It's sweeping in what it grants. In fact, it's so encompassing that the most common objection you'll get is that it provides unlimited and unrestricted use of someone's likeness, which may make some people uncomfortable. Mind you, most people won't have a problem, and they are likely to make up the bulk of your photo inventory, so it's best to use sweeping releases when you can.

As an example of how some people will sign anything, consider an interview conducted by Brooke Gladstone, host of National Public Radio's *On the Media* program, a radio show that talks about how the media business works. One on show, she was interviewing a producer for a reality TV cop show. During the show, sample footage was described of a drunk driver barreling through a set of mailboxes and careening into someone's living room. Later, the guy gets out of the car, his face clearly visible before the police dog-pile him in their arrest. Because the guy's face is visible, he must have

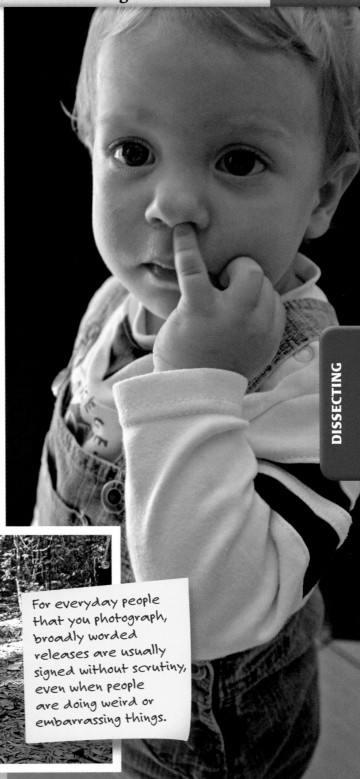

signed a release for the TV show to show him (because reality TV shows are not editorial, but commercial). To this fact, Gladstone asked the obvious question: "How do you get the people you videotape doing illegal acts to sign model releases for your TV show?" To which the producer replied, "People are incredibly stupid."

Unfortunately, not all your subjects may be as … accommodating. Wealthier people are more apt to scrutinize documents before they sign them, and they may give you pushback. And certainly professional models wouldn't touch this sample release with a ten-foot pole. For some, there may be privacy concerns. In all these cases, the concern will likely be due primarily to the broad language in the fourth part (the one I had you mentally bookmark), where it says, "any purpose, in any manner and medium." If any part of the release has to be modified, chances are it'll be that.

For everyday people that you photograph, broadly worded releases are usually signed without scrutiny, even when people are doing weird or embarrassing things.

DISSECTING

For whatever reason you may need to narrow down the scope of the release, the technical part is very simple: Just cross out what you (or they) don't want and write in new wording you both agree to. (You can even write on the back, and even in crayon.) Each party should initial the changes so it's clear they were agreed to, not made by you or the subject later. Neither the original release nor any changes have to be approved by a lawyer, a court, a notary, a witness, or anyone else but you and the subject.

While modifying language is technically simple, the real work is in negotiating the new wording. As before, you want to be cognizant of what the subject wants while keeping your business objectives in mind. For example, if the intended use for the photo is for the Acme Sports catalog, you could revise the release to say, "to be used only for Acme Sports catalogs," but that's making the same mistake I pointed out before: It excludes all other uses, thereby limiting your licensing potential in the future. If this is the only way you can get the subject to sign the release, then so be it. (Again, professional models.) But it'd be more preferable for a stock photographer to use more permissive language.

My general advice is to try to find that middle ground of appeasing someone's concerns (or financial interests), while trying to keep the terms of the release as open as possible. This is best achieved by writing in *exclusions* for those concerns expressed by photo subjects, rather than inclusions of the narrow list of things they do want. For example, exclude geographic regions (such as, "not to be used outside the state of New York"), or certain industries (such as, "excluding uses by political or religious institutions"), or publications (such as, "not to be used in the *National Enquirer*"), or types of media (such as, "not to be used in video games").

The point is, if you get pushback from someone about the language of the release, find out specifically what they *don't* want to happen with the photo, and write that in — try to avoid being specific about what they do want. (If this negotiation seems to be more about the subject getting more money, consider whether the licensing opportunities justify it. This may be hard to gauge if you're not already

working as a stock photographer.)

So, let's return to that school soccer game in Part 1 where you photographed the kid kicking a winning goal. If you ask the parent to sign a release, the parent may start out by insisting that it only be used for the school newspaper (which wouldn't require a release anyway), but you could counteroffer by limiting its use to local merchants (where the comfort level is higher because people know each other). "C'mon, Frank! Help the community!" (Scribble, scribble, scribble.)

When crafting a good model release, rather than include only those things you want in the release, exclude those items that the subject would prefer to NOT be in the release.

DISSECTING

DISSECTING

CONSIDERATIONS FOR EDITORIAL USES

Speaking of the school newspaper and the lack of need for a release, this dovetails with the other objective about optimizing your potential client base: Even though you may end up with a limited release, you can still license the image to anyone for editorial purposes, regardless of whether it's the school paper or the *New York Times*. The fact that you have a release (and what it says) is irrelevant for editorial uses. (Part 3 explains the distinction between commercial and editorial uses.)

So, if editorial uses don't require releases, why does the simple sample release specifically mention "editorial trade"? There are two reasons.

First, you may recall from Parts 3 and 4 that the conditions in which some photos are shot may restrict usages — even editorial ones; namely, pictures shot in a private setting, such as a paid photo shoot in a photo studio (such as a portrait store in a mall). Having this wording in the release alleviates that restriction.

Second, there is also the issue that some editorial publishers can be extremely conservative in their own risk assessments and prefer to be "extra safe." Publishers don't like being sued, even if they've done nothing wrong, and one way to reduce that risk (or so some believe) is to license only photos that have model releases that stipulate editorial uses (even though such uses don't require releases). Whether this actually deters a determined, litigious person is unclear, but it may reduce expectations of a high settlement or cut a lawsuit short. At any rate, it satisfies the publisher, and that helps you get business. Just keep in mind that it's a *business* strategy, not a legal one. ❖

Dealing with Photos of Property

In previous parts of this book, much of what I've presented about model releases involves photos you've taken of people. But the subject of a photo doesn't have to be a person; it can also be a thing, and a release may be necessary to publish photos of it if certain conditions apply.

If you're like most photographers, you're thinking ahead and saying to yourself, "property release," because that's a term commonly used in association with buildings, the most popular kind of thing that photographers get releases for. But there's nothing unique about buildings themselves. In fact, photos of them require releases only if they are trademarked, and then only under limited conditions.

The reason most people think releases are necessary for buildings is because of a perpetuating cycle of capitulation: The problem finds its roots in companies that overly assert infringement claims, which causes publishers' lawyers and other advisers to tell their clients, "If you really want to avoid a suit, just get a release," which then feeds the misinformed rumor mill on the Internet that both photographers and publishers alike require releases of these things (regardless of use). The more this cycle continues, the more misinformation perpetuates. And that's exactly what the trademark holders want, as it gives them more control than they are legally entitled to.

At the core, there is a legitimate reason for companies' overprotectiveness: Companies have a big stake in their reputations and other values engendered by their products, so they don't want anyone to either take advantage of such value for their own profit, nor do they want someone to devalue their reputations by misusing or misrepresenting their trademarks or copyrights. And that's just what's on the fear side.

On the greed side, there's new money to be made in an area where there was less to be made before: licensing. In a world of celebrities, icons, and all sorts of social fads and fashions — combined with the global nature and immediacy of the Internet — there is a great deal of money to be made in licensing known brands. And the way to increase this revenue is to be very assertive about preventing unlicensed uses — even legitimate ones.

So, for these two reasons, most (if not all) companies have every incentive to be as protec-

tive of their brands and designs as they can, and no incentive to permit otherwise legal uses of the same. There is no penalty for asserting an infringement claim, but only an upside by either winning in court or having the defendants capitulate (whether out of ignorance or because they can't afford not to). In fact, a 2007 *New York Times* article reported how this has become a greater problem of late, further sowing unnecessary fear and doubt among photographers and licensees alike over when releases are genuinely needed. A link to this article can be found on my Web site, at www.danheller.com/model-release-links.html.

Here's the hitch: The laws that provide such trademark and copyright protections are written differently than how these companies have been acting on them. The law is very specific about two things:

1 Only humans have the unique right of privacy and publicity, not pets, homes, trinkets, or anything else.

2 However, property can have similar protections if it has have been copyrighted or trademarked, but only under narrowly defined conditions.

Photographers and Publishers alike have naively assumed that photos of property of various kinds require releases. But this is mostly due to a slowly evolving trend by trademark holders to convince them of this.

It's this middle ground where a given use of a given photo may be an infringement that would require a judge's ruling to decide the answer.

For all practical purposes, that decision will ultimately find its basis in whether there is a direct or indirect "association" implied by the use of the photo (between the mark's owner and the publisher), and if so, whether there has been a direct economic effect on either party. Yes, just as with photos of people, where a model release is required if one can draw an association between the subject and the idea or product (etc.), the same concept can apply to photos of protected properties, but again, under much more limited conditions, largely due to the necessity to prove an economic benefit or harm. Similarly, the metrics for these assessments are quite different, involving many more variables, each of which may be subject to different exceptions and other details that I'll cover soon.

Companies that have well-known trademarks want protection from misuse, and to prevent others from unfairly profiting from them.. They also make money by licensing trademarks.

PROPERTY

THE ESSENTIALS

Although copyrighted and trademarked items enjoy sweeping protections, photos of them often don't invoke those protections. As the one selling photos, your risk is virtually nonexistent, unless you're in the business of self-publishing. The *licensee* of your photos has other issues. By law, the actual conditions where releases are necessary are so limited that, practically speaking, only direct competitors or those trying to materially benefit themselves or harm the trademark's holder would qualify as infringers.

But, with the already copious use of the threatening letters to impose restrictions on copyrights and trademarks by their holders, the business reality is that assessments need to be made based on other, less "legal" criteria to determine whether a release would be advisable.

In general, here are the questions to ask:

- ☑ What's the business relationship between the user of the photo and the copyright or trademark owner?
- ☑ What association is implied about the item (in the photo) and the two parties?
- ☑ What's the financial impact on either party as a result of the photo being published?

Answering these questions yields a risk assessment that the licensee (not the photographer!) needs to consider in determining whether it wants to risk using the picture without a release. The costs in time and money in seeking a release for such items is often more expensive than you realize, because trademark owners will almost always request money in exchange for granting a release, and that's after you manage to find them in the first place (which itself can take considerable time and effort).

Of course, if the use of the photo is editorial, there is no concern at all. And there may be uses considered to be editorial (for copyrighted items) that you might not realize, thanks to the fair-use doctrine.

So, there are three ways to look at photos of "property" in any of its forms: First, there is no law specifically addressing *photos* of property — it is only protected either by copyright or trademark law. Where photography is involved, as will be discussed below, it is usually so minimal that there is virtually no concern for infringement, unless someone is genuinely trying to do something intentional to infringe. It's not necessarily the photo itself that sparks the trouble, but the text associated with it. Second, where there can be infringement, the law is so very clear on matters of copyright and trademark infringement (as opposed to privacy and publicity laws that apply to people, where the law is more vague), that the photo would have to be used in a way that would cause confusion about who is the origin for a good or service. That, or again, a deliberate exploitation of a brand for the purpose of either making money from it, or to harm it. Third — and this is the real-world wake-up alarm that brings the other two together — it's the increasing use of infringement claims (some baseless, some not) that is inadvertently creating a wider middle ground gap and affecting behaviors of licensees. Of the tiny percentage of cases that actually make it to judgment in court, the majority have such unique or unusual circumstances, that there is not yet a set of broad, sweeping precedents that would overturn what is currently widely understood about the subject.

Still, despite the fact that no laws have changed, legal experts see the trend of infringement claims anyway. The expression being used in the industry is "legislation through litigation." In other words, if you can't get your way by law, litigate. A lot. When you want to change the behaviors of the general public, either method works. And indeed it has: Most people (photographers, publishers, and lawyers not directly involved with copyright and trademark law) usually believe that photos of things like buildings need releases, resulting in exactly what the

PROPERTY

For trademark and copyright holders, protecting the property from economic harm or exploitation is vital to their businesses. It makes sense to be assertive.

companies want: publishers backing down to avoid the expense of having to defend themselves, and instead choosing to license the copyrighted or trademarked item, even if they wouldn't legally need to for the use in question.

So, with all this as a backdrop, you'd think that the risk to the photographer is higher as well. Fortunately, this isn't the case. This risk is still borne by your clients as usual; they assume liability for any photo they publish or text they print. But there's even good news for them, too. Most of the problems that occur are virtually limited to very high profile uses with lots of money at stake. Though it's because of these high-profile situations that give people a disproportionate sense of fear in the general case, there remains one small fly in the ointment: There's still risk. Minimal though it may be, the costs for losing can be high. In fact, I characterize the landscape as analogous to flying in airplanes: The odds of a plane crashing are infinitesimal, yet the results are usually catastrophic. So, getting sued over the publication of such photos and losing the case in court is extremely rare, but if it does happen, it's not just "a simple misunderstanding" that's remedied by paying a minor

PROPERTY

fine. Damages are statutory and can be quite high. And, since licensees of such photos tend to be "companies," these awards could be catastrophic. With the widening gap between what is clearly permissible and what is clearly an infringement, licensees may need to either be more cautious or consider paying the license fee to a trademark holder as a form of "insurance."

> For photographers and publishers, use of images that may contain copyrighted or trademarked items should not itself be of concern. It's whether there can be an implied "association".

In deciding what business decisions you or your licensees make, understand that the spirit of the law is to give companies protection for their trademark or copyright, but not so much protection that a company could arbitrarily stifle competition or impede the normal course of business in other (unrelated) industries, editorial commentaries, or artistic expressions.

Before getting into the implications of copyright and trademark protections on model releases, it's critical to understand just what these intellectual-property mechanisms are meant to protect.

PROPERTY

UNDERSTANDING COPYRIGHTS

At its essence, copyright is about protecting expression: the specific writing, music, rendering, or other creative effort. Of course, there are many subtleties to understand, not the least of which is the fuzzy boundary between idea and expression.

Copyrights Protect Expression

Copyright does not cover ideas, just the specific expression of them. Ideas are protected through other means, like patents. And you can't photograph intangible things like ideas anyhow. In fact, the law specifically states that a copyrighted work must be in a "fixed and tangible medium for at least some period of time, no matter how brief." This even includes a dance. Note: Improvisational dance cannot be copyrighted — it has to be a choreographed sequence that is then repeatable through performances. This is important to know when photographing performances and then licensing those photos.

The law is very tough about protecting copyrighted items, though it can be a tad fuzzy regarding what <u>can</u> be copyrighted. Ideas can't, but physical expressions of them can.

Religious views can be copyrighted so long as they take the form of a written work or a structure or design. Though most religions don't care about copying — they encourage it.

It may surprise some people that religious views can be copyrighted because they are *expressions* of, yes, creative ideas, thought up by people and disseminated through documents. Courts continue to uphold a religion's right to copyright its teachings, as evidenced by the copious use of litigation by the Church of Scientology, which has continually won copyright infringement cases. (For more information, see www.danheller.com/model-release-links.html.)

Copyright does not protect facts — remember, only *creative works* can be copyrighted.

Scientific facts cannot be protected by copyright; only creative works can be, such as space ships and little green men from outer space.

So, while the text you are reading here is copyrighted by me because I am expressing them in my own unique way, the *facts* that I'm talking about are not subject to copyright. Same with math formulas, scientific findings, and events in history.

It is also very important to note that the degree of protections that copyrighted items receive vary on a number of issues, ranging from the type of work to the nature of its physical forms. For example, clothing is protected similarly to how photos are: Only the actual, physical design is copyrighted. Thus, similar-looking knock-off products are not infringements. We see this all the time in discount stores, where high-end apparel created by famous designers often have their products copied and sold for a fraction of the price under different labels. These knock-offs escape copyright infringement because they are produced not from the actual, physical design schematics but by

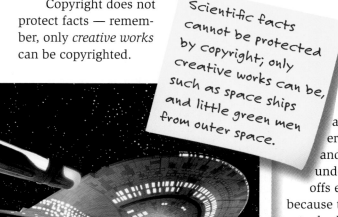

visually examining the products and creating new products "inspired" by the originals. (In almost all cases, photos of them.) This is in stark contrast to music, where songs can infringe upon the copyright of other songs if they merely sound similar to the original.

When Being Inspired Is Not Copying

When I say "inspired," you may be thinking "derivative work," which would be subject to copyright infringement. But these are two different things. Derivative works are those where the new creation is derived specifically from the original source. In music, a truly derivative work in music would be using an actual recording of a song as part of a new composition. If portions of the original work are audible and recognizable, the new song is a derivative work, and is therefore subject to copyright infringement on the source (provided that permission wasn't granted). You may be familiar with mash-ups, which are derivative works from various other sources that are mixed together to create new songs.

In photography, you can copy an image and modify it by changing colors or cropping it, or doing something as simple as removing dust from a scanned copy. These are all derivative works from the original copyrighted work.

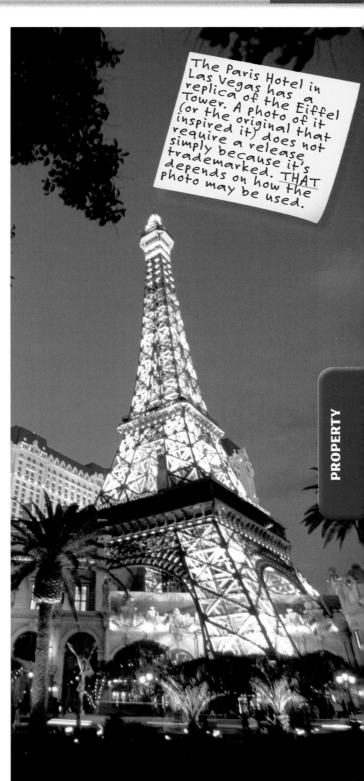

The Paris Hotel in Las Vegas has a replica of the Eiffel Tower. A photo of it (or the original that inspired it) does not require a release simply because it's trademarked. THAT depends on how the photo may be used.

PROPERTY

But an *inspired* work is not protected in photography: You can take the exact same picture that someone else did and not be subject to copyright infringement. Or can you?

Turns out, it's highly dependent on the judge and whether he truly considers it "unique." The classic view of the Golden Gate Bridge shown above is so common, that no one could claim that "it" is unique. As importantly, it's an obvious picture that anyone who goes there would eventually discover on his own. In fact, this is a critically important distinction.

The case of Fournier v. Erickson, 202 F.Supp.2d 290 (S.D.N.Y. 2002) involved a photo (left panel) that Microsoft was going to license, but negotiations broke down between the ad agency and the photographer, so the agency hired another photographer to do a similar image (right panel). The original photographer sued, claiming that his idea was stolen. The

judge agreed, ruling that certain elements of the photo were protected, such as lighting, composition, and so on.

What do we learn from this? Well, as the Internet rumor mill would have you believe, the idea is protected—end of story. While true, that's not really the whole story. The problem with cases like this is that a judge can clearly see the intent of the parties: The agency that was representing Microsoft was clearly trying to side-step a higher fee, but move forward with the idea that the fee would have paid for anyway, by having a new photo shot. This isn't right, so the judge granted the copyright infringement based on the fact that the idea is protected.

But let's be honest. Similarities in photos can be entirely arbitrary and occur out of pure happenstance, in which case, a judge would probably never have ruled the way he did. If the agency instead had chosen a number of similar-looking images from a catalog, and these same two were among many, it's highly doubtful that the copyright infringement claim would have been favored by the judge. The larger lesson here is not so much that photos can be "protected" because of their creative ideas, but more that the case to prove is that there was malicious intent. Though it's true that someone's unique idea can be copyrighted, it's more true that the law written for copyrights specifically indicates that "ideas" cannot be protected, only their specific expression of them. It's when people try to maliciously play the system

Louis Psihoyos' highly orchestrated photo of a curved wall of TVs was reproduced by another photographer for an ad by Apple Computer, triggering a copyright infringement claim.

in the manner represented by this case that judges have no choice but to make rulings the way they do.

It is for this reason that courts have ruled in favor of infringement claims for photos that are similar-but-different if the original is so unique that another of a similar kind could have only been made with the specific intent to copy it and sell it. (If it weren't for sale, there wouldn't be a claim.) How can one be assured of such an intent? This is where the term "highly orchestrated" applies. There are many photographers who go to great lengths to set up models or furniture or many other artifacts in a particular way that can only be repeated if another photographer was clearly intending to copy it.

An example of a highly orchestrated photo would be Louis Psihoyos' photo of a wall of 500 computer monitors in a circular formation. Apple Computer wanted to license it for a marketing campaign for its new Apple TV product but backed out of negotiations at the last minute. It used the idea anyway (via another photographer), so Psihoyos sued.

Once again, it comes down to intent. If it looks like you're copying someone's idea because a client likes a particular look, that's dangerous. Advise your client of the risk. You, yourself, have no risk, just as the photographers in the above scenarios weren't liable. But your relationship with the client can be better if you advise them well.

PROPERTY

I shot this picture in 1997 in Yellowstone, yet, I had no idea that the exact same picture was shot years ago by Annie Griffiths Belt, a National Geographic Photographer. Yes, coincidences happen.

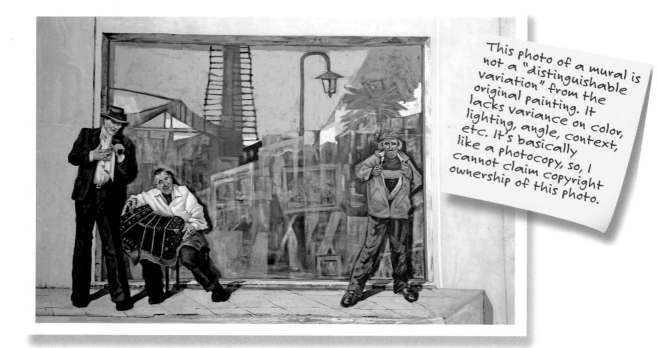

This photo of a mural is not a "distinguishable variation" from the original painting. It lacks variance on color, lighting, angle, context, etc. It's basically like a photocopy, so, I cannot claim copyright ownership of this photo.

Though this photo is of a protected, copyrighted painting, I own the copyright to this image, since the way it was taken is a "distinguishable variation" from the original work.

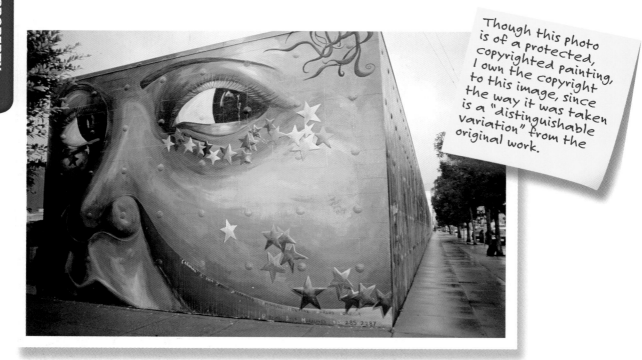

Interestingly, there is the yet unanswered question of whether photographs of copyrighted items are the same thing as the items themselves. Is a camera more like a copy machine, where the photographer merely pushes a button and gets a copy of the work? Photographers would vehemently dispute this, but the question is not so straightforward when examining a photo of another photo or of a painting.

At what point is a photo genuinely a unique and creative work separate from the work depicted as its subject? This question was put to test in the case Bridgeman Art Library v. Corel Corp. The library brought a copyright infringement action against Corel based on the inclusion of approximately 120 images of fine art in a series of Corel CD-ROM titles of well-known paintings of European masters. The case involved many twists and turns, but the presiding judge noted that for a photograph of other printed work to be protected by copyright, the case law requires a "distinguishable variation, something beyond technical skill to render the reproduction as original." Further, the judge concluded that a change in medium (such as from a painting to a photograph) is insufficient to find the requisite "distinguishable variation."

In other words, a photo of a painting that's so close to the original is probably not going to pass muster with a judge as being "distinguishable" from the original. In which case, the photo's copyright is still owned by the artist who made the painting. This is yet another situation that has to be judged on a case-by-case basis, and if you (or your licensee) are ever faced with this situation, you would be well-advised to think whether a judge might consider it to be more along the lines of a photocopy and thus rule in favor of the artist. If you can think beyond your own subjective interests in the matter, you will make better choices as to whether model releases would be in order or how far you want to pursue such a case in court.

PROPERTY

PROPERTY

Establishing Copyright

A copyright springs into existence the moment a given work is created. For photography, the work is instantly copyrighted by the photographer when the shutter is released. (Yes, the data on a digital media card counts.) For an author, it's when he writes his book. For a choreographer, it's the moment he designs a dance step. For a sculptor, it's when he chisels. For an architect, it's when he drafts new designs. For a drunk sitting at a bar scribbling prophetic love notes on a napkin, it's when his pencil (presumably) hits the fabric. Anything that involves an original creative process is automatically copyrighted by the creator when it takes a physical form.

You can and should register a copyright for all your photos, but it's not necessary to get copyright protection. However, that protection doesn't amount to much without the registration, because the act of registration is what permits the very high statutory damage awards, which itself acts as a strong deterrent from those who would infringe. (See Part 7 for details on these awards.) Asserting copyright using the © symbol is valid, but it doesn't provide the same level of protections as formal registration.

There are two exceptions to the creator gaining automatic copyright to his works:

1 Works created by government employees as part of their job function. These works are automatically placed in the public domain.

2 Works created under a specific contract called "work for hire" (or "made for hire") are not owned by the artists, but instead by those who pay them. This is defined by statute, not necessarily as a consequence of any given contractual agreement. So long as the contract uses the phrase "work for hire" or "made for hire," the photo and copyright are automatically owned by whoever commissioned the work (it could be an employer or someone you work under contract for as a freelancer). This is standard practice for most photographers who shoot for advertising, car, consumers goods, and fashion companies. The business model for these photographers is such that their income is derived entirely on a per-project rate, or an hourly rate, not necessarily through the sales of their photography. (See Part 7 for more details on the effects of work-for-hire agreements.)

By contrast, stock photographers — the target audience for this book — typically do not shoot under work-for-hire agreements.

Government employees whose duties include taking pictures do not own the copyright to the photos they take. Instead, they are placed in the public domain.

Similarly, photos taken as part of a contract called "work-for-hire" are owned by the employer, not the photographer. However, the wording in the contract <u>must</u> use those precise words.

Trademarks indicate a single source of origin, such as the CNN logo or the Nike swoosh. Trademarks can even be limited to local businesses, like a movie theater.

PROPERTY

UNDERSTANDING TRADEMARKS

Trademarks and copyrights are very different animals, though they share some superficial similarities. At its essence, trademark is about protecting brand and identity — the names and logos that distinguish one company from another, so buyers know they are getting the real thing and so the brand owner can exploit that value.

Now you can differentiate between trademark and copyright: The design of the jeans is protected by copyright; the use of the logo is protected by trademark. Copyright prevents someone from using the music or photo without permission; trademark prevents others from using the logo to suggest an affiliation or to create confusion in the market.

Trademarks Protect Identity

Federal law defines a trademark as "a symbol of goodwill as used in commerce, and as a distinct indicator of a single source of origin or sponsorship." The implications of this seemingly simple language are far-reaching and can create ambiguity if interpreted superficially. Yet the concept is something we're all familiar with: we all generally understand a trademark as a unique identity — a brand. Levi's is a trademarked brand, and we all know it when we see it.

An identity established by a trademark can be a name, an image, or even a musical tune. For example, the Nike name and the Nike logo are both trademarked to protect the identity of the sports apparel company; the name and its logo are individually and separately protected. The

CNN name and its icon on TV, and the Intel jingle you hear on television ads you see for computers, are also all trademarked. Each is a distinct indicator of a single source of origin. Furthermore, each company uses its logos consistently in a way that people will instantly recognize.

Note that the legal definition of a trademark warrants some slight clarification: The phrase "used in commerce" isn't the same as the phrase "commercial use" that I've been using in reference to photography licensing. Rather, it means that the trademark has to be used in the normal course of business, such as on letterheads, in ads, on product packaging, on Web pages, and so on. It has no bearing on the issue of commercial versus editorial use.

Like copyrights, a trademark springs into existence the moment it is used. But, as with copyrights, you gain better protection of a trademark by registering it with the federal government, especially because registered trademarks enjoy high awards against those who infringe upon them (again, just as with copyrights).

Counting the trademarks in this picture illustrates just how important they are in today's world, not just economically, but socially as well. They have become forms of personal identification.

Some trademark holders go to extreme measures to protect their marks for good reason. Some economists estimate that a good trademark can translate to 33% of a company's value.

PROPERTY

EDITORIAL HARM

Editorial use of trademarks can actually harm a company more than misuse or abuse by competitors. The reason is that editorial uses typically involve perception of credibility, such as news reporting about product defects or satires skewering a manufacturer's overseas child-labor practices. These can significantly reduce the brand's value.

You can be sure that TV comedy programs that satirize a company or its products get some kind of letter from the trademark owner, whether it's threatening or just a "friendly reminder" that they're ready to pounce. Just because a claim is made, it doesn't mean it's valid — but there can be a chilling effect that will cause your licensees to start playing it safe and stop licensing images that happen to use trademarked or copyrighted items, even in an editorial context.

Another issue to note is understanding your licensee's intentions for using images with copyrighted or trademarked material, lest you find yourself having to defend the accusation of "turning a blind eye" to a premeditated malicious infringement. (Granted, this is less likely to happen by the use of a photo of a trademark than it would be for the production and distribution of an actual product that used it.)

Determining whether a given use is actually a bona fide intent to harm a mark, or a valid form of expression, is not easy. This ambiguity is critical to keep in mind when you hear or read about such cases in the news or discussion forums; people often then cite them and draw simplistic or incorrect conclusions without properly understanding or interpreting the facts or circumstances of such cases.

Limits to Trademark Protection

One particular concern that trademark holders have about people overly using them is the risk of it going generic. Some well-known companies have lost their trademarks because they were so commonly used that they became generic terms: Aspirin, Kleenex, and Escalator are examples. Even today, powerhouse Google is becoming so popular as a verb that its executives are worried about its losing some protections for some uses. Many articles on this topic can be found by googling the phrase, "Google losing trademark protection." Many of the search results show that Google executives are upset about the latest Merriam-Webster's dictionary definition for "google" as such: "verb: to use the Google search engine to obtain information [...] on the World Wide Web." (Note that the dictionary definition doesn't even capitalize google in any of its forms, except in the definition, as shown above.)

Such generic usage is the first step down a slippery slope for a trademark to lose its value. The trademark isn't lost, of course — just the strength of its protection in some uses. This is especially troublesome if you try to assert protection by virtue of the brand's recognition value: if the defendant says, "Yes, but it's now generic." Such a fate is taking the teeth right out of the wolf's mouth, rendering the trademark owner practically unable to reap the kinds of license fees and infringement damages that were once so lucrative. The cascad-

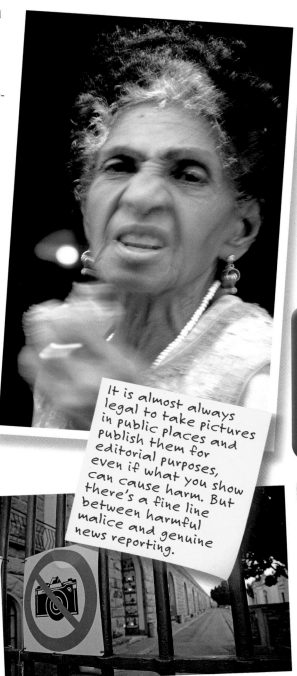

It is almost always legal to take pictures in public places and publish them for editorial purposes, even if what you show can cause harm. But there's a fine line between harmful malice and genuine news reporting.

PROPERTY

ing effect is one that continues to diminish the value of a trademark.

Unfortunately for trademark owners, they have less control over their trademarks than they would like. They have no way to control how individuals and the news media use their trademark: They can't make anyone say "search" instead of "Google" or say "photocopy" instead of "Xerox." Free speech for personal and editorial uses trumps their trademarks. They *can* go after a commercial violation of their trademark, such as use of their name by a competitor or an unlicensed seller.

The logos used by Sun Microsystems and the Columbia Sportswear Company look virtually identical. But, they operate in different industries with no crossover in products, so there is no basis for a trademark infringement claim.

And remember the phrase, "a distinct indicator of a single source of origin" in the trademark definition? This wording allows different companies to share the same trademarked name. As long as their businesses are in separate industries, the scope of trademark protection is limited only to the extent necessary to assure that each does not infringe upon the other's business. For example, Sun Microsystems and Sun Energy both trademark the name "Sun," but because they're in noncompeting businesses, there is no confusion among potential customers. Similarly, Sun Microsystems' logo is virtually identical to that of Columbia Sportswear. Much as these companies are probably not that happy about it, there's not much they can do because the government permits such multiple use, as long as there's no confusion among the public. If you're in the market to buy a computer workstation, neither Columbia Sportswear nor Sun Energy will steal any business away from Sun Microsystems, because no one would confuse the companies just because they share similar names and logos.

So why would the companies be so unhappy about it? It's because the more diluted trademarks are when they are shared, regardless of whether they're in the same industry, the less they can get in licensing fees (because of the diminished *perception* of value). Similarly, it's also harder to demand higher infringement damages.

It's sad when you may not be known or recognized, but it's worse to have once been known, or to have a tarnished image. Trademarks are extremely delicate, so they need careful protection.

It's every trademark holder's dream to be so universally recognized that their trademark's recognition becomes ubiquitous

PROPERTY

across all industries and geographic regions, because that's what ultimately increases the perception of value to your products, not to mention the fringe benefits of charging higher license fees and filing for higher infringement damages.

Although brands are often universal, global trademark protection is not automatic — the holder has to register the trademark in each country in which it does business. And many countries don't share the same trademark protections that most Western nations do.

The most famous example of international brand confusion is Budweiser. It's a trademarked brand of the U.S.'s Anheuser-Busch *and* the trademarked brand from Budejovicky Budvar in the Czech Republic. They use the same names, they use the same color schemes, and they have logos that are sometimes rendered similarly. Although neither company likes the fact, neither has prevailed over the other, so in some countries one has the trademark and the other holds it in other nations. There's no clear or simple resolution to this case, because both versions of the beer date back to the 1800s, giving both companies an inherently valuable reputation that each brand has earned over the course of time. It's not quite so simple to just "take it away" from one or the other. Yet, there they are, competing in similar markets with similar brands, perhaps causing confusion among the public, and, thus, financial opportunity to the trademark owners.

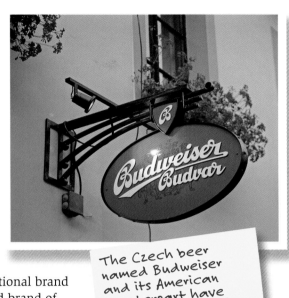

The Czech beer named Budweiser and its American counterpart have been in trademark litigation against one another over the name longer than any other in history.

PROPERTY

Unless you're really lucky, it takes a long time to build goodwill into your company's products and reputation.

PROPERTY

ASSESSING VALUE

The value of a copyright or trademark is termed *goodwill*. As you can imagine, such a value has broad implications for many things. And that's where the rubber meets the road for assessing the strength of an item's protection, and by extension, the relative need for a model release to publish an image depicting that item. Goodwill is generally hard to pin down because its value rises or falls depending on other factors, such as what form it takes, who's using it, and what the financial intent is. But a specific user of an image for a particular use should be able to assess that goodwill because that licensee knows whether their industries are related and whether there's likely to be a materially significant financial outcome from using a photo of the copyrighted or trademarked item.

It's important to note here that when I say you need to establish goodwill's value, I mean only in general terms. Getting actual, specific values for goodwill is more of an art than a science, involving what probably amounts to a solid semester's worth of graduate level business courses. But you don't need that, because all you're really trying to do is get a risk assessment for using a photo of a trademark.

One metric for valuing goodwill is the extent to which the owner maintains and defends the trademark. Owners must defend their trademarks from misuse by others, such as sending demands to others to stop using a trademarked term without permission, or the trademark office may consider the mark to be abandoned. Ironically, this very requirement fuels the fire that everyone else complains about: overly zealous acts of protectionism. (Hence, the expression, "Damned if you do, damned if you don't.")

So, the value of a trademark increases with use, which, as you can see, has a double-edged sword. If a trademark were so unimportant that no one ever used it, there would be no value. So, a photo of a building that has a relatively unknown company's name and logo on it is not going to have much risk of your being caught up in a trademark infringement case by whoever licensed the photo from you. (And if one were brought, the damages would be less than the cost of bringing the case to court.)

Interestingly, a copyright or trademark that is used a lot would appear to have great value, but its scope can be unexpectedly limited. For example, the U.S. Fourth Circuit Court of Appeals upheld a decision involving the Baltimore Ravens' use of the football team's copyrighted logo. The court found that, even though the team infringed the copyright owned by

Frederick Bouchat, a security guard who designed the original logo in 1996, it didn't have to pay Bouchat anything for the infringement. The court concluded that purchasers of Ravens T-shirts, caps, and other merchandise would buy whatever official team merchandise was offered, irrespective of the logo design. So the logo itself didn't contribute to the value and thus the income. (A link to the court opinion can be found at www.danheller.com/model-release-links.html.) The larger point is that a trademark is typically used to protect something that has value, and that "value" is not easily or universally defined.

All too often, sports photographers are very apprehensive about licensing photos that may contain team logos, or even those of their sponsors, for fear of trademark infringement. Although the problem is really the licensees', the reality of any given published used of the image is still next to minimal, since almost no one competes with a professional sports team — except for other teams, and they hardly ever use photos of other teams to promote themselves. So, the risk of publishing such photos is nearly zero, making the risk of licensing the photos essentially the same.

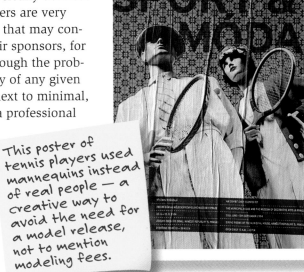

This poster of tennis players used mannequins instead of real people — a creative way to avoid the need for a model release, not to mention modeling fees.

Clothing is protected by copyright, so does this photo require a release? We all know it doesn't, but why? It's NOT because you can't see the labels.

IMPLICATIONS FOR MODEL RELEASES

So what does all this have to do with model releases? Plenty. When licensing images that may have a copyrighted or trademarked item in them — whether a logo on someone's shirt or the subject itself, such as a building — the first step for the licensee is to establish whether the intended use might imply an *association* between the owner of the mark and something or someone else (see Part 4 for details on association).

If so, the next question is the degree of that association, which is a leading indicator as to whether there may be a material financial effect on either party — the more significant the effect, the greater the chance of a legal dispute.

And that in turn requires an assessment of the relative value of a copyright or trademark.

To illustrate, consider the following four examples:

1 The first is a simplistic example of a photo of laundry hanging from clotheslines (left). Clothing designs are copyrighted and logos are trademarked, so if this photo were used for an ad for travel to Italy, does the use of this image trigger the need for a release? Most would say a release is not necessary because none of the clothes' logos or labels are recognizable. True, but if that's the case, what would you say about the next example?

PROPERTY

2 Say you have a photo of a woman and her bike standing next to a mural with the Coca-Cola logo in it, as shown here. Unlike the laundry photo, the company's logo and product are very recognizable. Does this have any effect on whether a release is necessary, such as for use in this book? It's pretty obvious to anyone reading this text that the topic has no association with the Coca-Cola company, its products, or even its industry. This is why you see photos with the Coca-Cola logo in many places — textbooks, newspapers, here, and even catalogs — and yet no release is necessary.

So, the fact that the clothes' labels or logos aren't visible is important, but not by itself (a point that I'll further illustrate later). Instead, the real test is whether there's an association between the item in question and its use. As for the Coke logo, yes, it's recognizable, but no one is purchasing this book because of the use of the Coca-Cola logo. (The only question left is whether the trademark's value is harmed, which clearly it isn't.)

These two scenarios illustrate the key point: While association and a trademark's value can independently affect whether a release would be needed, it is only the combination of the two that usually pushes you over the edge into wanting a release. An example of that would

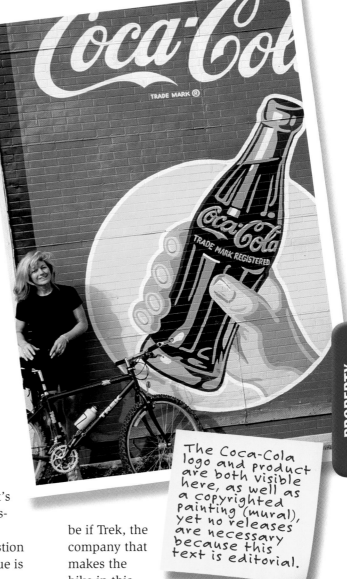

The Coca-Cola logo and product are both visible here, as well as a copyrighted painting (mural), yet no releases are necessary because this text is editorial.

be if Trek, the company that makes the bike in this photo, wanted to use it in an ad with the text, "Our bikes go well with Coke." Here, the obvious association and the heightened perceived value of the Coke brand would trigger Trek's need for a release.

PROPERTY

3 For the third example, let's say that Sears wants to run an ad in magazines and billboards that features a photo of a woman wearing a pair of jeans walking over a sand dune. As illustrated by Sears' Web site (shown below), Sears is counting very heavily on the strength of the Levi's brand to bring people into its stores to buy their pants. The depiction of the photo is not what requires the release from Levi's, it's the fact that Sears has an economic relationship with Levi's that does. It doesn't matter whether the model is actually wearing Levi's jeans (here, she's not).

However, the woman in the picture is also carrying a camera bag, which *does* have a logo (Lowepro). If the photo were to be used by a photo store that sold Lowepro products, then permission would *not* be needed from Levi Strauss because there is no business interest there. (A release would be required from Lowepro, though.)

So, again, our assessment is whether the photo would *result* in a direct economic effect on one party or the other, or if it would *imply* such a relationship. The visible depiction of the Lowepro logo and the fact that the licensee may be a camera store that sells Lowepro bags meets this test.

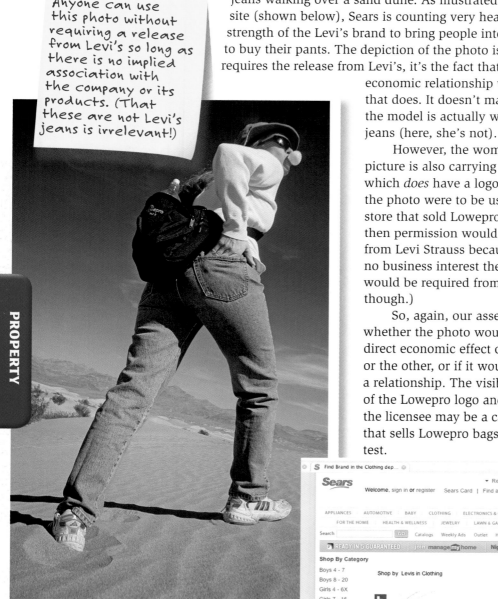

Anyone can use this photo without requiring a release from Levi's so long as there is no implied association with the company or its products. (That these are not Levi's jeans is irrelevant!)

PROPERTY

Because the Levi's tag is so visible in this photo, as well as their trademark pocket stitching, it would be harder for a licensee to use it in a way that wouldn't imply <u>some</u> kind of association with the clothing company.

PROPERTY

4 Now, let's consider a fourth example, this one involving a sculptor a gallery that sells his work. The gallery wants to place an ad in the local newspaper using a photo of one of the sculptor's pieces to draw people in. Would a release be required to use a photo that depicted the copyrighted item? One would think it would be, because the business relationship between the artist and the gallery is identical to that of Sears and Levi Strauss. But there's another factor to consider: the degree of that financial interest.

At issue is, among other things, whether the use of the photo results in a *materially significant* gain (by the gallery) or loss (by the artist)? The likelihood of either could be easily demonstrated in the Sears–Levi Strauss relationship, but for the artist and the gallery, it would be a stretch. At least, not with what we know so far (since nothing has happened yet — there's only been an advertisement).

So, for a claim to be worth making against the gallery for the use of the photo, something had to happen that resulted in a "materially significant" event. That is, it needs to outweigh the counterclaim that the outcome would have been the same regardless of whether that particular photo had been used. In other words, you don't just look at whether something "happened," but whether it happened *as a result* of the use of the image.

And to do that, you need a reference point — a history of events to compare to establish a difference. There are many ways to prove such a claim in court (and to disprove it), so a judge is going to want to see one side be more compelling than the other.

Let's get more concrete using two hypothetical outcomes for this gallery-ad example. First, say the ad doesn't draw more people in than is usual for the period when it was published. That is, the gallery runs ads every week in the local paper,

and the one week that it ran the ad using this photo, there was no difference in the number of people who showed up. If the artist's work doesn't sell, it would be a hard case to make to a judge that the use of the photo is the cause for his loss of opportunity. On the other hand, if the advertisement clearly brought in far more people than usual, and the gallery had made enormous sums of money, the artist would have a stronger case that the use of the photo contributed materially to the gallery's profits.

Does the legal technicality of copyright infringement matter here? Yes, but the practicality of filing a claim and going to the exorbitant expense of time and money of a lawsuit make such technicalities more moot than what the academics of law may suggest. The real-world issue here is simply money, and for that effort to amount to something, one side must demonstrate considerable harm or that the other side unfairly enjoyed considerable benefit.

I have no affiliation with the gallery shown in this photo. This is an example of having to specifically disclaim an association because the photo implies otherwise. Such disclaimers are rare, but necessary.

PROPERTY

The technicalities of whether releases may be necessary are not as important as the practicality of deciding to protect yourself or to take action. Sometimes, it's best to let sleeping tigers alone.

In the artist-gallery relationship, the use (or misuse) of the photo doesn't really matter unless something important happened as a result. But without a crystal ball, what should the artist and gallery have done in the first place? As with all business decisions, there's a risk/reward analysis. For this scenario, we can do a little predicting: Artists and galleries have existing reputations that can help forecast what kind of economic activity may take place, which then governs how much protection each side may need to employ. If either the artist or the gallery are well known, and sales usually jump as a result of one or the other's presence, chances are higher that each will want to protect its own business interests and secure a release. If it's just a local artist and small gallery, the likelihood of unusual sales activities is considerably lower, in which case, the risk for the gallery not getting a release from the sculptor is minimal, if not practically nonexistent.

The lesson with these scenarios is that the items in question have inherent value that could affect the financial equilibrium of the parties involved. Because of this value, the law gives the artist, Levi Strauss, Coca-Cola, and other companies and individuals a way to protect their properties through copyright (artwork) and trademark (brands).

PROPERTY

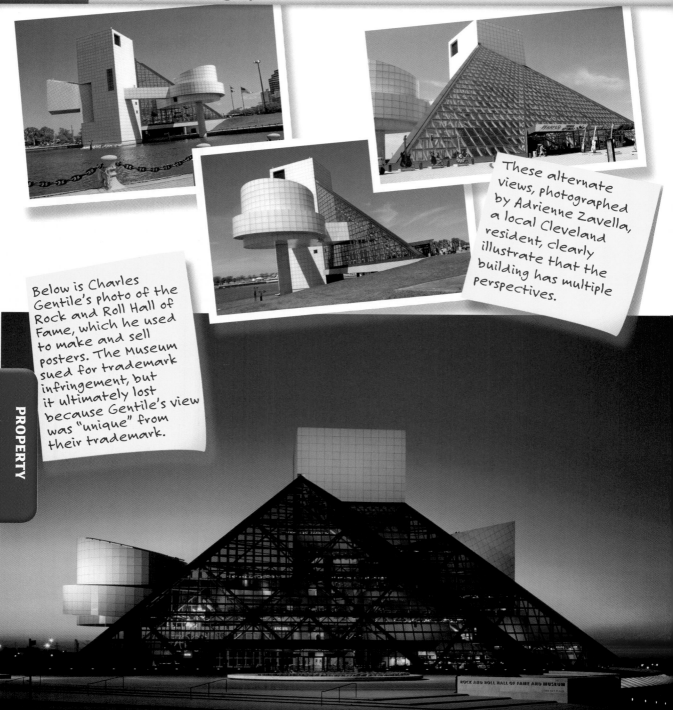

These alternate views, photographed by Adrienne Zavella, a local Cleveland resident, clearly illustrate that the building has multiple perspectives.

Below is Charles Gentile's photo of the Rock and Roll Hall of Fame, which he used to make and sell posters. The Museum sued for trademark infringement, but it ultimately lost because Gentile's view was "unique" from their trademark.

PROPERTY

© Charles Gentile (www.gentilephoto.com)

TESTING THE TRADEMARK SYSTEM

As noted earlier, successful claims of trademark infringement must satisfy the two key factors covered in this chapter: association and goodwill. Without both ranking highly, chances are that an infringement claim won't stand up in court. Consider these two examples.

The Rock and Roll Hall of Fame

First is a case in Ohio involving one-time professional photographer Charles Gentile, who sold posters of a photo he took of the Rock and Roll Hall of Fame in Cleveland. This is a well-known architectural landmark for the city, yet he decided to sell his posters of it despite the fact that it is a trademarked property. (Note: This is one of those cases where a photographer also happens to be the publisher — he publishes and distributes his own posters.)

The building's design is unique, and the owners of the museum had trademarked it. So they sued Gentile for infringement. (The issue was not taking the photo, but making posters using it.) Yet a federal court of appeals denied the museum's claim of infringement, permitting the use and sale of Gentile's posters. The judges in the majority opinion wrote, "In reviewing the museum's disparate uses of several different perspectives of its building design, we cannot conclude that they create a consistent and distinct commercial impression as an indicator of a single source of origin or sponsorship."

This case demonstrates many things, one of which is that "value" is not enough. The majority opinion wrote that the trademark itself was not consistently used, especially because many different angles of the building could be photographed, and that Gentile's particular angle was not one that was used by the museum in its own posters. Further, the depiction of the building and the sale of the poster didn't cause confusion among the public between Gentile and the museum.

On the other hand, the ruling was a 3-2 decision, a razor-thin margin that could very well be reversed by a new case involving different judges. Indeed, the opinions of the dissenting judges were along the lines that most people expected: that the poster benefited from the goodwill of the existing trademark, which is supposed to be protected. That the court didn't recognize this as sufficient to hold up the entire claim on its own should not be taken as a precedent by itself just yet. Could a similar case involving different players reverse the precedent established by this case? Possibly, but which photographers and mark holders want to go to that expense?

The case is Rock and Roll Hall of Fame v. Gentile, and it makes for interesting reading for a variety of reasons that the truly dedicated reader may enjoy delving into. You can find a link to the details at my Web site, at www.danheller.com/model-release-links.html.

PROPERTY

Hearst Castle

I was involved in a different scenario that almost resulted in a trademark infringement early in my career, due to the potential use of a photograph of Hearst Castle in California. I was contacted by a photo editor at a very high-profile magazine to license an image of the castle for use in an upcoming story, and the magazine was willing to pay an uncharacteristically high price for it, which was a nice surprise.

At first, I was honored, and felt that it was a great opportunity for me. But when I got the magazine's license agreement, I saw that the editors wanted me to agree to a provision that said that I understood that they were going to use the image beyond editorial use and that I would "hold harmless any claims that [Hearst Castle] would make against [the magazine]" — for just about any reason at all. (I address such indemnity clauses in Part 7.)

This kind of language was so far beyond the norm that I objected. The response was that it was just a boilerplate agreement and "no other photographer has a problem with it," which, as all pro photographers know, is a common response to just about any objection you raise about a contract. So it's not a response I take at face value. Instead, my usual response is to probe and pry and negotiate out of it.

But there was no negotiation on this point whatsoever. The intended use of the image was indeed beyond just editorial as the contract said. In fact, the magazine wanted the right to use the image in CDs, products of many sorts, and extended uses beyond description in perpetuity.

> The Hearst Castle is a trademarked property, and the owners forbid commercial uses of photos taken on the property.

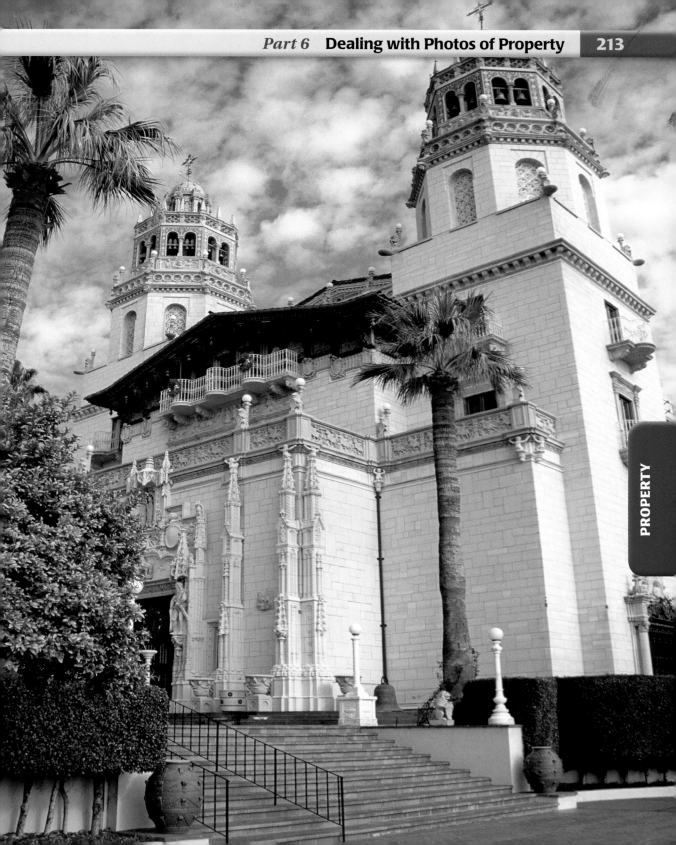

That raised several suspicions:

1 There are many images of Hearst Castle available from a wide variety of sources, so why was the magazine so interested in mine?

2 Why was the magazine willing to pay such a high price?

3 Assuming the magazine did go to stock agencies before contacting me, why would the agencies have passed up a relatively lucrative deal?

I had to do some fact-checking, so I went to the source: Hearst Castle. I talked to a representative for the castle, and it turns out that they have their own staff photographer, and they give images away for free to those who request them for editorial purposes. And then he said that the magazine had already contacted him, but he declined its request to use the castle's own images because of the intended commercial uses.

When I asked whether I could license one of my own images to the magazine, the rep said no, that it was a violation of my contract with the castle management. "Contract?" Yes, the ticket I bought to get in has a statement about how you can't take pictures for commercial purposes. The rep said the castle management would sue the magazine for trademark infringement and me for selling an image of a trademarked property. (I didn't know it at the time, but it seems that Hearst Castle is, in fact, trademarked. I didn't expect this because it's also a California state park. This unusual situation came about when the Hearst estate transferred administrative control to the state park system, which is really acting more like an elaborate live-in housekeeper than owner.)

By that point, I had put all the pieces together: The maga-

> The ticket used to get into Hearst Castle prohibits photos for commercial purposes. This kind of "contract" is used by many private venues, but the enforceability of such agreements varies.

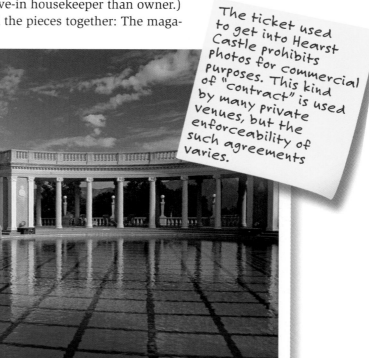

zine wanted to license the image from me because no other source was willing to do so. Then, the magazine was going to have me sign a contract making me liable in the event that the castle filed an infringement claim.

I called upon my usual cadre of legal references and ask two questions: First, is the magazine truly protected? That is, can the magazine point directly to me? If so, to what degree would I be held liable?

The short answer was that the magazine would get sued, but it would in turn come to me to collect (pay) the damages. Besides, the magazine's large size and deep pockets would be the more realistic target, especially because it was clear what the magazine's intent was (now that the plot had unfolded).

So, the strategy would have backfired in the end, which is not an unusual outcome for people with bad intentions.

Of course, all this assumes that the value of the products the magazine was going to sell would have been significant enough for the castle management to have sued in the first place. Given this and the fact that I wasn't going to be on the hook in the end anyway would have made this a very good deal for me. But I chose not to work with the magazine for an entirely different lesson I learned in a previous career: Be careful when choosing your business partners. Working with people like that often leads to

more trouble than the short-term money makes it appear.

For what it's worth, Hearst Castle is situated in such a way that you can't take pictures of it from any location that doesn't require having purchased the ticket that has the contract on it. If it were possible to shoot the castle without buying a ticket, photographing it from such a vantage point would freely permit the sale and publication of the photos, even in commercial form, as long as there was no confusion about the "single source of origin for products and services," as established by the Gentile case above, and as long as the use does not create an appreciable financial gain as a result of the goodwill of the castle. One would have to examine any given photo on a case-by-case basis to make such an assessment, though.

Because of how the castle is situated in the hills, this is the only photo that can be taken without actually being on its grounds, which requires buying a ticket. This is not the case for most such venues with similar "contracts".

PROPERTY

NAVIGATING THE TRADEMARK AND COPYRIGHT OFFICE WEB SITES

One thing about trademarks that will hit you sooner or later is, how do you know whether a given property is trademarked? In the case of the Transamerica Pyramid building, as someone who lives near San Francisco I know the building well and as a consequence I know that it's trademarked. But that's circumstantial. Just because something can be a registered or copyrighted or trademarked, though, doesn't mean it is (or that it has value). This can be a problem. A photographer once told me that his rule of thumb on buildings is that the more likely it is you recognize and know the building, the more likely it is that it enjoys a higher degree of protection. But I learned this isn't always true if you're a visitor to a city you're not familiar with. The first time I went to Chicago, I recognized only one building: the Sears Tower. But it wasn't until I put the photos I took of other buildings on my Web site and started getting license requests for them did I find out that they were also trademarked.

So, again, how do you find out whether something is trademarked? The first thought would be go to the federal registry (www.uspto.gov) and click on the Trademarks link. It'll open up to a menu of items, which are all helpful in getting you on your way. (The first one, Where Do I Start?, is perfect for a very brief overview of trademarks, including definitions and other related subjects, but unrelated to our focus here.) The second menu item, Searches, brings up a page for different types of search methods. Start by using the basic search. For example, do a search for Sears Tower, and you'll get hundreds of matches because many companies have their addresses there, not because you found a relevant match. So, even when you do know what to look for, you can get buried in irrelevant matches.

Now search for the Golden Gate Bridge. The results will show many trademarks, some owned by the bridge authorities and others not. Some trademarks are "live" and others are "dead" (like the mark for Golden Gate Bridge Beer, which actually sounds intriguing).

Of course, searches are more difficult for things whose names you don't know. All you can really do is try some descriptive information, such as the street name, that may show up in the filing.

So, searching can yield two dead ends: The lack of a match may not be an indication that something isn't registered — it just means you didn't find it. And a successful match doesn't mean you found what you're looking for. All this can lead to a publisher using a photo of trademarked items without ever knowing it.

If this seems like a dead end, you're right. But one that you have to know about. This is another reason why trademark holders have to be so assertive: No one else is going to do that work for them, and they can't assume that an infringer even knows they're infringing. Finding out whether something is actually trademarked requires hiring a special kind of trademark attorney, and that is an extremely laborious and expensive process. Typically, you don't go to this expense or effort without a real business objective of adopting a new trademark and using it for a new company or product or service.

The exact same problem exists for the Copyright Office Web site (www.copyright.gov). Actually, it's worse, because few people actually register their copyrights. Most simply attach a copyright notice to their work, using the © symbol. Often, there's not enough information with that notice to know whom to ask to get permission.

Does any of this matter in photography? Well, to the licensee it may, depending on how it wants to use the photo. And if so, is there materially substantive economic effect from the use? Fortunately for photography, the issue is less of a problem than it is for other sorts of uses, which is really what brings us to a soft landing on the issue: Anyone that licenses a photo that may contain a trademarked item is almost assuredly not using it in a way that would constitute a bona fide infringement. For if it did, they would be in a kind of business where they would be pretty well aware of it from the outset. Not that this wouldn't stop a trademark holder from sending you or your licensees a notice anyway. That's what brings us full circle: Trademark holders are going to be assertive because it's in their economic interests to be. It doesn't mean they're right, and now that you know the details of the issues involved, you can make smart business decisions.

PROPERTY

CONSIDERATIONS FOR COPYRIGHTS

The cases involving the Rock and Roll Hall of Fame and Hearst Castle are ones that address potential trademark violations. When it comes to copyrights, the same principles are involved regarding "economic effect from the use of the photo." But for copyrights, there's an additional consideration: whether the use of the photo adversely affected the copyright owner's ability to sell his own product. Copyrights apply to specific items, which can be sold individually and independently — a situation that doesn't apply to trademarks.

Other than that, all the other questions pertaining to trademarks still apply to copyrights: Does the use (of the image) diminish the copyrighted item's value? Is the use of the photo somehow enabling the user to benefit economically from the goodwill of the copyrighted item?

Although these questions are the same between the two forms, the analysis of the answers is different. That is, the goodwill of a trademark depends highly on its recognizability (because that's where the trademark's value is derived), whereas with copyright, the goodwill is dependent on the uniqueness of its design (expression), independently of whether it's recognizable by the average person.

To put it in practical terms: You may be willing to buy a new shoe you never saw before because of the Nike swoosh, in which case, the goodwill lies in the trademarked logo. But if you would buy a new shoe based entirely on its unique design, regardless of who made the shoe or whether you've seen it before, the goodwill lies in the copyrighted design of the shoe.

Although this is the primary difference between how goodwill can be established between trademarks and copyrights, there is a feedback loop between the two. Any company that can consistently come up with popular designs — each of which

The goodwill of the trademark usually affects people's perception of a new design. Is one more likely to buy this shoe because of its design, or because of the recognized logo?

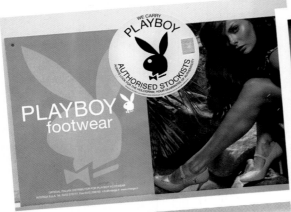

may engender its own independent goodwill — gains a cumulative effect that enhances the company's reputation, which in turn raises the goodwill of its trademarks (presumably names, brands, and logos). By consequence, as a trademark's goodwill rises, the more likely it is the people will be predisposed to liking whatever designs the company comes up with next. Think of Apple as an example.

> There's a circular dependency on the goodwill between trademarks and copyrights: Consistent production of likable products improves name brand value, which affects new perceptions of future products.

When this feedback loop yields parity between a company's trademarks and its copyrighted items, there's usually no problem in establishing whether there could be a materially significant economic effect by using photos that contain either of them.

Where one can draw incorrect conclusions about relative goodwill is when there is no parity: A company with no goodwill in its trademarks may lead someone to falsely assume that its copyrighted items (usually designs) also have no goodwill. Such a mistake often results in claims of copyright infringement by the copyright holder. In fact, it's this very miscalculation that leads some people to infringe upon photographers' pictures (by using them without permission). They erroneously believe there's no inherent value in the photos because the photographer is "unknown," thereby believing that infringement is either benign or has minimal damages. This can be a very costly assumption.

PROPERTY

To put these lessons into context, consider the photo of a dress and a scarf in front of a shop in the city of Dubrovnik, Croatia, at the bottom of this page. If an international airline wanted to license this photo for an ad promoting trips to the country to be published in *Vanity Fair* magazine, would a release be required from the dress and necklace designers? (Remember that I'm talking about an advertisement, not an editorial story, which wouldn't require a release.)

On one hand, the advertisement would be in broad distribution, and the nature of the ad assumes the target audience is interested in fashion, which

may be stimulated by the photo of this copyrighted design, benefiting from its goodwill. All this would imply a much greater potential for a materially significant economic effect as a direct result of the photo's use.

On the other hand, it could be argued that the jewelry and clothing in this photo have nothing to do with travel, and that the crossover between those who travel and those who read *Vanity Fair* is insufficient to stimulate interest in

Is this a valuable dress and scarf made by a high profile designer that aggressively protects their copyrights? Or is it an inexpensive mass-produced garment made in China?

Why do YOU need to know all this stuff if you're not the one taking the risk? Because your licensees may ask you to assume liabilities that you shouldn't have to.

Croatia beyond what is normally achieved by their ads in other magazines. That, plus the fact that the use of the photo didn't cause harm to the clothier's sales, suggests that a release for this photo *isn't* necessary.

On yet another hand still, it doesn't matter. The answer is that the airline shouldn't be taking the risk because the use is so high-profile, and the airline has deep pockets. The airline's lawyers should find out about the clothes. After all, it may turn out that the scarf was really a jewel-encrusted elaborate necklace made by a well-known designer like David Yurman, where the chances would be absolutely certain that someone's going to get a call from a lawyer. Remember: This is *not* the wearing of jeans, which is perceived as more generic, as I mentioned earlier in the Levi's example. These design styles are more unique than that, and have a more persuasive power of attracting a particular target audience.

As you read this, you may be thinking, "I'm just the photographer, and the risk is assumed by the airline, so I never need to worry about this stuff. Why go through all these details that ultimately aren't in my realm of responsibility?" For the simple reason that you're going to be dealing with many other people who don't understand this either, who may make demands on you that may worry you, who prompt you to do things you don't need to do, or who ask you to make guarantees or representations that you shouldn't have to make. When high-profile companies license images, they want to pass responsibility (that they otherwise own) onto you, as explained in Part 7. The better informed you are, the more you save in invaluable time and energy, not to mention reducing unnecessary legal exposure.

PROPERTY

Editorial Use

Now that I've covered commercial uses of copyrighted and trademarked property, let's get to the fun stuff: editorial uses of these items. As I've already covered everywhere else throughout this book, editorial uses do not require releases. What may surprise you is how *many* uses qualify as editorial, especially in the context of copyrights and trademarks, as opposed to people. And the reason for that is a concept called *fair use*.

Though "fair use" provisions permit the publication of photos of copyrighted and trademarked items without the need for a release, you may still wind up amidst a storm.

Fair use is a principle based on the belief that the public is entitled to freely use portions of copyrighted and trademarked materials for purposes of commentary and criticism, as well as other uses that are deemed to be in the public interest. For example, if you want to criticize a novel, you should have the freedom to quote a portion of the author's book without asking permission. Absent this freedom, copyright owners could stifle any negative comments about their work. Much the same way, you often see critiques of companies where they are identified through their logos. Similarly, photographs are critiqued in newspapers, magazines, and online discussion forums, and the photos themselves are shown, without requiring a license from the photographer. And lastly, photos of other copyrighted works and trademarks may also be published without the express written consent from the mark holders for certain editorial uses.

Yes, the implications of fair use go far and deep. This is particularly important in this day and age with copious use of Web pages, blogs, and other Internet resources where individuals express themselves. In fact, the very reason that photography itself — and the business opportunities that come with it — has grown so much in the past few years is precisely because of the freedoms that fair use gives people to post photos of just about anything.

The law provides protections to publishers for off-line uses (such as print) as well, and this book is a prime example. Stanford University has an excellent article on copyright and fair use, to which I provide a link on my Web site, at www.danheller.com/model-release-links.html.

This may feel like a sobering counterbalance to the trend of trademark and copyright holders unfairly asserting their protections where they shouldn't. This tug-of-war between protection and free speech is not new, it's just that the stakes are higher now, and the battles more frequent.

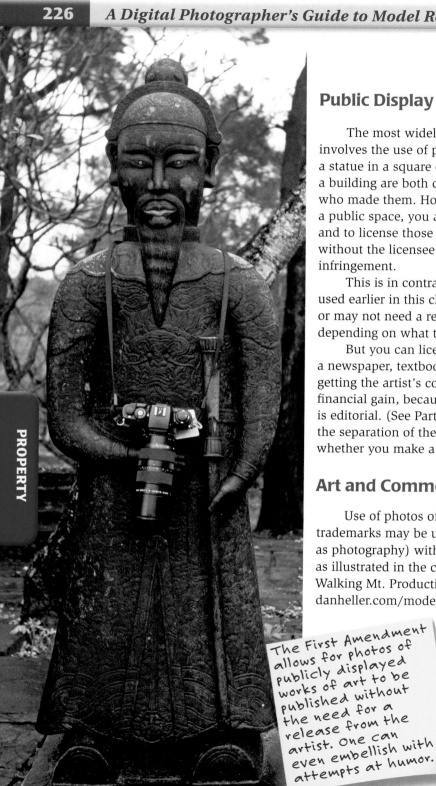

PROPERTY

Public Display

The most widely used fair-use concept involves the use of public display. For example, a statue in a square or a painting on a wall of a building are both copyrighted by the artists who made them. However, because they are in a public space, you are free to photograph them and to license those photos for editorial use without the licensee being subject to copyright infringement.

This is in contrast to the sculpture example used earlier in this chapter: The gallery may or may not need a release to use a photo of it, depending on what the use is.

But you can license the same photo to a newspaper, textbook, or news site without getting the artist's consent, regardless of your financial gain, because the use in question is editorial. (See Part 4 for an explanation of the separation of the need for a release from whether you make a profit.)

Art and Commentary

Use of photos of copyrighted items and trademarks may be used in works of art (such as photography) without requiring consent, as illustrated in the case Mattel, Inc., et al. v. Walking Mt. Productions. (Again, go to www.danheller.com/model-release-links.html for more information on this case.) Here, several claims were made by the Mattel toy company against Thomas Forsythe for his photographs depicting the famous, iconic Barbie

The First Amendment allows for photos of publicly displayed works of art to be published without the need for a release from the artist. One can even embellish with attempts at humor.

doll in a variety of poses, which were available not only for public display but also sold as prints. He also used the trademarked name Barbie to refer to the dolls in many of the pictures' titles. Because the court found the photos to be a parody (a form of commentary) of the Barbie doll, the photos were deemed editorial, so a release from the trademark holder (Mattel) was not necessary. The artist was also able to sell postcards and posters of his photographs without risk of copyright infringement. (This was also discussed in Part 2.)

To flesh out the point, let's apply that logic to the example of the art gallery that used a photo of a sculpture in its advertisement. If instead the gallery wanted to sell postcards of the photo, it would not be covered by fair use, because there is no parody or any other kind of editorial use. The intended use is strictly commercial. The artist himself can sell the postcards for the obvious reason that it's his work. The gallery doesn't own the artwork, so it can't sell postcards without a license to use his copyright. The gallery could certainly use the postcards to promote itself, in which case, we have the same situation as before: It's a form of advertising, and a release may or may not be required.

Found Art

Another example of fair use is for something called *found art*. This is the use of an object that, because of its very nature, evokes social commentary. Here, a protected item can be displayed (and sold) as artwork, overriding its protection. An example of this might be the use of a photo of an old Sambo's Restaurant. Until 1978, Sambo's was a chain of pancake restaurants based on the famous story of an encounter between a little black boy named Sambo and tigers in the jungle. The restaurant was forced to close its doors on due to the then-derogatory use of the name Sambo referring to black people.

Using imagery of the restaurant today, including its trademarked logos and copyrighted restaurant designs, to depict how social change has taken place is an example of found art. These images will still, no doubt, evoke strong emotions today as they had back in 1978. That is part of artwork's purpose, and is exactly why the artistic use of protected material without prior permission from the owner is permitted under the First Amendment as fair use.

Satire

A form of commentary, satire is another form of editorial use that falls under the fair-use principle. Usually, people associate satire with humor, where someone makes fun of something else, usually at the target's expense. TV shows such as *Saturday Night Live* satirize celebrities and political figures all the time, but they also poke fun at other TV shows and specific products, using their names, logos, and everything. Again, the editorial nature, even in a commercially-oriented entertainment program, trumps the copyright owner's rights, allowing their use without permission.

Photos used for journalism do not need releases, but some publishers try to masquerade their statements as "news," when in reality they may be acting with ulterior motives.

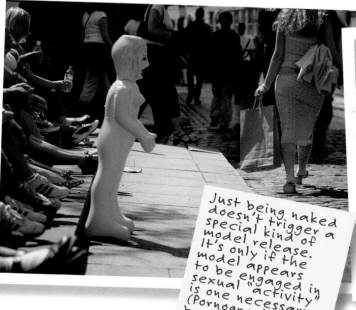

Just being naked doesn't trigger a special kind of model release. It's only if the model appears to be engaged in sexual "activity" is one necessary. (Pornography is beyond the scope of this book.)

One twist on satire is the extent to which it extends into commercial ventures. In other words, to what extent is the copyright (or trademark, for that matter) being capitalized on to promote the sales of a new product? If someone were to make a T-shirt that satirized a well-known hamburger restaurant chain, this is clearly satire and the permission isn't necessary. This is true even if the T-shirts were mass-produced — the act of making money has no bearing on whether a trademark has been violated. It's all about the editorial nature of the use. (This is the same situation as the Barbie doll postcard example earlier in this section.)

Satire never requires having a model release, either from people or from copyrighted or trademarked property. However, expect a big and expensive fight about it anyway.

PROPERTY

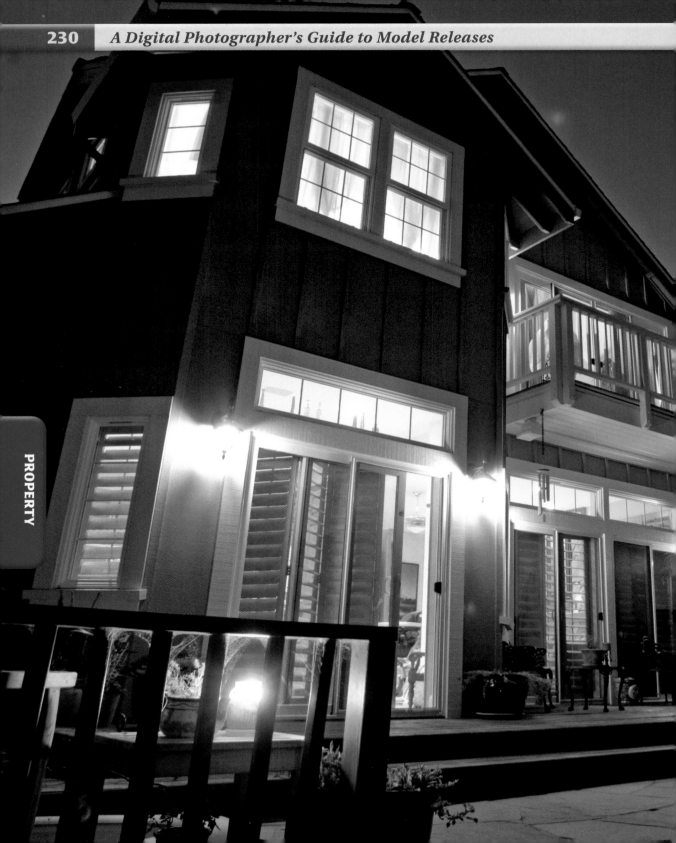

SPECIAL CONSIDERATIONS FOR PHOTOS OF BUILDINGS

Buildings and other structures are often trademarked or copyrighted, and as such, they are not unique from any of the other examples discussed in this part. But they deserve special attention for two reasons. The first is because of the long-held perception among most photographers and publishers that photos of buildings present some sort of additional legal liability. To illustrate, most photo contracts or license agreements from mainstream advertisers or publishers will invariably have text that reads, "Photographer warrants that he has releases for all photos of people and buildings …" In fact, these contracts don't even list other copyrighted or trademarked items — they list only people and buildings. If these contracts were properly written, they would say, "… for all photos of copyrighted and trademarked items for which there may be an association with the product being advertised or depicted in this publication." In other words, the pervasive misunderstanding of the subject warrants individual attention.

The second reason why buildings deserve special attention is that they are prominent, permanent, and seen every day by people on a regular basis, making their familiarity and public display prime candidates for the fair-use doctrine (covered earlier). Moreover, a building's use by the general public is not as directly associated with *how* photos of them are used, making it difficult to draw the kind of *association* that would necessitate a release.

Most important, although a building may have a high value in its recognizability, few buildings command such a value that the trademark holders could attribute the user of the photo *directly capitalized* on that recognizability. More often than not, it usually comes down to the text associated with the photo, not the photo itself.

The misperception that photos of buildings require property releases is pervasive. Yet, they are no different than other potentially trademarked items: is what's <u>the association</u>?

PROPERTY

PROPERTY

The net result is that photos of buildings and structures actually have a higher mark to meet before the genuine need for a release would be required, compared to most other copyrighted and trademarked items. The risk assessment, which is clearly a lower bar, is another matter. And to that, there is — as you would expect — a spectrum of risk levels, depending on the structure, the use of the photo, and the level of protection the structure may have. Note that personal residences have extra factors to consider, as I'll explain later.

The Golden Gate Bridge is such a universally-known symbol that even though it is trademarked, photos of it are used copiously in many forms across a wide range of uses.

Though the icon cannot be used to represent a specific product or service, using it for an ad to sell trips to San Francisco by a specific tourism company is not a violation of the mark.

Commercial Buildings

Two examples that show such risk differences are the Golden Gate Bridge and the Transamerica Pyramid building, both in San Francisco.

The Golden Gate Bridge is trademarked, but photos of the bridge are so copiously visible in all manner of media that the risk of violating the trademark through most commercial uses, such as advertising tourism to San Francisco, is virtually nil. This doesn't mean that the trademark has lost its protection; it just means that the scope in which the bridge is able to enforce its protections is limited. Because association is a difficult one to attribute, it's a tough case to show infringement.

Where the bridge district has chosen to assert its trademark and copyright protections — which also includes one of the few possible areas where it can — is in commercial depictions of the bridge where the bridge itself is the subject. For example, movies. As such, you rarely see scary or harmful images of the bridge in movies, such as it being blown up.

In general, organizations use photos of the bridge in highly commercial ways, such as in brochures and advertisements for conferences. Licensees of these photos never bother to seek permission because the subject of the conference isn't the bridge but San Francisco — the bridge is merely an iconic symbol for a destination, and as such it has general recognition and appeal. In other words, it's generic in this context. And because these uses don't harm the bridge's perceived value in any way, the management doesn't really have incentive to do much about such uses.

TRANSAMERICA
INVESTMENT MANAGEMENT, LLC

On the other end of the spectrum, consider the Transamerica Pyramid building, whose owners hold both a copyright and a trademark registration. The copyright protection prevents similar buildings from being erected, but the trademark protects the business identity. So Transamerica uses its logo (whose design is similar to that of the building) as part of its business trade (letterhead, advertising, business cards, and so on), and it has trademarked the logo to prevent others from using it (or defaming it) for financial gain.

Because the company enforces its trademark, a different company can't have a beer named Transamerica Beer that uses the logo (whether as a photo or a simple drawing). Such use would cause a reasonable person to assume that the beer company was somehow affiliated with the parent company, or it might cause someone to buy the beer because of the goodwill associated by the logo. In fact, the name of the beer has

nothing to do with the intended use of the logo. It could be called "Joe's Beer" and still not use the Transamerica logo.

On the other hand, I can freely use both the Transamerica logo and a photo of the building in this book to discuss the topic, because the use is editorial.

The Transamerica Building is copyrighted and trademarked. One cannot use the logo or photos of the building if it might cause confusion about the association between the user and the Transamerica Company.

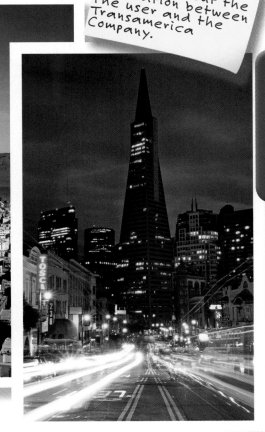

PROPERTY

Personal Homes

The issue of model releases for personal homes is slightly different than for other buildings. The building's copyright is held by the architect, and homes are rarely ever trademarked. But homeowners have other concerns, mainly related to their personal privacy and, in some cases, their financial opportunities (such as when they want to sell). For these reasons, they may want to have similar control over how photos may be used.

However, speaking strictly, they do not have any legal protections. But, even compared to dealing with large companies, it's worse dealing with unruly homeowners who are upset about photos of their homes appearing in places, because they don't know anything about this topic, making their annoyances akin to constantly swatting at a gnat. On the other hand, because the problem can be solved for less money and time than that of

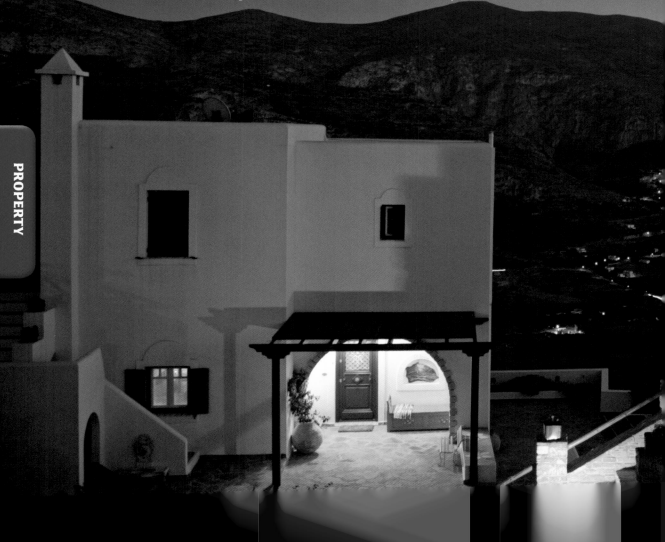

PROPERTY

a large company, it's often worth the few moments and pennies on the dollar to have the homeowner sign a property release.

What kind of property releases should you use? To this end, I'm reminded of the *Monty Python* skit where a man is arguing with a clerk about the purported need for a license for his pet fish Eric. The clerk tries to assure him there is no such thing as a fish license, but the man disputes him by showing him his cat license. The clerk replies, "That's a dog license with the word 'dog' crossed out and the word 'cat' written in, in crayon."

If you need to get a property release from a homeowner who is upset, just use a model release and cross out "model" (or "likeness," or whatever) and write in "home." (But don't use crayon — you're not dealing with someone who likely has a sense of humor.)

PROPERTY

PROPERTY

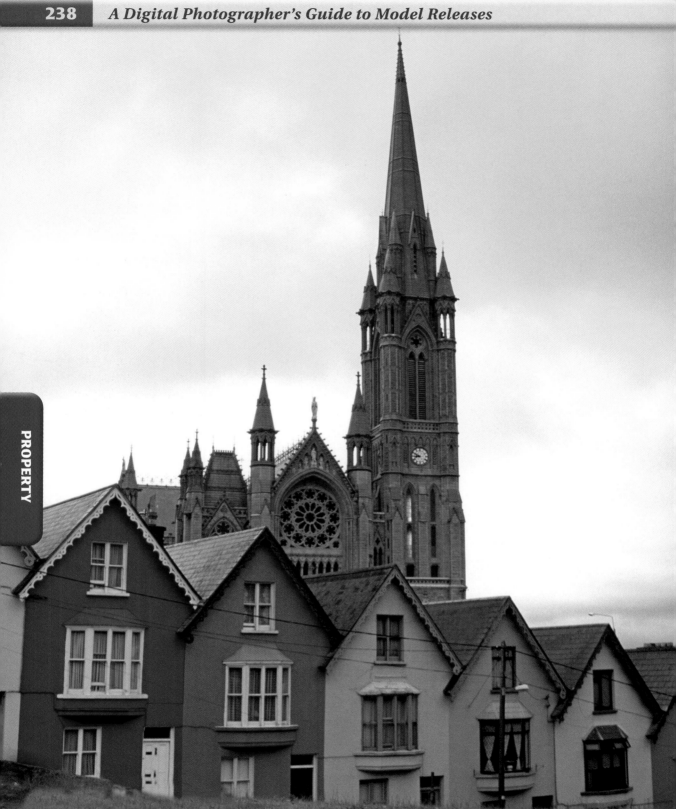

Another issue comes up with homeowners that involves the photographer a little bit more circuitously. Many real estate contracts include provisions for photo permissions, so the real estate agent can show pictures of the house on Web sites, flyers, ads, and the like. All's well and good up until the point where the house is sold. But let's say the new owners later want to sell the house as well, and they sign up with the same real estate agent they used to buy it. They sign the new sales agreement, which (again) permits the use of photos, so the real estate company uses the same photo it used before. The agent is the same user of the photo, the contract contains the same permissions, and the photograph is the same. Can you spot who raises an objection here?

You can trademark a personal residence, just as you can for other logos, phrases, or other icons that present a single source of original used in commerce. However, this is rare, as a home.

The photographer. Why? The license agreement. (Remember that?) Yes, I threw you a curve ball. See, the license agreement to use the photo was originally part of the first sale of the house, not the second one. More often than not, photographers who shoot real estate do so for a particular house *and* a particular sale. Once that sale is complete, the license agreement terminates. The use of the photo for the second sale requires an additional license from the photographer. This obviously has nothing to do with model releases, but it's a very common oversight because people are too focused on other problems. Regardless of who owns the house, the photo of it is still the photographer's, and he still holds the copyright — no one else.

PROPERTY

Homeowners from Cobh, Ireland to San Francisco, California have an understandable concern for how their private residences may be portrayed. But according to US laws, they are no different than other properties.

Licensing your photos is just another business transaction, like buying music CDs or signing up for an online dating service. Keep customers by making licensing simple.

The Business of Licensing

The business of licensing photography is technically a simple one: You grant someone rights to your property (photographs) in exchange for money. The granting of that permission comes in the form of a contract called a *license agreement*. And, like the model release, it's just another kind of contract, just as I described in Part 4.

For purposes of this part, there are two kinds of contracts to consider.

One is the implied agreement, which is what you see for common, everyday things like music, software, tickets to Disneyland, or your camera. Each of these (and many more) come with implied agreements that stipulate what you can and can't do. You are bound by these terms the moment you use the product (cameras), open its packaging (software), or even access it (music). As for Disneyland, you agreed to certain terms when you entered the premises, as indicated on the back of your ticket stub or on your payment receipt. For any of these agreements, if you violate the terms, the penalties can range from something as simple as a voided product warranty or ejection from the park, or as major as being sued for something as serious as copyright infringement.

The other kind of contract is that species of long, involved contracts that require signatures from the parties involved. You sign things like these when you buy cars, buy homes, get married, have surgery, acquire an oil

THE ESSENTIALS

In general, the main objective for a license agreement is to be brief, to be quick, to give away as little as possible, and to assume as little responsibility as well. Because you start out owning everything and assuming no risk, it's always better to not have any sort of agreement that changes that position.

Most smaller licenses are simple enough that you don't need a signed contract, just a list of the terms of uses that your client may have with your photo. This is the "implied agreement," and it achieves the dual objectives of not giving away anything and of eliminating your responsibilities. It is also here where you should state whether you have a model release, and if so, what its restrictions are so that the licensee is properly notified. Placing this information on the price quote and/or invoice the clients receive when you deliver is the best and easiest way to handle this. Their acceptance of the image is their implicit agreement to those terms.

On the other hand, there will be occasions where a signed contractual agreement is necessary. This will be when the stakes are high and the money is big — or if the risk of losing money is big. It may also be the case that you want something from the licensee (other than payment) that needs to be spelled out and signed, to convey mutual understanding.

Once signed contracts come into the picture, there will invariably be indemnity clauses to assure that one side is protected in the event that the other side fails to honor its warranties. For example, if you warrant that you had a model release — a factor that the licensee has to take on faith from you — it's not unreasonable for it to expect you to take the responsibility if it turns out that the release didn't exist or was insufficient. Similarly, it is also reasonable for you to be protected against any malfeasance by the licensee by having a reverse indemnification.

Finally, always be thinking *quid pro quo.* If the client wants something, don't assume bad intentions; just ask for something in return. Usually, money.

In the end, the unsigned "implicit" agreements work best in your favor.

company, or sue the telephone company. Chances are, if it's big and there are things that both parties need from the other, with expensive consequences if someone fails to do their part of the agreement, then you're going to use a signed contract.

Licensing photography can either of these kinds of agreements. Which is most appropriate depends on what the licensee wants to do with the photos. To illustrate, consider how music is licensed. For people like you and me, we're common users, and all we want to do is listen to whatever we bought. So the implied license agreement is used. You may or may not know it, but when you buy a music CD (or download music from a Web site), you are agreeing to "terms of use" that are spelled out in a license agreement somewhere. The money you paid, whether 99 cents for single song or $25 for a double-CD set, is all part of the same transaction and the same terms of use.

On the other end of the spectrum, let's say a car company wants to license a song for use in a TV commercial. The price will be a lot more than 99 cents, and the license agreement will be lengthy, enumerating the various permissions and exclusions that the car company may do with the song. But the same principle applies: There's a price and a set of terms that each party agrees to. The difference here is that high-level executives from

each company will sign this agreement (after teams of lawyers finish haggling about it).

Licensing photography works exactly the same way. If someone wants to license a photo from you, you can either present very simple license terms that permit the intended uses via an implicit (unsigned) agreement, or you can present a

longer contract that stipulates the detailed terms of use down to the letter, which then requires signatures from you and your licensee.

Which kind you choose depends on the complexity of the deal. How does the deal get complex? Various reasons, one of which being the model release.

Why is the model release a complicating factor? Well, the licensee bears the responsibility for how the photo is used. Because you're the one providing the release (that is, if this is a traditional stock-photo licensing situation), your licensee may want some assurances from you that the photo has been cleared of this risk. In other words, the client may want you to warrant (promise) that a model release exists and that it's appropriate for the intended use. And the most legally binding way to secure this promise of yours is to have you sign your name to it in a contract. The fact that you put your signature to a warranty makes it much easier to take you to court and win a judgment against you to collect the money he lost because of your error. (Well, that's the way he sees it, at least.)

Keep in mind that both implicit and signed agreements can be modified to accommodate the existence (or lack thereof) of a model release, so don't think that it's the perceived need for a release that triggers the use of a signed agreement. It's only neces-sary if the client wants it. And, with some exceptions I'll mention later, it's usually in your interests to avoid the signed agreement.

WHO OWNS WHAT?

To begin, you have to step back a little and be sure that you actually own whatever it is you're going to license. And to do that, start with this rule: Photographers own all rights, ownership, and copyright to the photos they shoot, unless and until they assign those rights to someone else. (This, unless they are shooting under a "work for hire" contract.)

To avoid mistakes in negotiating and writing license agreements, commit the following ground rules to memory, because these are the basic assumptions made by any contract, and therefore never have to be (re)stated in them:

1 A photograph and its contents (what is represented in the photo) are separate things. The photographer owns the copyright to the photo, which is the only thing that permits licensing rights. The subject within the photo can assert some restrictions on how the photo may be used in some cases. (That's why a photographer gets a model release.)

Remember that you start out owning everything about your photo, and you assume no risk on how your client uses it. License agreements can change that.

2 Physical ownership of photos (prints, film, and digital) has nothing to do with its copyright. That is, the photographer retains all rights to the copyright of the photo, even if he doesn't have the physical media in his possession. You can buy the physical negatives or digital media of photos that someone took (of you or anyone else), but this is not a transfer of copyright. (It's the same with music: You can buy a song, but this doesn't give you the right to republish it.) You need to either own the copyright of the photo or license it from the copyright owner to use (publish it).

3 Neither the subjects of photos nor the hiring party that paid the photographer

has inherent rights to the physical media. This is done either by licensing, or by a contractual or other mutually agreeable arrangement. If physical media is withheld from the rightful copyright owner against his wishes (usually due to a misunderstanding of the law I'm describing here), it is tantamount to theft, and the photographer can file criminal charges.

Simple example #1: If you buy the original negative of the famous picture of the Beatles walking across Abbey Road, you do not own the right to republish it in any way. You can make prints for yourself and family and friends, but don't venture into that netherworld realm of distribution, or you'll be finding yourself in big trouble.

Simple example #2: If you hire a photographer to shoot your wedding or portraits of your family, the terms of the photo agreement stipulates whether or not you get prints, copies of the media, a photo album, and so on. If the agreement doesn't list it, you don't get it. And this includes the right to resell or relicense those pictures. It would be very unusual for a photographer to grant these rights, so don't assume you have them.

Simple example #3: If someone pays a photographer to take portraits, but doesn't like the results, they do not have the right to destroy or take back the media. Doing so is a criminal act.

The more text in a license agreement, the more likely you're giving up rights you have or are assuming new responsibilities you wouldn't have.

THE BUSINESS

Work-for-Hire Contracts

It's not uncommon for clients and photographers alike to misunderstand the photographer's status with respect to rights to images, copyrights, and publishing. The default rights depend on whether the work is done as a work for hire or not. As a work for hire, the employer owns the work by default. ("Employer" includes someone who contracts the photographer for a specific project, not just an employer in the sense of someone who gives you a regular paycheck.) Otherwise, the photographer owns it by default.

So follow this simple rule: The photographer is either working as a contractor under the work-for-hire provisions, or he's not. There is no middle ground. And there is only one way to be working under those provisions: The contract must use the phrase "work for hire" or "made for hire" and be

signed by both parties before the work begins.

If a photographer is hired as a work-for-hire contractor, he is obligated to turn over the media to the hiring party. Not doing so at the request of the hiring party is a criminal act, unless the photographer has not yet been paid, in which case, the hiring party has not fulfilled his part of the agreement (which is *not* a criminal act).

The photographer may not make copies of the media without permission, although such things are often done to assure there are backup copies. When relationships go well, this isn't a problem. It's when they don't go so well that people face trouble if they don't understand how the law works.

Photo discussion groups that focus on stock photography have a notorious disdain for work-for-hire agreements because the photographer does not get to keep his photos. This is understandable, because such a business relies on the accumulation of photos over the course of time. However, there's nothing inherently wrong with such agreements,

If the contract uses the phrase "work-for-hire", the roles are reversed: the client owns everything, and you are tied up. You get only what's in the written contract.

Being paid to shoot events for clients does not automatically give them usage rights. Their rights must be spelled out in a written contract.

and many publishers are simply accustomed to working that way. (The common assertion in these forums that such clients are intentionally attempting a rights grab is largely misdirected anger.)

In the event you are presented with a work-for-hire agreement that you'd prefer not to work under, the best thing to do is request that you revise the contract to stipulate all the rights that the client wants for the images in exchange for the removal of the work-for-hire provision. It's almost always the case that clients don't really know what that means anyway, in which case you may have good success in that negotiation. (And if they do know the implications of work for hire, they usually know not to hire a stock photographer.)

Government employees who shoot as part of their job function do not own the copyrights to their photos. They are automatically placed in the public domain.

THE BUSINESS

Non-Work-for-Hire Contracts

Because there is no middle ground, or just due to ignorance of the law, those who hire photographers under agreements that are not work-for-hire can mistakenly believe they own (or have rights to) the pictures, simply because they are paying for the assignment. This is not the case — they are entitled only to whatever is written in the assignment contract. Unless the contract says so, the employer does not have the right to license photos to others, nor does the employer own the media. (Emerging models and people who hire photographers to do family portraits often make these mistakes.)

If a subject who commissions photography wants to use the images taken of him for anything other than personal use, he either needs to write that into the original contract, or he must license the photos from the photographer, just as any other licensee would do.

In the same way that photo subjects misunderstand the photographer's status, photographers often do, too. They mistakenly assume that because someone is paying them to shoot, they don't own anything. This is often the case for emerging travel or event photographers.

When under this misconception, such photographers will write assignment contracts with terms and provisions that try to get back rights they never actually lost. This is a mistake (even if you think you're just clarifying what you own), because now it can be inferred that you gave up the remaining unstated rights that you didn't list.

Because the photographer owns everything, an assignment that is done without a contract stipulating some set of terms, it is possible to shoot the assignment and not give the client anything whatsoever. This isn't good business (to not

give them anything), but this base case illustrates just how much power the photographer starts with. In fact, some photographers actually prefer to shoot some assignments without agreements precisely to maintain control of the relationship. This not only assures an upper hand in the event that the relationship fizzles somewhere, but it allows the photographer further control, such as being able to edit photos and pick and choose what to give the client, without the risk of an enforceable objection. Of course, most professionals know that they want to keep the client happy and will provide them exactly what they want.

This aspect of working without a contract also has risks: namely, that you have nothing to compel the client to pay you. This isn't normally a problem with conventional business relationships: I never deliver photos until I've been paid. Instead, I provide thumbnail index pages that let the client review what I shot. This obviates the risk of not getting paid. But that risk always remains, irrespective of a contract (checks can be cancelled). If the client didn't like the way the assignment went for some reason, your getting paid may be costly and full of drudgery no matter what.

It may appear that there's an implicit distrust or friction in these relationships, but that's not the intent. What I've described is standard practice, even for the best of business partners. Sticking to these conventions is perfectly well accepted by experienced parties on both sides of the transaction, so you shouldn't feel like you're sending mixed signals. Still, relationships can go bad now and then, in which case, you want to have the upper hand.

LICENSING AGREEMENT BASICS

With those foundations clear, let's move to the basics of a license agreement. There's only one point of a contract: to spell out the terms and conditions that each party has. As such, the first thing to know is that when you (the photographer) own everything and risk nothing, you want to do as little as possible to change that status.

What changes that status? The license agreement. Therefore, the contract should stipulate only those terms that are different from what is otherwise the default. Because (outside as work-for-hire situation) you start in the best possible position, the more the agreement says, the more likely it is you risk giving away something you don't want to. That, or taking on more responsibilities and other risks.

CHIMPANZEES HUMANS

That said, the licensee is, after all, paying to get some rights, and you want to give it rights. You just want to do so in a way that doesn't give more than you want to. So, you'll want to use an agreement that you write and that the licensee doesn't get to modify — at least, not easily. This is precisely why there are so many of these implied agreements: the software license, the product warranty on your camera, and the tickets to the zoo. All of these are implied agreements that are enforceable (with some exceptions beyond the scope of this book), and are thus most desirable.

Always inspect signed contracts. If you use a lawyer, ask tons of questions and learn the nuances of how language is drafted. This makes you a better negotiator.

Yet you're not always going to have the option to use an implied (unsigned) license agreement. There are going to be cases and conditions where the client will want to more formally spell out conditions and request that you make certain warranties.

Signed License Agreements

In a signed license agreement, there are a few basic things the client is most likely going to want assurances on from you (the warranties): that you own the image (copyright), that you are authorized to grant the use of the image (in other words, it's not already under an exclusive license to another party), and that you have the model release (and guarantee its authenticity and content). At least, if there is a need for a release.

There may be other provisions as well, especially in longer, more involved agreements, but these are the basic ones.

Such warranties are not only for the practical protections in the event of a dis-

Understanding the implications of what you're agreeing to in a license agreement is critical. Don't sign something you don't understand well.

Photographer warrants that he or she has the right to enter into this Agreement and owns and can convey the rights granted to the Publisher; the Work (photograph) contains no trademark or copyright, nor infringes on the rights of others. The Photographer will hold the Publisher and its distributors and licensees harmless against all liability, including expenses and reasonable counsel fees, from any claim which if sustained would constitute a breach of the foregoing warranties.

pute; they may also be for insurance purposes. That is, if a publisher uses an image in a way that turns out to have required a release, and it gets sued, its insurance company will pay the damages for a lawsuit, provided the publisher made best efforts to avoid risky behaviors in the first place and can't recoup those costs from someone else. Not checking to see if a photo has a release would be considered risky behavior. Publishers rely on insurance heavily in a world of litigious and frivolous lawsuits, so many contracts that you may be presented with will have provisions that may be non negotiable for this reason. In fact, some companies may require using their license agreements. Either way, one thing that will assuredly exist in any such agreement is an indemnity clause.

The Indemnity Clause

The text shown above is a prototypical indemnity clause from a typical licensing agreement that I get from clients. The part that pertains to model releases is in green, while the part pertaining to indemnity is in blue. If you sign an agreement with such a provision, and if the subject of a photo were to make a legal claim against the publisher and win, the

publisher might be able to come to you for reimbursement for their losses, as long as the claim was due to a breach of your warranties. To clarify, it means that if you made a specific promise about something and they get sued as a result of that something not being "right" somehow, you pay the damages, whatever they may be.

That does not mean that the publisher will point the prosecution's lawyers over to you, nor does it mean that you have to pay ongoing legal bills, nor would you have to defend the company in court. The phrase "hold harmless" just means that you'll pay the company back whatever it may have lost, but only in the event of a court ruling. (Settlement out of court is not a "sustained" ruling.)

Here's the scenario where you would be in trouble: You took a photo of someone, did not get a release, licensed the photo to someone else and said you *did* have a release, and signed a contract that had an indemnity clause that said that you "warrant that the photo does not infringe upon the rights of others." In this case, you have breached your warranty to the licensee. This indemnity clause allows the licensee to go after you to recover the money it lost due to your malicious act.

So, that's the most important effect of an indemnity clause. Without it, the aggrieved licensee would still come after you, but it would likely face an uphill battle to get money from you.

While that sounds really scary and makes it seem as if you could have a huge legal and financial burden, I sign agreements that have this language all the time, even for photos of people or trademarked or copyrighted items that have no model releases. It's not that I'm a risk-taker by any means. It's just that I know the risk is reduced by a chain of factors.

Yes, the above indemnity clause says the work "contains no copyright," but this is unrealistically sweeping. The photo in question certainly could contain some kind of copyrighted item, simply by virtue of the fact that such items exist in the world and there's no avoiding them. Clothes are worn by people, for example, and they often contain copyrighted designs. The only way such a warranty could be effective is if the copyrighted item in question was relevant to the claim.

NEGOTIATION HINTS

Don't look the other way on issues that matter just because a client may be bigger, or because you need the deal.

THE BUSINESS

Don't fall asleep at the wheel. Details are important, and you need to look out for yourself. No one else will. Understand the implications of what you agree to.

Don't argue with yourself. You may have competing objectives, and you may not always serve all of them in a single license agreement. When in doubt, seek advice.

Stick to the issues at hand. Don't try to preserve rights that are already yours. By attempting to do so, you could lose others you otherwise wouldn't have.

THE BUSINESS

Next, such claims are rare to begin with. Then there's the even slimmer chance that such claims are valid, meaning that it'll never even get to court. And if the judge still ruled in favor of the prosecution, it would probably be because the licensee's use was so egregious that the judge would keep the liability squarely on the publisher's shoulders.

Sure, the publisher could then try to pass off responsibility to me (which in a case of any importance, it would try to do anyway, indemnity clause notwithstanding), but doing so is itself yet another expensive and legally tenuous trial, which frankly is not likely to result in anything substantial enough to bother with.

In short, I'll take that risk.

So, no, the publisher does not have any real, practical safety through an indemnity clause for things like photography licensing (although such clauses are extremely important for other kinds of licensing). With this one exception: if you committed fraud, or misrepresented what kind of release you had, or did any of those other things I warned you not to do back in Part 2. In that case, you might want to start thinking about what kind of hairdo looks good with an orange jump suit. Assuming you haven't done those bad things, and if you disclosed at the outset whether the image has a release, the only issue now is what color pen you want to use to sign the contract.

Irrespective of any model release — or contract, for that matter — if someone makes a claim against the publisher, you are still going to be involved to some degree or another. Most legal cases of this nature involve deposing the photographer to find out what he knew and when he knew it. The indemnity clause isn't what's compelling you to participate in this legal discovery process, so don't think you can get out of it just because there may not be a requirement to participate in the contract (or if there's no contract). Instead, the indemnity clause is there to assure that you take responsibility for the warranties that you make.

Negotiation 101: The *Quid Pro Quo*

Perhaps you're the conservative type, or you suspect your client may be doing something risky in its use of a photo, raising your suspicion that your client may get sued. Such a case would make you feel uncomfortable about having an indemnity clause. If you want to give yourself some protection, you may want to consider trying to negotiate terms for a form of *reverse indemnification*. That is, just as the licensee may want protections in case you misrepresent your warranties, you may want similar protections in case it misrepresents itself (such as how it intends to use a photo). Note that this is not an attempt to negate your indemnity to the client; it's an attempt to protect you in case the client does something wrong. (The two don't overlap.)

For example, say a client wants to license a photo of the San Francisco skyline for a coffee mug that it would sell in tourist shops around town. You may think that because the photo has the Transamerica Pyramid building clearly visible that it might violate that trademark. The client believes the general cityscape

THE BUSINESS

view comes under fair use, and there is no association with anything that would warrant the need for a release. You may disagree on this, but is it enough to kill the deal?

Of course, you could choose not to license the image, but a better option might be to have the client indemnify you in case the Transamerica company tries to assert that you knowingly licensed a photo for a use that would have required a release. Although it hasn't been established that this use would require a release, the point of the provision is a precaution against the risk of being held accountable for the "blind eye" accusation: that you knowingly licensed a photo to someone who you knew would violate their trademark. It may seem to be a stretch to be accused of such a thing, but the reverse indemnification would take care of that remote possibility.

So, what does such a provision look like? It could take many forms, depending on the circumstances of the deal, but you can always start with their indemnity clause and go from there. Or, here's a generic stab at it: "Licensee understands that it bears responsibility for how it

Quid Pro Quo, or "something for something," is the first rule of contract negotiations. If the client asks for something, ask for something in return.

THE BUSINESS

Having an "implicit agreement" makes it easier to enforce this strategy, since there is less room for argument about the language of a signed contract.

publishes the photo, and that the photographer makes no claim on the suitability of the photo for any use. Licensee also indemnifies photographer against any claims made by third parties for the use of the photo."

Although this language serves your needs and doesn't appear to contain language that a licensee would object to, it shouldn't be taken for granted that a client would easily accept it. After all, you're asking it to assume a risk that it tried to pass onto you. What's more, the client may already know that its intended use is inherently risky and want some of that risk passed on to you, which a reverse indemnity would prevent. So your mileage may vary.

When it comes to negotiation, you'll have to judge whether the cost of negotiating the point is worthwhile on a case-by-case basis. For what it's worth, though, most such negotiations go on a *quid-pro-quo* basis. That's Latin for "something for something," and the natural *quid pro quo* when the client introduces an indemnity clause is for you to say, "Okay, if you'll agree to mine as well." (The client may not take our proposed reverse indemnity clause as is, but here's where you can start changing each others' language until you're both satisfied.)

THE UNSIGNED "IMPLICIT" AGREEMENT

Although it may surprise most stock photographers to hear it, I don't use any kind of signed license agreement for most of my business. It's only when a client requests that I use its signed agreement do I ever vary from this *modus operandi.* The business rationale starts with the premise I mentioned above: I own all copyright and rights to the image, and the client owns only responsibility for how the photo is used and the obligation to pay me. Because I never deliver an image until after payment, I don't worry about the former.

Now, obviously, the client needs to be given rights, but it doesn't need a signed contract to get them. All the client needs is a statement that minimally describes what rights it gets in exchange for its money. You know, like the contract you agreed to (and weren't aware of) when you bought that music CD. I do exactly the same thing for my images: I have

a very brief list of things the client can do with a photo, and I attach it to the price quotes the client receives when it places an order for an image, as well as on the paid receipts it receives when it gets the license. Simple. Easy. No bureaucratic muss of fuss.

> If a licensee uses an image beyond the agreed terms, suing for copyright infringement will get the immediate attention of lawyers and quick payment.

THE BUSINESS

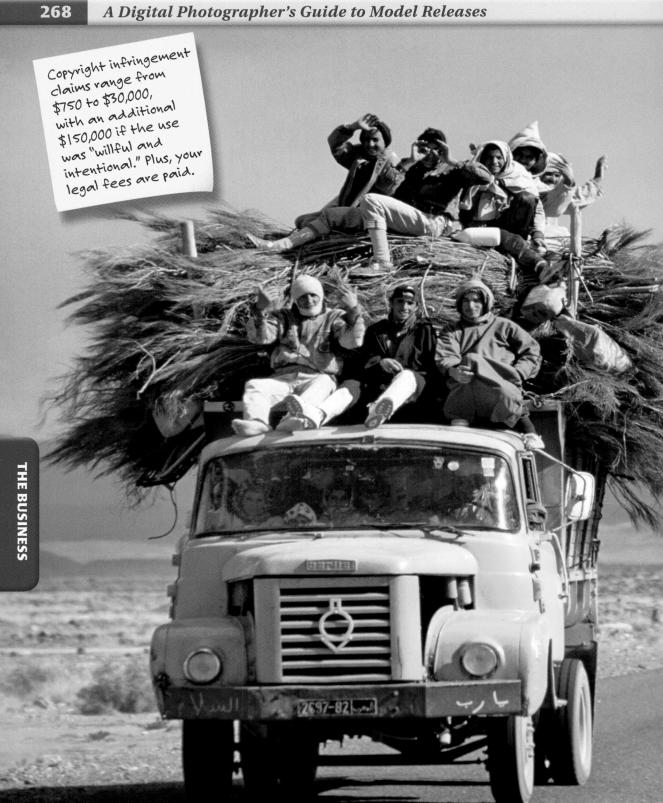

Copyright infringement claims range from $750 to $30,000, with an additional $150,000 if the use was "willful and intentional." Plus, your legal fees are paid.

THE BUSINESS

Note that my terms state nothing about my obligations to the publisher — it lists only restrictions on the publisher's part. Because I have no obligations, I'm pretty clear of any risk for claims made against me. If anything were to go wrong, it'll probably be due to something the publisher does. Thus, if a person were to file a claim against the licensee for using a photo for which there was no release, it's much harder to draw me into liability.

If that were enough, that'd be fine. But there's another, even stronger benefit to using an implicit agreement: suing for damages in case something goes wrong. This is beneficial in two directions: It's harder for the client to sue you, and easier for you to sue it. To understand this, consider the implicit agreement associated with the music CD: The license gives you permission to listen to a song, but if you then use it in a TV commercial, this is considered copyright infringement. The license to use the music is not a contract, and suing for copyright infringement has seriously substantial penalties than for breach of contract. It's a different case to present and to defend, as well as having a different set of standards to meet than with a contract. Best of all, the financial upside is huge.

So, let's put this back into the photo-licensing context: Say you licensed an image for $500 to a magazine for a domestic circulation of 100,000 copies. You later learn that the magazine used the image in its international edition as well, adding an additional 100,000 copies. So you send a bill for the additional license fee of $500. But you are met with a stone wall of silence. Out of frustration, you threaten to sue. Depending on the kind of agreement you have, your claim can come in one of two forms: If you used a signed contract, you would sue for breach of contract and be

THE BUSINESS

Threatening to sue on a breach of contract is difficult at best, and your only upside is the amount owed by the terms of the agreement. This is effectively begging.

eligible to collect exactly $500 if you win. This isn't going to get the attention of many lawyers (or the accounts payable department) very fast.

On the other hand, if you used an implicit agreement that was not signed, there's no contract to breach (just an implicit agreement), so instead you file a claim of copyright infringement. By statute, infringement claims start at a minimum of $750 and go up to $30,000, per infringement. You also get an additional award of up to $150,000 if the use was deemed willful and intentional. Best of all, the defendant also pays your legal fees. And courts routinely award higher damage awards if the defendant fails to reply to attempts at communication.

Clearly, a communication of this sort will get the immediate attention of the company's lawyers, who will most assuredly direct the accounts payable department to cut you a check for your $500 instantly. The cost of trying to defend an infringement claim exceeds the original $500 upon the first hour the lawyer has to pay attention to the matter.

Obviously, in the event of an actual lawsuit, the company's reasonable and expected defense would be that there is no copyright infringement, and that it's really just a breach of contract. Fine, but no company wants to go to court in the first place — it's just a simple claim of $500. It's much easier to pay it and be done with it.

Those who deliberately infringe upon your photos would be subject to the full amount permitted by law — or, at least, however much you're able to wrestle out of them.

Bridging the gap in contract negotiations is not only hard, it's just the beginning. There's still no telling what's on the other side. Thus is the challenge of business.

INDEX